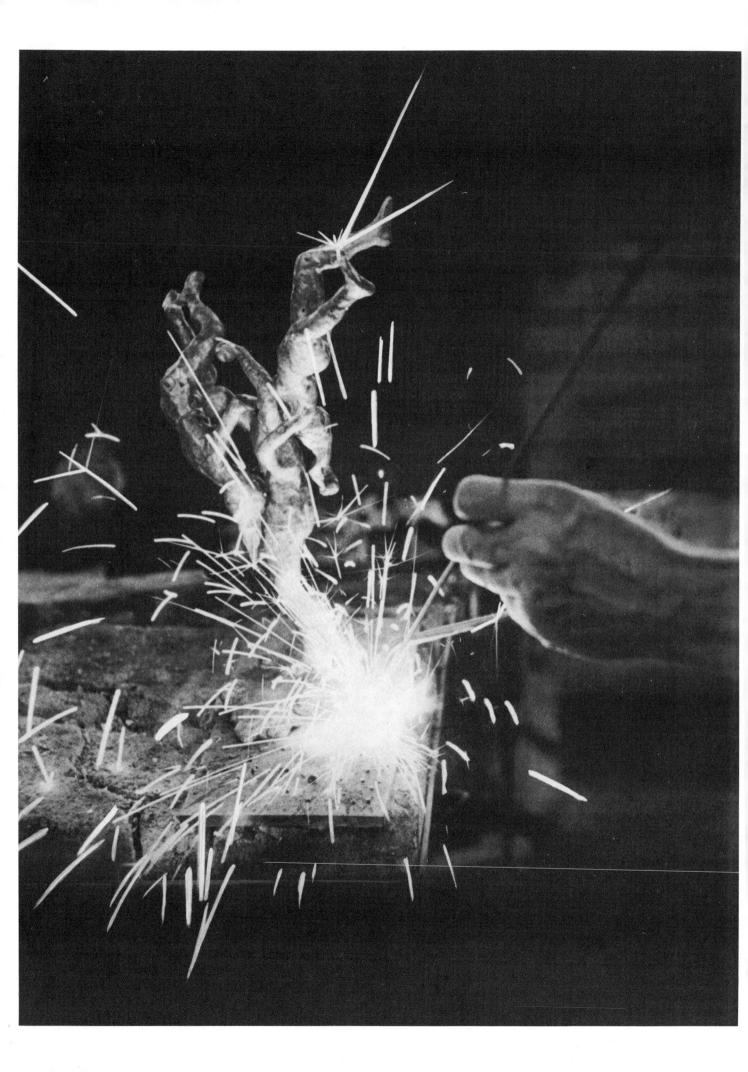

Creating Welded Sculpture

Nathan Cabot Hale

DOVER PUBLICATIONS, INC.
New York

Bibliographical Note

This Dover edition, first published in 1994, is a republication of *Welded Sculpture*, originally published by Watson-Guptill Publications, New York, in 1968. A new foreword and final chapter have been prepared by the author specially for this edition.

Library of Congress Cataloging-in-Publication Data

Hale, Nathan Cabot.
 [Welded sculpture]
 Creating welded sculpture / Nathan Cabot Hale.
 p. cm.
 "A republication of Welded sculpture, originally published by Watson-Guptill Publications, New York in 1968"—CIP t.p. verso.
 Includes bibliographical references and index.
 ISBN 0-486-28135-3
 1. Welded sculpture—Technique. I. Title.
NB1220.H3 1994
731.4′1—dc20 94-9025
 CIP

Manufactured in the United States of America
Dover Publications, Inc., 31 East 2nd Street, Mineola, N.Y. 11501

For Terri and Lisa

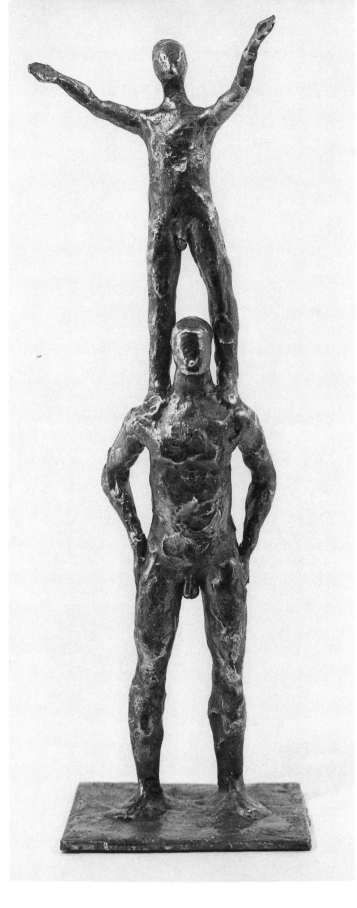

Father and Son, *nickel silver, 12" high, collection, Mr. and Mrs. Eugene Powell. These figures were connected by modeling the feet of the child figure directly onto the shoulders of the adult figure. The hands of the larger figure were also modeled onto the hips after the arms were attached and positioned.*

It is a source of great pleasure to me to see this new Dover edition of my book. The years since the original publication of the book in 1968, under the title *Welded Sculpture,* have brought a wide acceptance of the welding techniques. Now one can see numerous examples of large-scale abstract welded sculpture in cities all over the world. This is ample proof of the usefulness of the welding process in sculpture.

There are, however, other aspects of the problems of sculpture that this new edition, *Creating Welded Sculpture,* will address. The first is the use of the oxyacetylene technique in the modeling of the small-scale human figure. This application of the welding process is a longer-term study of the methods of modeling molten metal. But with the learning of this method there will come a new era in figurative sculpture, for this method frees the artist to experiment with small-scale figure composition. This method can allow the artist to conceive and execute finished figure pieces in bronze with a freedom never before known in sculpture. This method will give the sculptor a new independence in composing and working out new ideas in a form more suited to the coming age.

This brings us to the second application of figurative welding, which has to do with pursuing a newer and deeper understanding of the abstract forms of energy in the universe as they relate directly to the people of this planet. I have added a new chapter to show how I have tried to understand these newly discovered processes. Though I have only scratched the surface, I feel that the future holds great new adventures for the artist.

The methods I describe in this book have been developed by me over a period of forty years. They represent valuable and reliable technical tools to the methods of our craft.

NATHAN CABOT HALE

Amenia, New York
1994

Other Books by Nathan Cabot Hale

*Reprinted by Dover, 1993.

Contents

Acknowledgments

The process of writing this book has not been a one man show. There are a number of people who have made it possible for me to write it by their generous help and understanding. They are:

Alan Gruskin, Director of the Midtown Galleries, New York, my dealer and good counselor.

Dorothea Denslow of the Sculpture Center, New York, who gave me a place to work when I needed it most.

Robert Beverly Hale, instructor of drawing and anatomy at the Art Students League of New York, for his masterful teaching.

O. E. Nelson, photographer, New York, whose fine photographs illustrate part of this text.

Walter Russel, photographer, New York, for additional photos.

McKinney Welding Supply Company, New York, for sound technical advice and many years of considerate service.

Don Holden, Editor of Watson-Guptill for his skill in translating from Serbo-Croation.

Alison Hale, my wife, for smoothing out all the rough spots of my life so that I can work in peace.

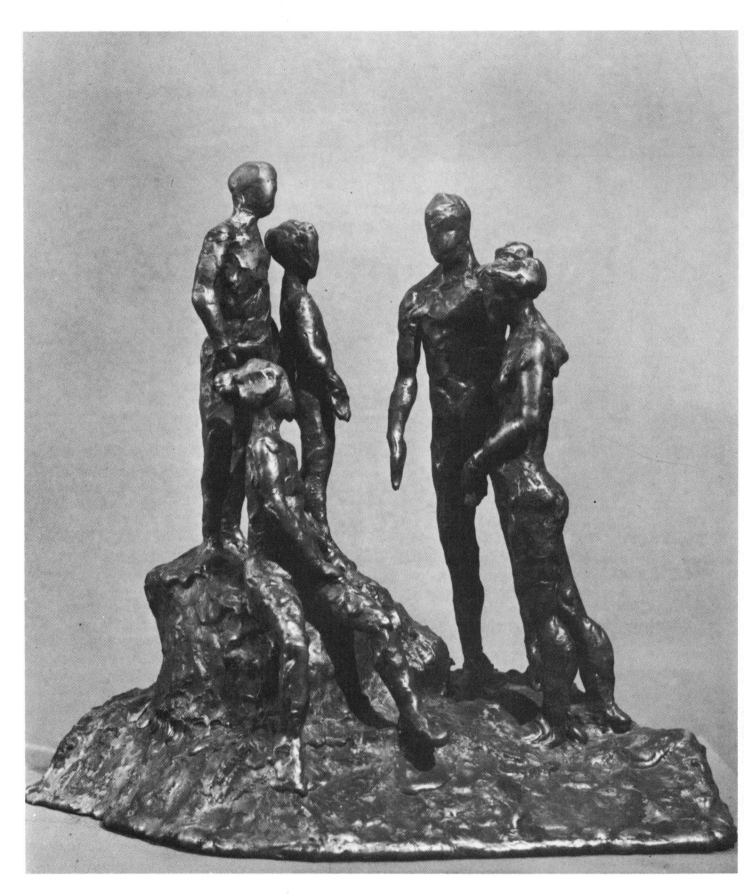

Concord, *manganese bronze, 10" x 8", collection, Mr. Michael Stewart. In this composition, the shape of the base plays a major part as it gives three different levels for the possible placement of the figures. Two figures stand on the ground. The girl sits on the rock form. The two children stand on the rock. A major part of any figure composition lies in the figure's relationship to the ground level and to the forces of gravity.*

The basic assumption of this book is that it is necessary for a sculptor-welder to have the same professional skill as a good job-welder. Not everyone agrees. These people do not seem to care about technique as long as the welds appear to hold together. The whole point is that a bad weld will *not* hold together in time. Only a skillfully made weld can last. If the sculptor develops the skill and craftsmanship of welding, he will be able to create any kind of weld and produce any kind of textured surface he desires.

In some quarters, there has been an irrational fight against technical skill and against knowledge of form construction in art for a number of years. Unfortunately, this controversy has spread into the new field of welded sculpture as well. I want to mention this debate since you will be subjected to these ideas, and will have to examine the facts and decide for yourself. Is it possible to "just go ahead and express yourself," or should you spend time accumulating basic technical skill in your chosen medium?

There have been a number of people who have taken up welded sculpture who have never mastered the fundamentals of craftsmanship. Some of them have gotten considerable recognition. But quite often in these cases, the sculptor has mastered another sculpture medium before he became interested in welding. In other words, he was already technically oriented to form. This orientation may give his forms a feeling of quality, but his sense of form does not guarantee he handles metal to his fullest capability. Actually, there is no real alternative to learning the craft of welded sculpture.

To learn welding for sculpture, I spent four years working in various kinds of welding shops. Since that time, I have worked steadily as a sculptor-welder with some success. Because I had been oriented toward art all my life, the years I spent learning the facts of metal work were difficult for me. However, the disciplined thinking of the industrial welder which I learned has been invaluable. I learned about structure, form functions, and work patterns. I learned a lot of bare facts about mechanical and geometrical shapes. In this book, I hope to crystallize my experiences for you so that you will not have to spend extra time in non-art jobs just to learn what someone else already knows. This book is intended to give you all the facts that a sculptor-welder will need.

As you have accepted me as your teacher, you will more or less acquire some of the things that I have learned the hard way. But all basic learning is done the hard way, namely through effort and determination. One of my main teaching goals is to encourage you to value craftsmanship and to acquire as much skill as you can. Teaching and learning are a two way proposition; even though I may not be right next to you to encourage you to put forth your best effort, I am there in spirit, urging you to master all these basic exercises.

Perhaps you have never given much thought to the matter of tools, but now that you are beginning to learn to do welded sculpture, I think it is a good idea for you to start out by understanding their origins and functions. Today, even though tools are important to the very existence of our society, they are too often taken for granted. Since welded sculpture uses some of the most advanced tools that man has developed, you must first understand the most basic thing about *all* tools. Tools are extensions of our human anatomical functions. They reach; they touch; they are used to model and shape our environment. Today, tools even affect the growth and development of the human species itself.

☐ ORIGIN OF TOOLS

The use of tools goes back to the very beginning of mankind. The cultural development of the human race has gone hand in hand with the development and use of tools for shaping and understanding matter and energy. Even the stone axe and the stone drill had their period of growth and development at a time when they were an advanced and sophisticated technology.

A visit to the local museum of natural history will show you how the art of stone tool-making grew over periods of thousands of years. At the beginnings of the Egyptian culture, for example, stone-working had reached a very high peak of development. But someone started smelting metal from copper ore, and that gradually drove the stone tool-makers into a new line of business, although there may have been some academic die-hards who fought the "new-fangled" ways for a century or two. As a matter of fact, today, some of the older academic sculptors regard welding as heretical. This would seem to teach us that technology changes, but people do not.

By Greco-Roman times, the basic tool principles had all been discovered, and nothing really new has been added since that time. The new discoveries have come from adapting tool principles to new sources of motive energy: water, steam, electricity, gasoline, diesel, and nuclear power. Behind all these advances stand man's anatomical functions, and the basic modeling capacities of his life energy.

To me, there has always been an implied moral in this understanding of the origin of tools. I feel that the user has an inherent responsibility for the best possible use of the tool. Some people never become quite worthy of the heritage of tools. They misuse the tools themselves; they do not appreciate or understand their meaning or history; and they never realize what an honor it is to be the inheritor of these implements that make wealth, shape human destiny, and model the world we live in.

So when you hold a tool in your hand, pause for a moment to reflect on the knowledge that you hold an object that took thousands of years of thought and striving to develop. A tool represents thousands of years of ancestral pondering; it is the crystallized hopes of your forefathers. In its very nature, a tool implies a logic, an understanding, and an obligation for you to do the best job of which you are capable.

Good sculptors love their tools and take delight in using them well. There is a sense of pleasure in the feel of a hammer, a pair of pliers, or any tool that you have carefully chosen and worked with for a few years. Tools are beautiful in themselves; and they grow more beautiful in time, the more they are used. Treat your tools well and kindly and they will serve you faithfully through the years.

A great part of welded sculpture depends on the use of tools. We could not make our kind of sculpture without them. And since part of the sculptor's reward results from the act of work itself, this knowledge of tools will give your experience a feeling of depth.

☐ BASIC TOOLS

Although welded sculpture does involve a significant investment in tools, it requires less equipment than you might think. A great many tools are likely to be found in any well-equipped family tool box. Here are the basic tools you will need to begin welding.

1. Torch handle
2. Tips 1,2,3
3. Oxygen hose, 20′
4. Acetylene hose, 20′
5. Oxygen regulator
6. Acetylene regulator
7. Torch lighter
8. Goggles
9. Gloves
10. Hammer
11. Cold Chisels
12. Pliers
13. Hacksaw
14. Screw driver
15. Wrench
16. Steel tapemeasure
17. Steel square

Later on, you may want to add some of the other equipment I describe in this chapter, but these seventeen items are the only indispensable ones.

☐ THE NATURE OF OXYGEN AND ACETYLENE

The most important tools you will use are two gases. One, oxygen, is always present in the earth's atmosphere and constitutes about one fifth of its volume. The English scientist, Joseph Priestley, discovered oxygen in 1774. It was later found that oxygen is the chief supporter of the combustion of all substances, although it does not burn by itself.

The other gas we use in welded sculpture is acetylene. This gas is not ordinarily found in the atmosphere but is, rather, a manufactured compound. In 1836, Edmund Davy compounded a highly flammable gas by mixing water with calcium carbide. This gas was later named acetylene. But it took sixty years until a French chemist named Le Chatelier discovered, in 1895, that when these gases were brought together under pressure and ignited, they produced a flame that would burn at a temperature between 5700° F. and 6300° F.

This discovery came at a time when science had developed ways to produce both oxygen and acetylene gases in quantity. This soon led to the development of the oxyacetylene welding process. Since this process had many useful applications, it was then and is *still* being improved by research. Today this welding process is used in every country of the world.

Both oxygen and acetylene are delivered to you compressed in steel cylinders (Fig. 1). Oxygen presents no problem when stored under high pressure. It is delivered to the commercial user in three different cylinder sizes: 63 cubic feet, 122 cubic feet, and 244 cubic feet.

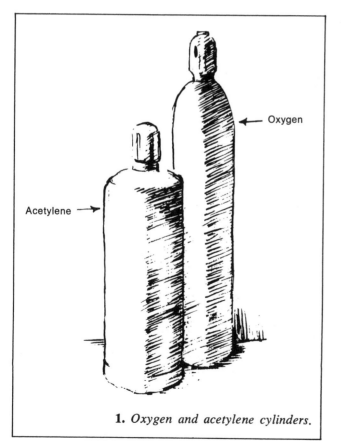

1. *Oxygen and acetylene cylinders.*

Acetylene storage is more complicated since this gas will ignite spontaneously under pressures greater than fifteen pounds per square inch. So acetylene cylinders are air-tight and made of steel; the inner part is filled with porous material. Into this porous material, liquid acetone is injected. The acetone then absorbs acetylene gas in large amounts, and gives off the gas at safe pressures. Acetylene is delivered to commercial users in four cylinder sizes: 40 cubic feet, 100 cubic feet, 180 cubic feet, and 333 cubic feet.

Oxygen and acetylene cylinders in smaller sizes can be purchased directly from some welding supply houses. The larger cylinders are never sold, only rented. In some cases, it is just as convenient to order the cylinders on a rental basis as it is to buy them. Usually, there is no charge for the rental of the cylinder if the gases are used within a month's time; the only charge is for the volume of gas that the cylinders contain. After a month's time a slight charge (called a demurrage charge) is made—a few cents a day—until the cylinders are again picked up by the welding supply house, or until you return them. I own two sets of cylinders, and find this convenient for my own purposes. Some sculptors prefer to rent them. As a beginner, you would do best to rent a set of small cylinders at first.

☐ REGULATORS

Both oxygen and acetylene cylinders have valves on them that are similar to garden water taps. The acetylene cylinder differs by not having a handle; instead, it has just a square valve stem on which you use a special acetylene key wrench. Of course, these valves have a much *finer* control of outflow than water taps do; but even so, the outgoing pressure cannot be controlled properly by the valves. Since welding requires a steady and unvarying gas pressure coming to the torch, pressure regulators are used to maintain this steady flow of gases. These regulators fit onto the cylinder valves by threaded attachments.

The two types of regulators (Figs. 2 and 3) resemble each other in general appearance, but there are some important differences between them. Both have threaded couplings that attach to the threads on the cylinder valves. The coupling leads the gas into the pressure regulating chamber, which is the main body of the regulator. Both regulators have a large key on the front of the chamber which is used to

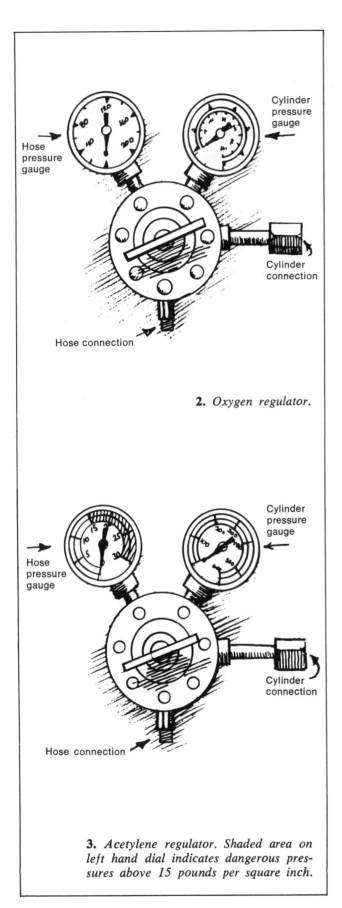

2. *Oxygen regulator.*

3. *Acetylene regulator. Shaded area on left hand dial indicates dangerous pressures above 15 pounds per square inch.*

regulate the pressure of the gas going to the welding torch. Each regulator also has two glass covered pressure gauges. One of these (the cylinder pressure gauge) indicates the actual gas pressure in the cylinder; the other (the hose pressure gauge) indicates the pressure the operator sets with the adjustment key. The adjustment key controls a diaphragm in the pressure chamber which regulates the outgoing pressure. And, both regulators have a threaded coupling to which you connect the pressure hose to the torch.

There are two basic *differences,* however, between the oxygen and acetylene regulators. First, the oxygen regulating diaphragm and pressure chamber are constructed more heavily because of the great pressure under which oxygen is kept in the cylinder. So, naturally, the oxygen cylinder's pressure gauge has a higher reading: it shows oxygen from 0 to 4000 pounds per square inch of cylinder pressure. The hose pressure gauge shows a reading of from 0 to 100 pounds per square inch going to the torch. The second basic difference is that the oxygen regulator couplings for both the cylinder valve and for the hose coupling are threaded with clockwise, right hand threads. The acetylene cylinder is just the reverse, for reasons I will explain.

The acetylene cylinder has counter-clockwise, left hand threads on it to prevent its being put on the oxygen cylinder by mistake. Since both the pressure diaphragm and the acetylene regulating chamber are lighter than those of the oxygen regulator, both would break if they were used for oxygen. Also, it is necessary to have a built-in safety factor for controlling the acetylene pressure: the fact that the acetylene regulator has left-handed threads keeps the operator aware of acetylene's dangerous characteristics.

In addition, the gauges on the acetylene regulator have special markings. The gauge showing the cylinder pressure reads from 0 to 600 pounds per square inch (some also show the cubic feet in volume). The gauge showing the regulated pressure to the torch reads from 0 to 30 pounds per square inch. The area on the dial above the 15 PSI is marked in red as an additional safety warning not to use pressure *greater* than 15 PSI.

The differences between oxygen and acetylene regulators are built-in safety devices for the operator's protection. They serve as a constant reminder that acetylene gas, when not handled properly, can be dangerous. Some companies even paint the acetylene regulator red and the oxygen regulator green to

emphasize the difference. All welding hose manufacturers use these colors for the two hoses.

There are several major manufacturers of oxyacetylene equipment. Just which manufacturer's product you will eventually prefer will depend on the experience you gain with different set-ups.

All the major manufacturers make good products, but each has its own special variations. There are different regulators for heavy or light usage. There are torches for very heavy industrial welding, and light ones for lighter uses. Some manufacturers produce a welding kit that is an ideal beginner's set-up. I started welding with one such kit and, though I have since purchased other equipment, all of my kit tools are still in working order and are occasionally used as a second outfit or as temporary replacements for the newer tools. These kits consist of the two regulators, a welding torch, welding torch tips, a cutting attachment, 25′ lengths of double hose, goggles, a lighter, wrenches, and a welding manual.

□ WELDING TORCH AND TIPS

The welding torch is a two part tool that receives its gas supply from the regulators by a hose. The hand held part of the torch is called the mixer (Fig. 4); the other part is called the torch tip. The mixer has two threaded attachments for the hose: one right hand threaded for the oxygen, the other left hand threaded for the acetylene. The mixer also has two valves to control the flow of gases into the tip. And there is a threaded connection for the torch tip which attaches to the mixer.

Welding torch tips come in graduated sizes (Fig. 5). There are tips suitable for every welding need. Those with very small openings are used for welding lighter gauge metals. Those tips with larger openings are used for welding thicker stock.

All welding tips, regardless of size, are fastened onto the mixer by a threaded coupling. The seating end of the tip and the housing that holds the tip in the mixer are very carefully fitted to one another, so that torch tips can be seated only by a firm hand tightening. Never seat a torch tip with a wrench; this may damage the tip.

Tip openings are cleaned with tip cleaners made of steel wires in graduated sizes. These cleaning wires are hung on a spindle inside an aluminum case that is very compactly made.

There is also the torch lighter (Fig. 6), a hand operated device of heavy flexible wire, which

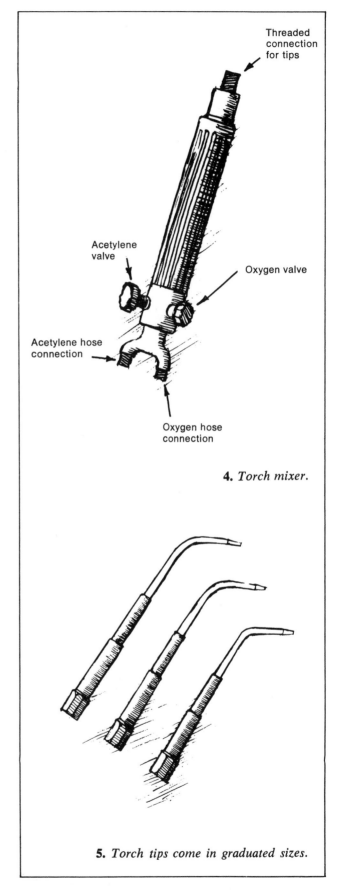

Threaded connection for tips

Acetylene valve

Oxygen valve

Acetylene hose connection

Oxygen hose connection

4. *Torch mixer.*

5. *Torch tips come in graduated sizes.*

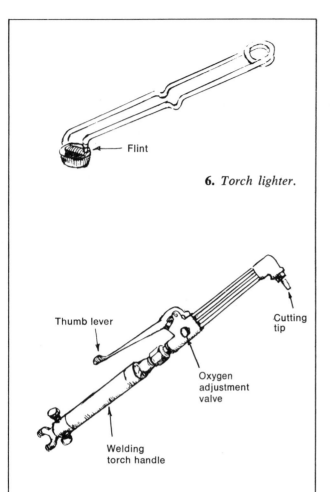

6. *Torch lighter.*

7. *Cutting torch. Oxygen adjustment valve controls amount of oxygen to be mixed with all oxyacetylene flames. Thumb lever controls amount of pure oxygen to center hole of cutting tip.*

8. *Cutting tip attaches to cutting torch. Oxygen hole is in center, surrounded by cluster of holes for individual oxyacetylene flames.*

scratches a flint across roughened steel. The sparking flint ignites the acetylene that flows from the torch tip.

☐ CUTTING ATTACHMENT AND TIPS

I have now described all the apparatus required for welding steel or bronze, except for an additional attachment that fits onto the mixer. This is the cutting attachment which fits onto the mixer handle by the same sort of threaded coupling used for the welding tips. The cutting torch is not a necessary item for the beginning sculptor-welder, but it is a very useful tool to own as time goes on.

This type of oxyacetylene metal cutting torch (Fig. 7) utilizes a cluster of oxyacetylene flames surrounding a jet of pure oxygen, to cut through steel or cast iron. The coupling of the cutting torch is also constructed to be hand tightened onto the mixer.

The torch end itself also uses specially designed cutting tips—different sized tips for cutting different thicknesses of metal—but these are locked in by a wrench.

Cutting attachment tips (Fig. 8) may have from three to six flame holes that circle around an oxygen hole in the middle of the tip. Each of the flame holes is for an individual oxyacetylene heating flame.

The flow of gases to the flames is controlled by the acetylene valve on the mixer handle and by an oxygen valve on the cutting torch. Open up the oxygen valve fully on the mixer handle once the cutting torch has been connected. There is a valve on the cutting torch that regulates the amount of oxygen going to the flames, called the oxygen adjustment valve. The jet of *pure* oxygen from the middle of the tip is controlled by a thumb lever on the cutting torch.

☐ EYES AND HANDS

I said at the beginning of this chapter that your tools are merely extensions of your anatomical functions. Your organism uses these anatomical functions to change and rearrange matter—tools merely help your organism to do this. In welding, your hands and eyes are the chief guides in the welding process, so you must be extremely careful to protect your hands and eyes from intense light and heat.

The welding flame gives off such high intensity light that it can irritate your eyes unless you use your welding goggles at *all* times (Fig. 9). These goggles

use lenses that can be changed to darker or lighter ones to suit the kind of welding you are doing. To protect them from scratches and sparks, the lenses are covered with a clear, replaceable cover glass. The goggles are designed to fit snugly over the eyes and are held in place with an elastic headband. For those who wear spectacles, there are special goggles made to fit over them.

When you work for long periods with hot metal, you occasionally forget the high heat and touch something with your bare hands. This forgetfulness may cause you serious and painful burns. Also, a chance movement that puts your hand in front of a torch flame can cause a dangerous burn. Sculptors tend to want to touch and fondle their work, and there are many times in welding that this should not be done; but it is almost irresistible when you have made a particularly nice form. So, to prevent burns, you should wear leather gloves of the gauntlet type (Fig. 10), or asbestos ones.

But even "old hands" at welding get carried away from time to time and get singed for it. With this kind of sculpture, you will be burned from time to time regardless of the precautions you take. These are generally minor burns, but even so it is wise to keep some first aid material in the welding shop. Like Indian fire walkers, welders' hands often became somewhat immune to blistering; I know this from personal experience.

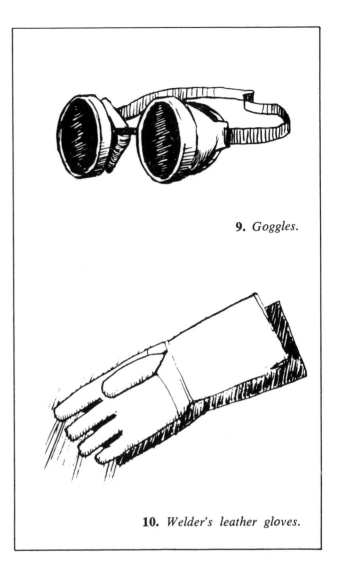

9. *Goggles.*

10. *Welder's leather gloves.*

☐ WORKING CLOTHES

Welding requires some special thought about clothes, too. Blue denim is a very good material for the welder to wear—or any hard woven dark cotton fabric used for work clothes. Woolly or fuzzy materials like flannel can catch fire very easily, as can rayon, so avoid them. Professional industrial welders generally wear leather welding jackets and trousers; arc welders, in particular, need this kind of protection. This protective clothing is necessary because welding steel with either arc or oxyacetylene gives off a great many sparks. These bits of steel are red hot; when they catch in a fold, cuff, or pocket, they can burn quite large holes before you know it. So all these undesirable features of apparel should be avoided. Also, for some reason, light material seems to catch fire more readily than dark cloth.

As there are frequently hot drops of metal on the floor, rubber or crepe soled shoes are not desirable. Beads of hot metal can burn through crepe soles

almost instantly. Moccasin-type shoes, sandals, or open toed shoes of any kind do not protect your feet well enough when you are welding. An oxford-type leather shoe or a high topped one will serve you best. You do not necessarily have to buy special clothing. Just follow the suggestions I have made, and your old work clothes will probably serve the purpose.

☐ BASIC HAND TOOLS

There are seven basic hand tool functions. A sculptor-welder requires all these tools in one form or another. Once you have acquired your basic tools, you will be able to do most sculpture jobs. Any additional tools you buy will merely be variations on the basic tools, which either add power or put two functions together.

You will not have to invest more than a few dollars for the basic tools; but most sculptors develop a

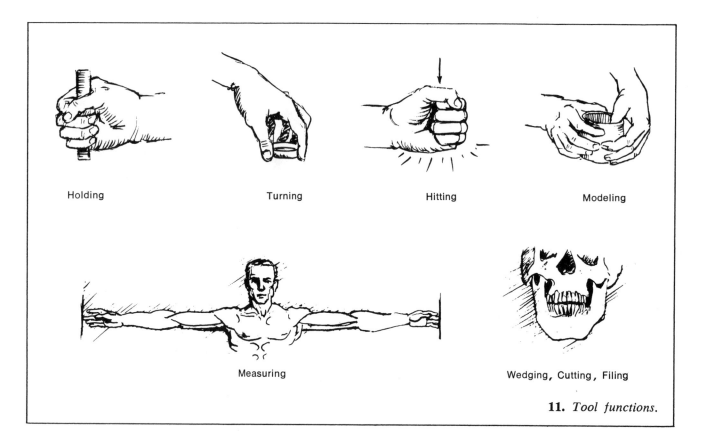

Holding Turning Hitting Modeling

Measuring

Wedging, Cutting, Filing

11. *Tool functions.*

soft spot about their equipment, and in time willingly invest in more advanced set-ups. One of the best feelings in the world comes from having some job come up that requires a tool you bought three years ago, knowing that it would come in handy some day. You dig it out of your tool box, put it to use, and chances are that the few dollars you invested in it are paid back with its first use. It might have taken hours to improvise a set-up that would produce the same results.

Good sculptors develop a "tool sense" that, actually, means an acute awareness of the *anatomical* basis of tool design. After some experience, you will be able to discern the difference between the "gim-crack" tool, the one-purpose tool, the multi-purpose tool, and the poorly designed and constructed tool.

In time, when some new approach to a work problem is needed, you will be able to visualize the sort of tool you need, and perhaps you will even be able to construct it from material at hand. You will become an avid collector of tool catalogs, and you will read them as other people read detective stories.

To help you understand basic tool functions at the beginning, and to make it clear that they *originate* in anatomical functions you already have, I have broken these tool functions into seven basic cate-

gories. These categories are functions of the human hand, jaws, and teeth, acting in conjunction with the whole organic sensory apparatus (see Fig. 11).

(1) There are *holders*: clamps, vises, pliers, wrenches, etc.

(2) Tools that turn on an axis based on the wrist movement are *helix* tools: drills, borers, and screws.

(3) Tools based on hitting or pounding are *percussion* tools: all the hammer family.

(4) Toothed cutters, such as saws, files, and grinding wheels, are called the *abrasives*.

(5) There are *wedge* tools, such as the chisels, shears, planers, and wedges.

(6) There are the weights and measure tools: *rules* and *scales*.

(7) And there are the *modeling* tools, such as the trowels or clay modeling tools used to shape semi-soft matter; in your case, the modeling tool is the welding torch.

These seven tool functions are all based on movements and capacities of the hand and jaw. Most people have at least *some* of these tools around the house; so you might not have to buy them all.

I recommend four pairs of pliers, which you will use to hold things you are welding, as well as for other jobs around the shop. You might get along

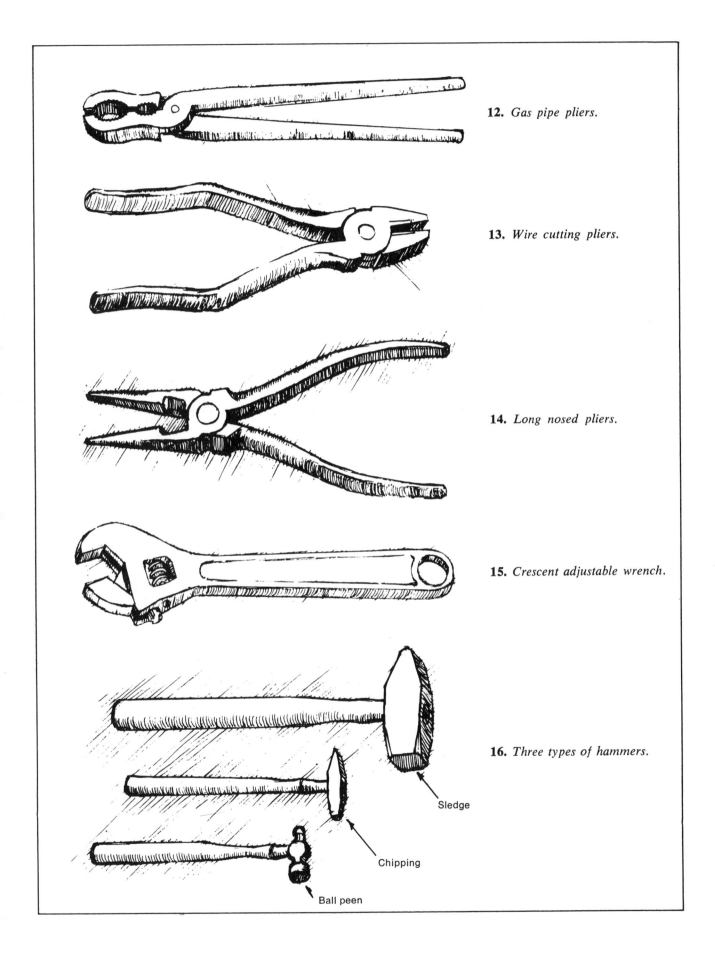

12. *Gas pipe pliers.*

13. *Wire cutting pliers.*

14. *Long nosed pliers.*

15. *Crescent adjustable wrench.*

16. *Three types of hammers.*

Sledge

Chipping

Ball peen

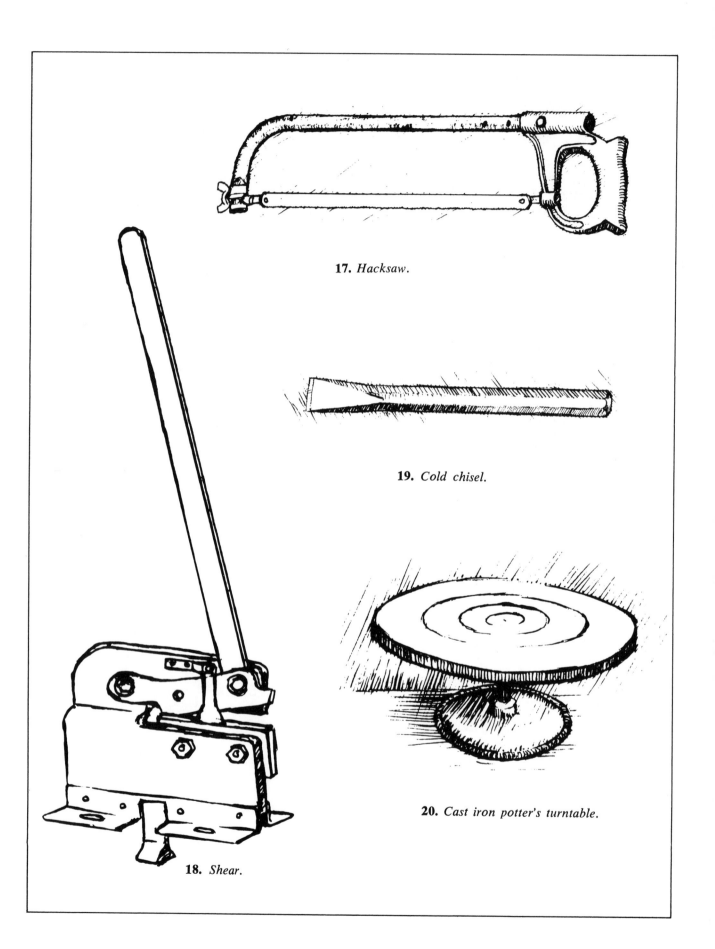

17. *Hacksaw.*

19. *Cold chisel.*

20. *Cast iron potter's turntable.*

18. *Shear.*

with just one pair for a time at the beginning, but these four will round out your needs: a 12″ and a 10″ pair of plumber's gas pipe pliers (Fig. 12), for holding welded pieces (since one pair of pliers usually will heat up, the second is used while the first pair cools off); one 8″ electrician's wire cutting pliers (Fig. 13), for bending and cutting welding rod for armatures; one 8″ electrician's long nosed pliers (Fig. 14), for holding and adjusting delicate pieces of work. These are the four pliers that I have found most useful among the many kinds that are made. I suggest that you buy these, but also try out all the types that seem to interest you.

For wrenches, a 10″ crescent adjustable wrench (Fig. 15) is useful for attaching regulators to cylinders. Open end combination wrenches are furnished with welding kits, but these never seem to do the job well enough for me. I prefer a crescent wrench because it feels better in my hand and it can be adjusted for a tight fit on the nut; I do not like to see adjusting nuts chewed up by ill-fitting wrenches. There is no point in having your regulators damaged, or other equipment scarred up, by using inadequate wrenches. Your equipment is an investment; it has money value, as well as work value. A good crescent wrench can be used for many different jobs because it is adjustable and it will protect your equipment.

Hammers? You should start with one, at least. You will acquire others as time goes on. (Three types are illustrated in Fig. 16.) I have thirteen of them now, ranging from a very tiny machinist's ball peen up to a three pound sledge. There are hundreds of different types of hammers: jeweler's, auto body and fender, blacksmithing, upholsterer's, carpenter's, stonecutter's, and probably a number that I have never even heard of.

When I was a small boy, I had no appreciation at all for the ball peen hammer. It has no nail-puller on it, and the rounded part on one side of the head cannot be used for driving nails. To my young mind, there was no purpose for the peening end; it irked me and I thought it was invented by some bungler. But I cannot describe the pleasure I experienced when I later learned the usefulness of the ball peen hammer in metalworking. It was like finally relieving an itch that had never been scratched. By all means, you must buy yourself a ball peen hammer—it is an excellent tool. Test the weight, and make sure that it feels right to your arm. But if you are not ready to appreciate it fully, then use the family carpenter's hammer; it will suffice.

For cutting metal, you will need a hacksaw (Fig. 17) and a hand-operated metal shear. The hacksaw is not expensive and can be purchased in the local dime store, along with inexpensive blades. But if you have a little more money to spend, buy better blades and you will find that they last three times as long as cheap ones.

The hand-operated shear (Fig. 18), fits into a vise or can be bolted to the workbench; the shear has a scissor action that can cut metal up to ⅛″ thick. (Do not confuse this shear with a pair of shears.) An extremely useful tool, this shear costs about $45, and, with care, should last a lifetime. I have one that, after fifteen years' use, will even cut a sheet of paper. The beginner does not have to buy a shear right away; he can get along without one for a while. But when you are ready for one, I recommend the model #1 shear made by the National Machine Tool Company.

Cold chisels are useful too (Fig. 19); try three blade sizes: ¼″, ½″ and ¾″.

A cast iron potter's turntable (Fig. 20), 8″ in diameter, is very useful when you weld the small figures described in Chapter 5. It is useful for many small sculpture jobs that require revolving the piece as you work on it. Use a piece of ¼″ steel on top of it while welding, and this will prevent the lubricant on the shaft bearing from burning.

There are miscellaneous tools like files, screw drivers, clamps, a roll-up steel tapemeasure, steel square, and drill bits that you will find useful in time (Fig. 21). But you do not need these things to begin welding at the outset.

Do not feel that you have to go out and buy all kinds of tools in order to begin welding. All you need are the basic hand tools I have recommended. The sculpture you work on will demand certain tools. It is far better to acquire tools as you grow in experience; let the work lead you. No one *ever* has all the tools he needs. At first you might buy second-hand tools; you could probably get the basic ones for $5. Later you can add to these.

☐ METAL

There are three types of metal that I recommend for use in the projects described in this book. One is *mild steel*, which is a term used for a widely used, easy to work steel alloy. (There are many different types of steel, some of which are too hard, too brittle, or much too difficult to weld for practical sculp-

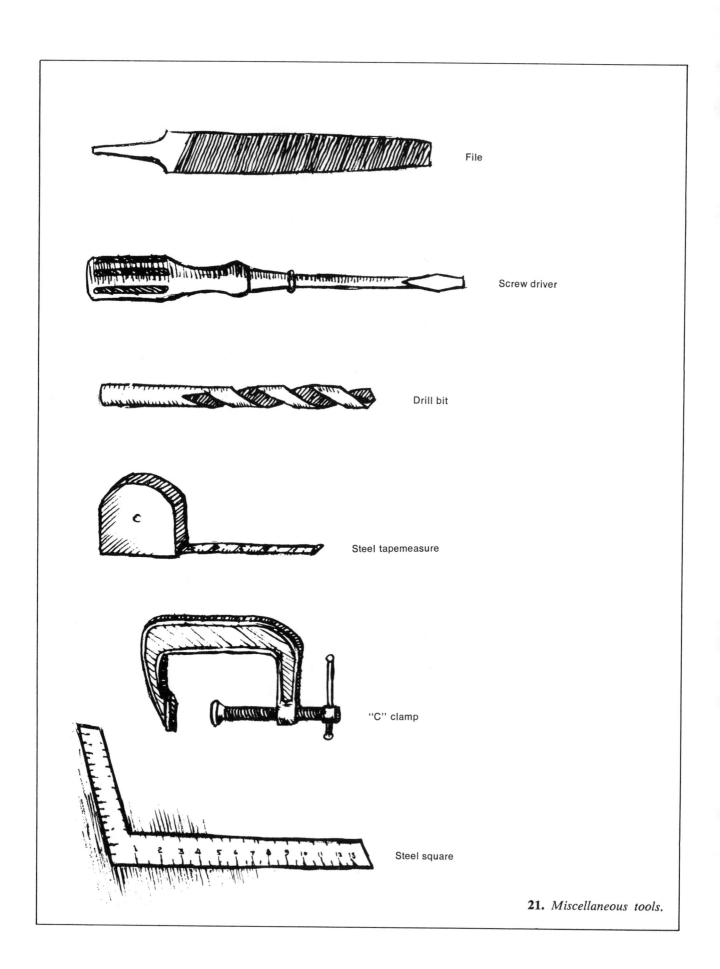

File

Screw driver

Drill bit

Steel tapemeasure

"C" clamp

Steel square

21. *Miscellaneous tools.*

ture purposes.) Manganese bronze is a semi-soft copper alloy that is ideal for welded sculpture. And nickel silver is a copper-nickel alloy that has a silver color.

All these metals are supplied by welding supply houses in the form of welding rod. The rod sizes range from $\frac{1}{16}''$ to $\frac{1}{4}''$ in diameter in standard lengths of 36". Sheet, plate, or strip forms of these metals are also useful and can be obtained from metal supply firms. Metal is always sold by weight and steel is the least expensive of these metals. Welding rod can be bought in odd lots by the pound or in 50 pound packages, but the *sheet* metal or strip recommended for your use must be bought by size—width, length, and thickness—then weighed and priced. The thicknesses recommended are from $\frac{1}{16}''$ to $\frac{1}{8}''$.

□ BASIC SHOP

Where to weld is an important question. Welding is an occupation that involves fire; so, in many localities, welding is regulated by fire prevention laws. You should try to observe all reasonable regulations. In areas where there are no restrictions, natural rules of fire prevention and your own sense of good workmanship and safety should dictate self-imposed rules for work.

Some fire laws do not allow oxyacetylene welding in wooden buildings or in buildings with wooden floors. Some regulations require sheet metal to be put down on wooden floors. In any case, you should never weld near flammable or volatile materials. See the list of safety instructions recommended by the American Welding Society at the end of this chapter. Consult your local fire department and your insurance agent for the specific regulations that affect your locality.

Like driving a car, welding can be either safe or dangerous. If you follow rational rules of workmanship, your shop will be a safe place regardless of what laws are in effect or not in effect. In working out your shop set-up, use your understanding of the nature of acetylene.

Be sure to make it a rule that small children and pets are not allowed in your work area while you are welding. Get a clear place to work where you will not be distracted. A garage with a cement floor or a patio can be ideal. I did my first piece of welded sculpture in a five-dollar-a-week room in a rooming house; but I would not recommend that type of set-up for anyone.

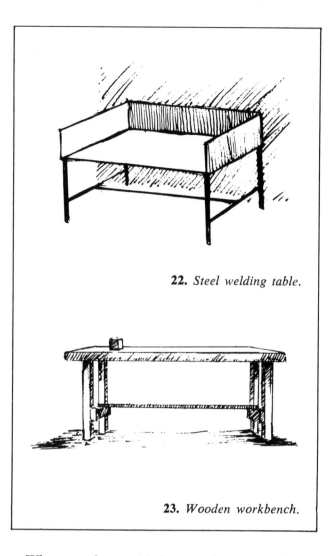

22. *Steel welding table.*

23. *Wooden workbench.*

When you have settled on a place to work, you may build some of the larger pieces of equipment yourself. You will need a steel welding table (Fig. 22), and a sturdy wooden workbench (Fig. 23). You may not even have to build these items; unless you have some special design in mind, it is highly possible that you might find exactly what you need in a junk yard, in a city dump, or in a used tool outlet. Americans throw away some very useful and valuable things. More than likely, you can find some good equipment just by looking in those places. A little paint and shining up, and you may have something nicer than anything on the market.

The welding table can be any size that is comfortable for you to work at, just so long as it has a metal framework and a fireproof work surface. Use firebrick or sheet asbestos for this. (A steel or sheet metal top will warp in a very short while, as soon as you begin to work on it.) For a stand, I have used the legs and the supporting framework from an old-

fashioned off-the-floor gas cooking stove. There are many things that might work: an old sewing machine frame, or any rigid metal framework that has the height and breadth that seem to suit your work space. A metal stool or a typist's posture chair will do to sit on.

The wooden workbench must be strong enough to hold a metal worker's vise. The top should be made of planks about 1½" thick so that any pounding, drilling, or other rough work will not break the bench top or shake the bench apart. A workbench does not have to be fancy, only constructed sturdily enough to enable you to work on it properly.

One of the most important factors in a welding shop is good ventilation. When you weld brass, bronze, or nickel silver, an oxide of zinc is given off. Breathing these zinc fumes can give you zinc poisoning if you breathe them for prolonged periods. Although zinc poisoning is not fatal, it is very unpleasant, and should be carefully avoided. Good cross-ventilation is the best way to prevent this. Work near an open window and, if you can, use an exhaust fan.

For fire prevention, keep a bucket or two of sand in the shop. Get a CO_2 fire extinguisher, and be close to a source of running water.

If you cannot afford an elaborate studio, remember that the most important part of sculpture comes from the sculptor himself, and not necessarily from perfectly set up studios. The best kind of studio is one in which you can do the best possible work with the available equipment.

☐ LATER ADDITIONS

No one expects a beginner to sacrifice other things and put all his money into welded sculpture equipment. But once you really get into the swing of welded sculpture and decide to do it seriously, you can spend money on equipment in the same way you would for a family dependent. You will want to see your work grow and prosper. To do this, you must invest in good equipment and in some of the amenities of professional life. You may not be able to fit your studio out with everything you desire at one time; but, little by little, you will spend your extra money on your work needs.

There are some tools that are indispensable to the professional and to the advanced amateur. Of these, the most useful are the ¼" electric power hand drill (Fig. 24) and the hand operated shear that I men-

tioned earlier. The drill can be used for several different purposes: there are attachments for polishing metal, sanding discs, grinding wheels, milling cutters, wire wheels, drills, and countersinks.

Later on, you may wish to use a shop-type drill press (Fig. 25). This is a tool which my grandfather Ferris, who was a grumpy old master pipe-organ builder, called the most versatile tool in any shop. It is very useful. There are a number of electric power tools that are good for the sculptor (Fig. 26): high speed auto body sanders, motor driven flexible shafts, and die makers' grinders that are fine for surfacing metals and can adapt to other uses, too.

A well equipped studio should have a power saw. There are four different types (Fig. 27): bandsaw, table saw, radial saw, and the hand held power saw. (There are others, but they do not apply to this type of work as well as those listed.) The bandsaw is particularly useful to the metalworker since it can be adapted for wood or metal. I recommend the bandsaw and suggest that you supplement it with a hand operated power saw. The belt power sander is perfect for sanding sculpture bases, and is a good complement to the bandsaw.

A blacksmith's anvil (Fig. 28) mounted on a large wooden block or log, is a necessity for hammer forming and shaping metal. The anvil is not just something to pound on. It is a tool that has many uses. The anvil shape took centuries to perfect; its various forms are used for straightening, curving, making circles, etc. There are many attaching tools, called *hardies*, that fit into the square hardy hole. Hardies are sometimes useful to the sculptor and come in different shapes used for various purposes: fullers, swages, flatters, etc.

A chain hoist (Fig. 29) is useful for lifting large, heavy sculpture and metal plates. Anyone who does large works should have a hoist and *use* it. The advanced welder's studio should also have a good roll-away tool cabinet so that the sculptor does not have to run across the shop away from his work, but has all the tools he needs at hand.

There are really so many fine and useful tools that after a while it is more a problem *not* to buy them, or to buy very selectively. There is no one perfect set-up for a welding studio. Needs and preferences vary from one sculptor to another. This is why I have not included any floor plans for the "ideal studio." Such a place does not exist.

The studio is really an expression of the sculptor's development. It shows the way he prefers to work,

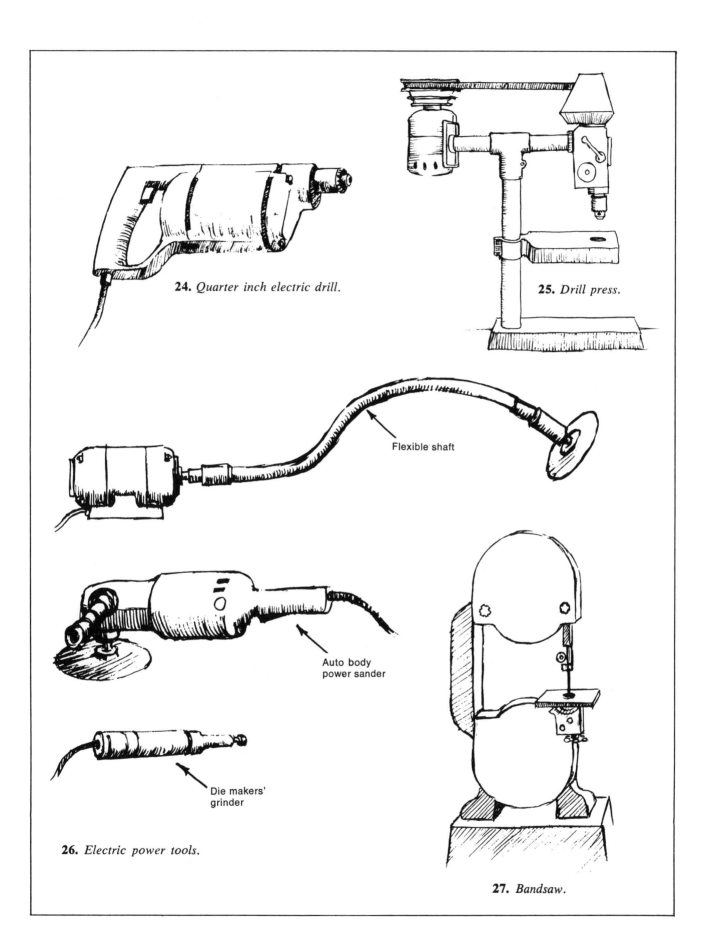

24. *Quarter inch electric drill.*

25. *Drill press.*

Flexible shaft

Auto body
power sander

Die makers'
grinder

26. *Electric power tools.*

27. *Bandsaw.*

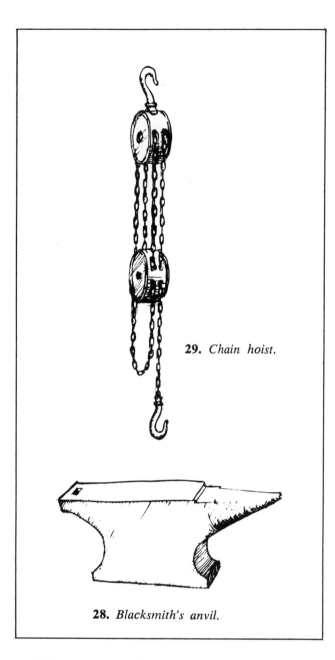

29. *Chain hoist.*

28. *Blacksmith's anvil.*

and his own sense of order. I suggest that you visit welding shops and visit other sculptors' studios from time to time. See how other sculptors function in their work. This is the real way you learn. You will find that the most famous artists are often very friendly and helpful to beginners. But be sure you call them on the phone and do not just drop in unexpectedly; for they can also be very annoyed if they are not treated courteously.

Art is, after all, a studio-learned subject, even though books and schools are part of the learning process. Your tools will teach you a great deal, for they are nothing but potential movements, actions, and thoughts.

AMERICAN WELDING SOCIETY SAFETY RULES

OXYGEN

1. Always refer to oxygen by its full name, oxygen, and not by the word air.

2. Never use oxygen near flammable materials, especially grease, oil, or any substance likely to cause or accelerate fire. Oxygen itself is not flammable, but does support combustion.

3. Do not store oxygen and acetylene cylinders together. They should be separately grouped.

4. Never permit oil or grease to come in contact with oxygen cylinders, valves, regulators, hose, or fittings. Do not handle oxygen cylinders with oily hands or oily gloves.

5. Never use oxygen pressure reducing regulators, hose, or other pieces of apparatus with any other gases.

6. Open oxygen cylinder valve slowly.

7. Never attempt to mix any other gases in an oxygen cylinder.

8. Oxygen must never be used for ventilation or as a substitute for "compressed air."

9. Never use oxygen from cylinders without a suitable pressure reducing regulator attached to the cylinder valve.

10. Never tamper with nor attempt to repair oxygen cylinder valves.

ACETYLENE

1. Call acetylene by its full name, acetylene, and not by the word, gas. Acetylene is far different from city or furnace gas.

2. Acetylene cylinders should be used and stored valve end up.

3. Never use acetylene from cylinders without a suitable pressure reducing regulator attached to the cylinder valve.

4. Turn the cylinder so that the valve outlet will point away from the oxygen cylinder.

5. When opening an acetylene cylinder valve, turn key or spindle not more than one and one half turns.

6. Acetylene cylinder key for opening cylinder valve must be kept on valve stem while cylinder is in use so that the acetylene cylinder may be quickly turned off in an emergency.

7. Never use acetylene pressure reducing regulators, hose, or other pieces of apparatus with any other gases.

8. Never attempt to transfer acetylene from one cylinder to another, nor to refill an acetylene cylinder, nor to mix any other gas or gases in an acetylene cylinder.

9. Should a leak occur in an acetylene cylinder, take cylinder out in the open air, keeping well away from fires or open lights. Notify the manufacturer at once.

10. Never use acetylene at pressures in excess of 15 *p.s.i.* The use of higher pressures is prohibited by all insurance authorities and by law in many localities.

CAUTION

When working from oxygen and acetylene supplied through distribution piping systems, the instructor shall give the trainee specific directions on setting up, taking down, and safety precautions applicable to this equipment.

GENERAL PRECAUTIONS

1. Do not permit anyone to strike an arc on a compressed gas cylinder.

2. Do not weld in the vicinity of flammable or combustible materials.

3. Do not weld on containers which have held combustible or flammable materials without first exercising the proper precautions recommended by the American Welding Society. (Recommended Procedure to Be Followed in Welding or Cutting Containers Which Have Held Combustibles.)

4. Do not weld in confined spaces without adequate ventilation or individual respiratory equipment.

5. Do not pick up hot objects.

6. Do not do any chipping or grinding without suitable goggles.

7. Do not move individual cylinders unless valve protection cap, where provided, is in place, hand tight.

8. Do not drop or abuse cylinders in any way.

9. Make certain that cylinders are well fastened in their stations so that they will not fall.

10. Do not use a hammer or wrench to open cylinder valves. If the valves cannot be opened by hand, notify the instructor.

11. Never force connections which do not fit.

12. Never tamper with cylinder safety devices.

13. Always protect hose from being trampled on or run over. Avoid tangles and kinks. Do not leave the hose so that it can be tripped over.

14. Protect the hose and cylinders from flying sparks, hot slag, hot objects, and open flame.

15. Do not allow hose to come in contact with oil or grease; these deteriorate the rubber and constitute a hazard with oxygen.

16. Be sure that the connections between the regulators, adapters, and cylinder valves are gas tight. Escaping acetylene can generally be detected by the odor. Test with soapy water, never with an open flame.

17. Do not use matches for lighting torches; hand burns may result. Use friction lighters, stationary pilot flames, or some other suitable source of ignition; do not light torches from hot work in a pocket or small confined space. Do not attempt to relight a torch that has "blown out" without first closing both torch valves and relighting in the proper manner.

18. Do not hang a torch with its hose on regulators or cylinder valves.

19. Do not cut material in such a position as will permit sparks, hot metal, or the severed section to fall on the cylinder, hose, legs, or feet.

20. When welding or cutting is to be stopped temporarily, release the pressure adjusting screws of the regulators by turning them to the left.

21. When the welding or cutting is to be stopped for a long time (during lunch hour or overnight) or taken down, close the cylinder valves and then release all gas pressures from the regulators and hose by opening the torch valves momentarily. Close the torch valves and release the pressure adjusting screws. If the equipment is to be taken down, make certain that all gas pressures are released from the regulators and hose and that the pressure adjusting screws are turned to the left until free.

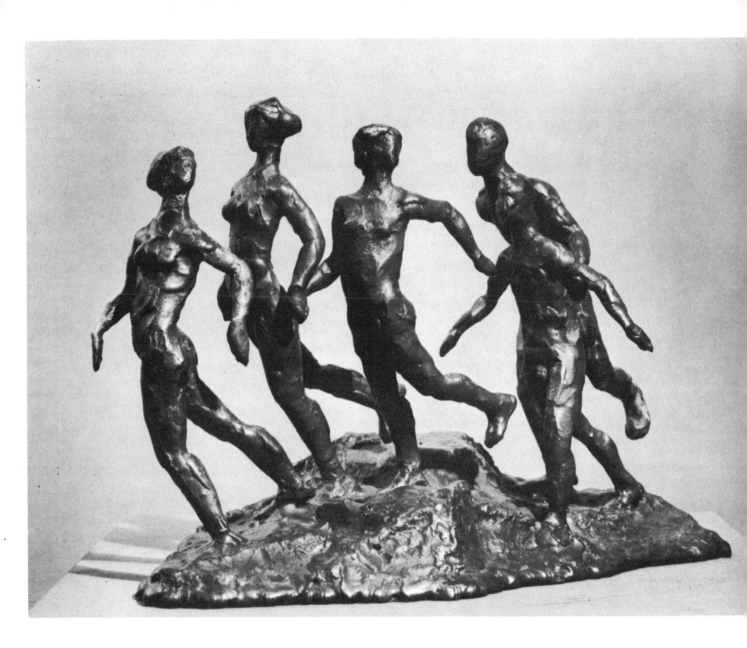

The Living Game, *manganese bronze, 9" x 11", collection, Mr. Bill Cullen. The running motion of these figures is achieved by the bends of the torsos and the thrusts of the legs and arms. The backward turn of two of the women's heads brings the eye of the viewer back from the forward movement to the two pursuing male figures. The forward movement of the men again swings the movement back— setting up a circular shift in the viewer's attention.*

Now that you have acquired the basic equipment for welded sculpture and have found a suitable place to work, you are ready to begin the process of learning. I use this term *process,* to make clear to you that you are entering a field that requires you to give something of yourself in study, work, and time. In return for this commitment, you will grow and enlarge your intellectual and emotional capacities.

In all fields of human endeavor that are part of the cultural process—science, law, art—the beginning student needs comprehension of the time and direction his study will require. Learning a body of knowledge is not done with the same unconscious ease that marks the growth of a plant or organism. In cultural fields, the learner must take over himself and regulate his own growth processes.

In nature, a fully developed organism requires a full term of preparatory development in the embryonic stage. Nature provides this for plants in the structure of the seed, in the shelter of the earth, and in the pulsation of the four seasons. Animals find their sheltered, pulsating development in the mother's womb.

But you, as a beginner in welded sculpture, will have to watch over your own development. You will have to shelter yourself and time your own growth. You will have to regulate your infant steps as you explore the world of this sculpture medium. So do not be ashamed of your innocence, for it will be your most valuable tool in learning. You are not required to know everything at the beginning. Do not expect too much of your first efforts. Only time, study, and practice can give you genuine assurance.

In other words, your frame of mind in beginning this study is important. I have not set out to write a glib, shortcut manual on how to do welded sculpture in a day. Welded sculpture has taken me many years

to learn, and I am still in the learning process. What I want you to realize is that sculpture itself *is* a learning process. Because it is, making good sculpture depends a great deal on your open eyed innocence, your intellectual freshness, and your curiosity. Cynicism, arrogance, bitterness, defensiveness, and too much sophistication tend to shrivel and decay the sense of form. A good sculptor should be as much in contact with his tenderest and truest feelings at eighty as he was at fifteen.

All this is said so you will not begin with the idea that there is any need to turn out a masterwork on the first run. At the beginning, you will require some time to master the welding medium. You will be making simple things in the first exercises I will set for you; these exercises will be the foundation of your learning. But you will have some pleasure in making these things, even though what you make at the beginning cannot rightly be called sculpture. However, each exercise will definitely relate to sculpture problems which you will encounter later in the book, as each exercise is a way of handling form.

In my own self-imposed training in industry, I spent quite a few months learning welding processes before I began my first piece of welded sculpture. This wait was very good; by the time I did begin, I had developed some skill with the torch. Actually, I have enjoyed making all the pieces which illustrate the exercises in this book because, even though they may seem simple to you as a beginner, they embody some rather profound principles of construction. To do them well requires good workmanship.

□ SETTING UP YOUR EQUIPMENT

After they have been filled at the supply house, your oxygen and acetylene cylinders are generally deliv-

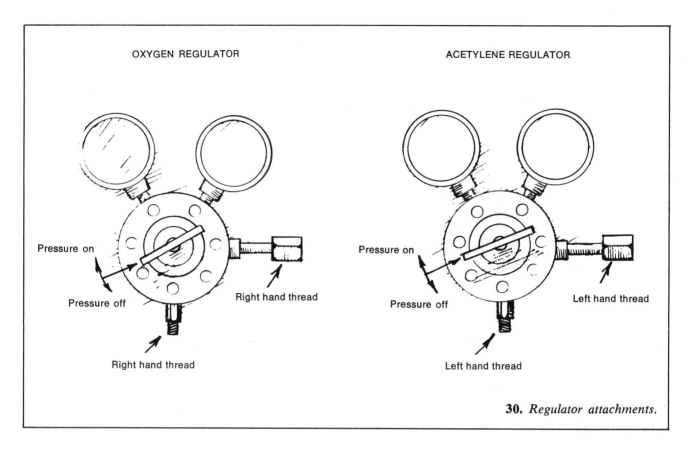

OXYGEN REGULATOR

ACETYLENE REGULATOR

Pressure on

Pressure off

Right hand thread

Right hand thread

Pressure on

Pressure off

Left hand thread

Left hand thread

30. *Regulator attachments.*

ered to you in an *open* delivery truck. It is always possible that dust or grit may have blown into the valve attachments during transit. Or if the cylinders have been unused in the studio for any length of time, some dirt from the studio may have settled in the valves. So to prevent any chance that this dirt might be blown into the pressure regulating mechanism, both oxygen and acetylene cylinders should be opened up before they are attached. A quick on-off turn will release enough pressure to blow out any dust.

Before attaching the regulators (Fig. 30), turn their adjusting screw keys on their fronts counter-clockwise, so that they turn loosely and there is no pressure on the chambers. Take the oxygen regulator and screw the regulator attachment nut onto the cylinder valve until it is as tight as you can get it by hand. Make sure that the front of the regulator faces you, and that the dials are easy to read. Tighten the nut snugly with a wrench. When *both* the regulators have been mounted in this way, connect the hoses to the fittings on the regulators. If you have difficulty, remember the left hand threads on the acetylene equipment.

The two cylinders should stand side by side and be secured by a chain (Fig. 31). You may use a welder's cart for your cylinders, or you may keep them next to the wall, or in a corner away from the work area. Never use oil on the regulators. Never dust them off with an oily cloth. Be sure not to wear greasy gloves when you turn the regulators on or off, because oil often ignites in the presence of pure oxygen.

To turn on the oxygen regulator, turn the cylinder valve very slowly, so that the oxygen does not rush into the regulating chamber with a high pressure blast. This high pressure could rupture the pressure diaphragm and make your regulator useless. When the pressure gauge has stopped moving, open the oxygen cylinder valve fully.

The acetylene regulator follows the same procedure, except that the valve, once opened, is only opened *one and a half turns*. Be sure to leave the cylinder valve key *on* the acetylene valve while the cylinder is in use.

When both hoses are attached to the regulators, turn the pressure key of the oxygen for just a moment to blow out any dust. Do the same with the acetylene. Connect the mixer handle to the two hoses. Tighten the hose connections snugly. Select the tip size recommended for $\frac{1}{16}''$ steel in your equipment instructions. Tighten the tip by hand so

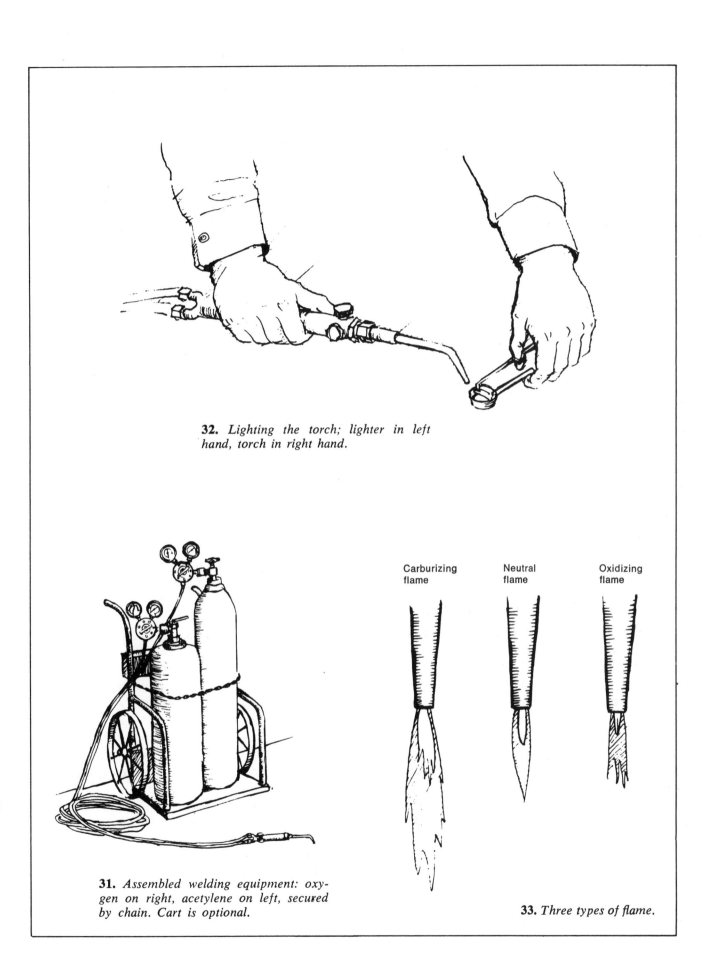

32. *Lighting the torch; lighter in left hand, torch in right hand.*

Carburizing flame

Neutral flame

Oxidizing flame

31. *Assembled welding equipment: oxygen on right, acetylene on left, secured by chain. Cart is optional.*

33. *Three types of flame.*

that it fits snugly. Check the tip direction. Recheck all your connections as a safety measure.

☐ LIGHTING THE TORCH

Always hold the torch so that the tip points away from you, and away from anything that may ignite when you light it. Point the torch in the direction of the floor and toward the open space in the work area. Make sure there is no one near you. With the acetylene valve on the torch closed, open the oxygen valve on the torch and adjust the regulator to the proper pressure of flow. Turn off the valve on the torch. Open the acetylene valve on the torch and adjust the regulator pressure. Turn off the acetylene valve on the torch.

Now you are ready to light your torch for the first time. It may be a very exciting moment for you. It was exciting for me the first time I properly lit the torch, and it has continued to produce a thoughtful and awesome feeling throughout the years of welding in sculpture.

Put on your goggles and your gloves. Hold your lighter in your left hand and the torch in your right hand (Fig. 32). Open your oxygen valve just a fraction of a turn. Open the acetylene valve a quarter turn. Scratch your lighter flint in front of the tip and keep your hand away from the flame. The flame will be an orange color and will have no particular form, because it is almost pure acetylene. When lighted, pure acetylene would give off a heavy carbon soot, so the slight bit of oxygen prevents this.

To adjust this formless flame to a welding flame, open the acetylene valve until the jet of flame almost begins to leave the tip. The flame will still be orange. Slowly add oxygen to the flame. As you do this, the color changes to a lighter, brighter orange—almost yellow—then begins to turn blue. A long feathery flame of blue begins to appear. As you add oxygen, two distinctly different forms begin to appear, one inside the other. As you continue to add oxygen, the inner flame becomes shorter, loses its feathery edge and draws down into a cone. If you add too much oxygen, the flame will blow out.

☐ FLAME AND HEAT CONTROL

Welders use three different types of flame in welding various metals. Most used is the *neutral* flame. This is the flame of total gas combustion. The neutral flame is characterized by an inner flame (or cone) of light blue, surrounded by an envelope of darker blue. The inner cone of the neutral flame has fullness, but no little feathery extension on its tip.

The *carburizing* flame is recognized by the feathery extension of the inner cone. This is caused by an excess of acetylene which does not completely burn off. According to the degree of excess acetylene, this flame allows a certain amount of carbon to enter the welded metal.

The *oxidizing* flame can be recognized by the lack of fullness of the inner cone and by the flame's taut, hissing noise. Instead of being full, the inner cone shrinks in size and seems to have a wrinkled form. The excess oxygen in the flame tends also to enter the weld metal, and creates excessive oxidation, which will make the metal rust quickly.

The neutral flame is used most of the time when you weld steel. You would use a slightly oxidizing flame when you weld manganese bronze and nickel silver, as an oxide film is formed that prevents the zinc from *fuming off.* (You want to prevent fuming off, which happens when zinc is burned out of the metal, thus weakening it and filling the air with poisonous fumes.) The carburizing flame is used to make hard or brittle welds in steel, and is also used when you weld aluminum.

Take some time to practice adjusting the gas pressure, lighting the torch, adjusting to the neutral flame, the carburizing flame, and the oxidizing flame.

Flame control is one of the two most basic things in welding. With proper flame control, you control the state of the molten metal and the condition of the weld. The use of the correct flame prevents unwanted changes from occurring in the composition of the metal—that is, prevents the formation of oxides which weaken the weld. You maintain flame control by your awareness of the flame's characteristics and by making adjustments to maintain the needed flame type.

The second basic factor is heat control of the welded metal. You maintain this control by your awareness of what the flame does to the metal, by selecting the right welding tip, and by retracting the flame if the metal overheats. Only with time and experience will you learn heat control by observing the molten metal's characteristics.

These two aspects of welding—flame and heat control—must become almost instinctive to the welder. When you have become confident that you can adjust the three types of flame with ease, proceed to the next exercise.

□ RUNNING THE BEAD: EXERCISE ONE

The *process* of oxyacetylene welding consists of fusing together two pieces of metal of the same type. (Joining dissimilar metals is done by brazing, silver soldering, or by soldering with lead alloys, which I will not discuss here.) In order to weld two pieces of metal of the same type, the pieces are placed together and the torch flame is concentrated on one spot where they meet. The metal melts, flows together in a pool, joins, and hardens into one piece.

The welding *action* involves traveling the molten pool continuously along the joint that is to be fused. This is called "running a bead." When running a bead, the welder usually adds metal to the molten pool from a filler rod of the same type of metal. The rod is used to build up, strengthen, and reinforce the seam. But good welds can be made by fusing two pieces together without the use of filler rod.

The best way to learn to control the molten pool is to run the pool on a single solid piece of steel before you attempt to fuse two pieces together or to run a bead. Take a 4"x 8" piece of steel plate, $\frac{1}{16}$" to $\frac{1}{8}$" thick. Place the steel flat on your welding table. Select the correct tip for the metal thickness and make the correct pressure adjustments. Put on your gloves and goggles and light your torch. Adjust it to the neutral flame—add the oxygen until the last feather on the inner cone disappears. (See Fig. 34.)

Then adjust the metal so that the long side runs from right to left, facing you. Hold the flame about $\frac{1}{2}$" in from the edge of the steel on your right hand side. The object is to run the molten pool from right to left in a continuous line (Fig. 34). Hold the inner cone of the flame still, about $\frac{1}{8}$" above the metal surface, until a pool of metal $\frac{1}{4}$" to $\frac{3}{8}$" in diameter forms under the flame. (When you are welding, you always work with the inner cone, not with the outer cone, as the inner cone is the part of the flame that produces greatest heat.) The metal will heat gradually from a deep red, through orange, to a whitish yellow orange.

Just before the pool forms, the steel will glisten and begin to look wet on top. Next, directly under the torch, the pool begins to form and to spread out to its widest margin. The larger the tip size, the larger the pool that forms. If too large a tip size is used, you cannot control the pool and it melts right through the metal, leaving a hole.

By manipulating the torch, you set the pool in motion. Move the flame from one side of the pool to the other in a crescent shaped movement (Fig. 35).

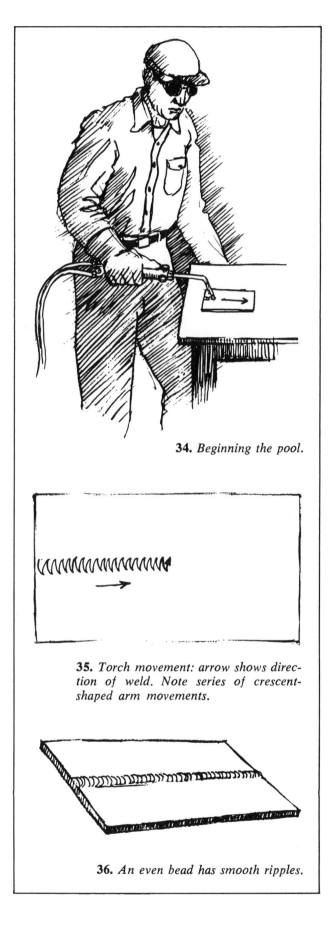

34. *Beginning the pool.*

35. *Torch movement: arrow shows direction of weld. Note series of crescent-shaped arm movements.*

36. *An even bead has smooth ripples.*

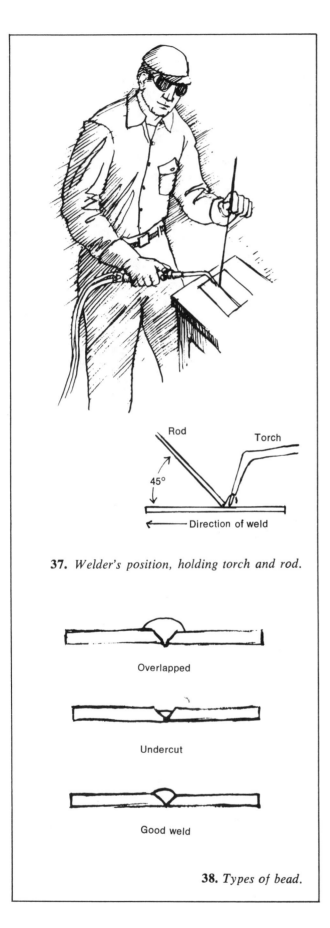

37. *Welder's position, holding torch and rod.*

Rod

Torch

45°

Direction of weld

Overlapped

Undercut

Good weld

38. *Types of bead.*

The movement is carried back and forth continuously, made with the whole arm, rather than from the wrist. The shoulder muscles control the motion; the rest of the arm only serves to hold the torch in position. This motion moves the pool forward in ripples. Each crescent movement advances the pool and leaves a ridge of solidifying metal behind it. Your arm motion and the melting point of the metal (governed by both tip size and metal thickness) determine the possible speed of forward motion. Since your object is to obtain an even flow and deposit of metal, the welding cannot be rushed.

The welder has to "give in" to rhythmic movement dictated by these other factors. You may not be able to grasp this rhythm right away. You may move the pool at an uneven speed, causing the bead of metal to be wide in the spots where you were slow, and narrow in the spots where you were too fast. You may hold the torch in one spot too long, causing the pool to melt through or sink below the surface.

But it is possible that you may grasp the rhythm of the process right away and make a perfect bead in the first few trials—in which case, I suggest that for the sake of experience, you deliberately *make* all the errors I have described as part of this exercise; then you will understand how these errors are made.

However, if you do not pick up this technique right away, run about five beads on each of several plates until you are confident of your ability to handle the pool properly. You will be able to tell when you are ready for the next exercise when the beads have a uniform succession of ripples (Fig. 36). If the beads are straight and smoothly rippled, you can proceed to the next exercise.

☐ RUNNING THE BEAD: EXERCISE TWO

Use the same size plate as I suggested before, but this time your object is to flow the pool across the steel plate, while you add welding rod to the pool. This makes a raised bead across the surface. If your steel is ⅛″ stock, use a ⅛″ rod. If it is closer to ⅟₁₆″, use ⅟₁₆″ steel rod.

Put on your goggles and gloves, light your torch, and hold the welding rod in your left hand so that the rod faces the pool at a 45° angle (Fig. 37). As the pool forms, bring the tip of the rod down into the outer part of the flame so that the metal heats, but does not melt.

When the full pool forms, lower the tip of the rod

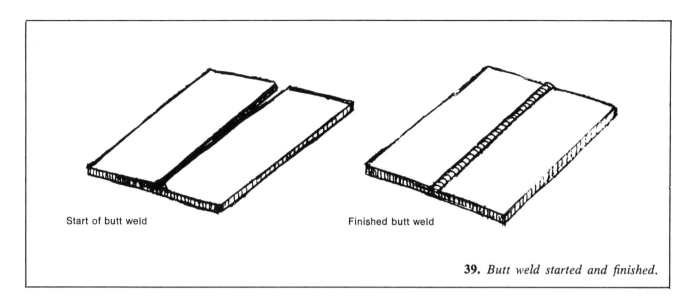

Start of butt weld

Finished butt weld

39. *Butt weld started and finished.*

into the front edge of the pool. The rod will melt and create a raised, rounded pool. As this happens, begin your arm movement and work the raised pool forward, adding the rod to it so that it remains a uniform height as it travels. If the pool becomes too large, lift the rod momentarily until the excess metal has been worked forward. Then return the rod to the pool. A side to side movement of the rod will aid the forward movement of the pool. Continue the bead across the steel plate.

There are several errors which lead to an imperfectly raised bead (Fig. 38). Irregular width is caused by an uneven welding speed. The bead can be undercut on the sides; this is caused when you move forward too fast and you do not add enough rod to the pool. The bead can be poorly fused—overlapped onto the plate rather than penetrating it; this is caused by adding too much rod to the pool and running this pool across the top of a plate which has not been properly melted.

Practice running the bead on several sheets of steel until you can run a bead that is even in height and width, and that has a uniform pattern of rippling. If you have had no difficulty in achieving this, try making the mistakes that I have described until you understand how bad welds are made. It is very important that you understand, and can easily recognize, a bad weld.

There is also a method of running a bead called *back hand welding.* With this method, the flame is held in front of the weld and the rod is held in back of the weld. The torch is given the same crescent movement, but the bead moves in a direction opposite to the one described above. In other words, with this method the flame is always pointed toward the bead itself, rather than toward the area that is being welded.

☐ SEAMS AND JOINTS

Oxyacetylene welding was described as running a metal bead along the seam of two pieces of metal—a bead that fuses and joins them together. This can be done on level, horizontal, and overhead surfaces. You must master seam and joint making in all positions. (Once you have mastered welding in different positions, you enter another phase of the technique —fitting and joining shapes. I shall discuss fitting and joining, or the construction of abstract shapes, in the next chapter.) Right now, you will learn the most simple joint, the *butt weld;* followed by other basic seams and joints.

Butt Weld: To make a butt weld (Fig. 39), prepare two pieces of ⅛″ steel, 2″ x 6″ (or you may use lighter material, up to $\frac{1}{16}$″ thick). Place them side by side along the 6″ edge, leaving a crack between them $\frac{1}{16}$″ wide at one end and ⅛″ wide at the other end. Adjust your cylinder pressure, put on your goggles, and light your torch. Take a piece of ⅛″ welding rod ($\frac{1}{16}$″ if the metal is lighter than ⅛″) and focus the flame on the two corners at the $\frac{1}{16}$″ end of the seam. This seam should be nearest your right hand. Just as the corners begin to melt, add some rod to the pools and make the corners join across the seam.

Begin your pool, again on the $\frac{1}{16}$″ end, by playing your torch on each side of the seam. As the

metal begins to melt, add rod to the pool and begin to travel the pool up the seam, using the crescent shaped arm movement. When the metal appears to overheat, retract the torch momentarily. Make sure that both sides of the metal are molten before you add more metal to the pool from the rod. If your rod gets stuck, merely play the flame on its end till it melts off again.

At first, you will find that your pool will melt through occasionally, and that large drops of metal will form on the underside of the seam. This happens because of poor control of the heat and poor rod manipulation of the pool. To overcome these problems, practice the crescent shaped arm movement, and move your rod from side to side as the seam is being welded.

Bevel Weld: To weld material thicker than ⅛″, grind down the sides of the pieces to be butted together to a 30° bevel on each side of the seam (Fig. 40). This seam is then welded in one, two, or several passes, depending on the thickness of the metal. For most of the sculpture purposes that use the oxy-acetylene method, it is more desirable to use material no more than ⅛″ thick.

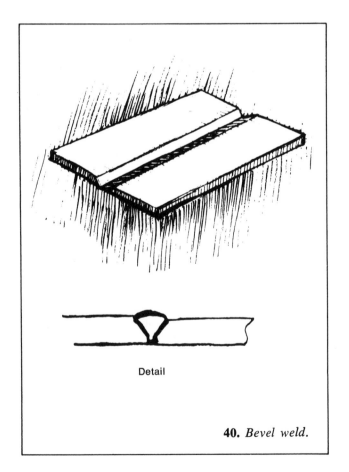

Detail

40. *Bevel weld.*

Caulking Weld: The *caulking weld* is used to close up an opening, a burn-through, a crack, or a hole (Fig. 41). It is not used for joining.

Use your torch to melt a large hole about ¾″ wide in a ⅛″ plate. Let it cool. Heat one edge of the hole, and as the metal becomes fluid, add more metal from the welding rod. Keep adding metal till the hole is filled. If you let the metal become too hot, it will drop through. The trick is to let the metal on the side of the hole get just to the molten stage, and then add a little metal from the rod. Retract the torch, let the metal cool a little, and then begin again.

Any hole can be patched with this type of caulking. This method is also used to build out projecting forms from flat or curved surfaces.

Fillet Weld: A *fillet weld* (Fig. 42) is done by welding a piece of plate flat on top of the surface of another larger plate. The welded seam is made along the four edges of the smaller piece and the pool penetrates the edges of the upper piece and the piece below. The angle of the welded bead slopes 45° from the top plate to the surface of the lower metal. The bead has to be thick enough and strong enough to hold the two pieces solidly together. This weld is used primarily to reinforce an area of possible weakness.

Lap Weld: The *lap weld* (Fig. 43) is similar to the above fillet, but it is used to join two overlapping pieces together to make a longer or wider solid piece. Two seams are made, one on each end of the overlapping joint.

Flush Weld: A *flush weld* (Fig. 44) is merely a seam in which two pieces of metal butted together are welded with no raised addition of metal. The weld stays flush with the surface of the plate. This is done by running a regular bead, but smoothing it out with the torch.

Corner Joint: To make a *corner joint* (Fig. 45), take two pieces of plate (2″ x 6″ and from ⅛″ to ¹⁄₁₆″ thick) and tack them together so that the 6″ sides meet at a 90° angle. Use a fire brick to prop the two pieces together for tacking. Run the bead along the outside part of the joint; this is not at all difficult.

Tee Joint: To make a *tee joint* (Fig. 46), use two pieces of plate the same size as the previously described corner joint. Lay one plate on the welding table surface and stand the other on top of it at a 90° angle. Place the upper plate on its edge along

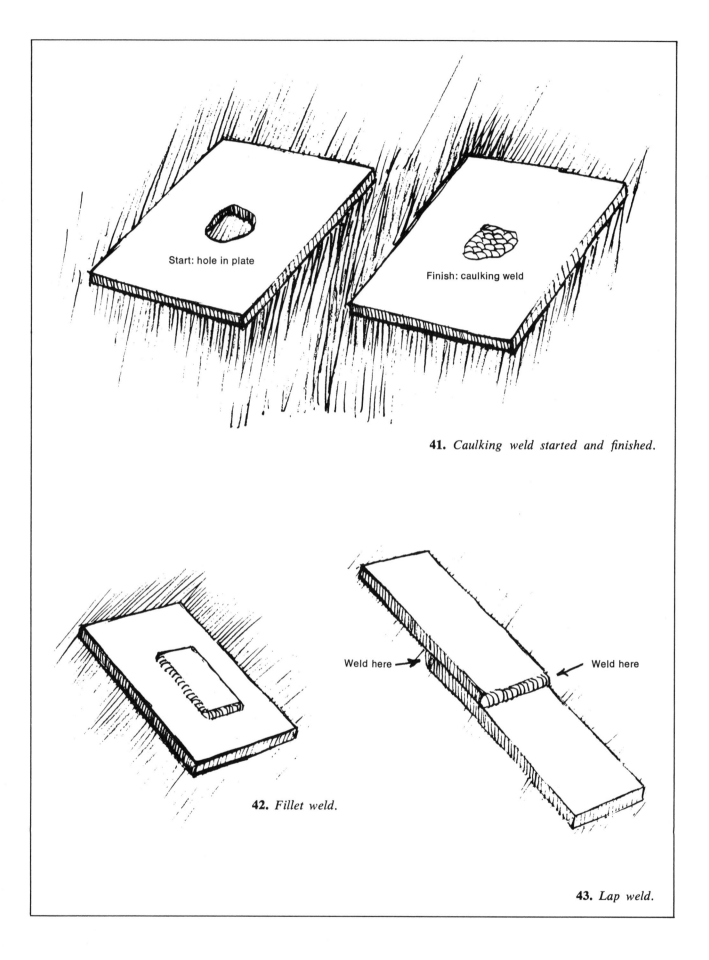

41. *Caulking weld started and finished.*

Start: hole in plate

Finish: caulking weld

42. *Fillet weld.*

Weld here

Weld here

43. *Lap weld.*

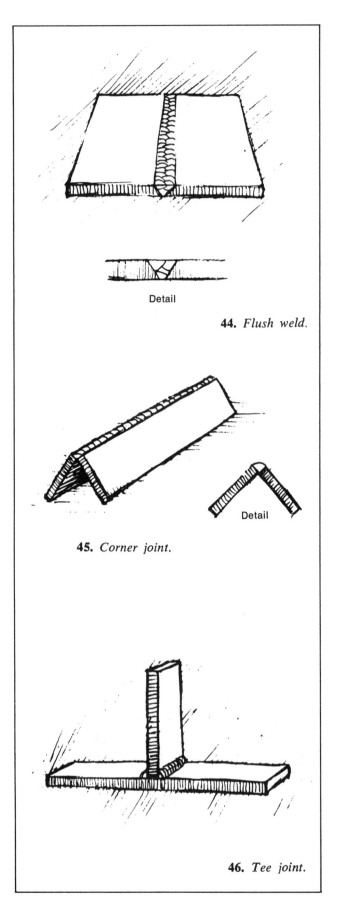

44. *Flush weld.*

45. *Corner joint.*

Detail

Detail

46. *Tee joint.*

the center line of the lower one. Seen from either end, the form will look like an inverted T.

Tack the plates in this position using fire brick to hold them in place. Run a bead along one side of the joint. Then weld the other side.

Welding this type of joint is not as easy as welding a flat seam. The pressure of the flame tends to bounce back off the upright piece and this tends to prevent the flame from heating the bottom of the joint as quickly as it does the side. So focus the flame more on the bottom plate, making sure that you have the flame adjusted correctly, and take the time to let the pool form at the bottom of the seam. If you do not take enough time, the metal will only fuse at the sides of the weld and the bottom will only be overlapped. Restrain yourself from adding metal to the pool until the bottom of the seam is molten.

These joints and seams are the basic ones for welding flat stock (metal). I suggest that you spend some time practicing these welds before proceeding further to the next exercises. I recommend that you do all of these welds several times. Ten hours would not be too much to spend on these welding exercises. When you feel that you can do the exercises fairly easily, try making them in horizontal and vertical positions; place two pieces upright and weld seams that run from left to right and from top to bottom. And when you feel you have become adept at these positions, try welding metal which is in an overhead position.

☐ PIPE WELDS

Pipe welds or circular welds can be done in two ways. If the conditions are right, the welder can move the work by revolving the pipe. This makes pipe welding more like flat welding, which is always the easiest way to weld. But sometimes the welder cannot move the work to suit his needs so he must make his welds around the pipe from horizontal to vertical, to overhead, back to vertical, and so on to the end of the weld. Pipe welding is probably the best way for a sculptor to learn position welding because it more closely approximates the conditions of welded sculpture.

It is difficult for a beginner to understand how a welder can work metal in these positions. It may seem that the molten metal defies the law of gravity. But the tendency of any liquid is to adhere to the surface it comes from. In overhead welding, there are two factors working to keep the welding pool in

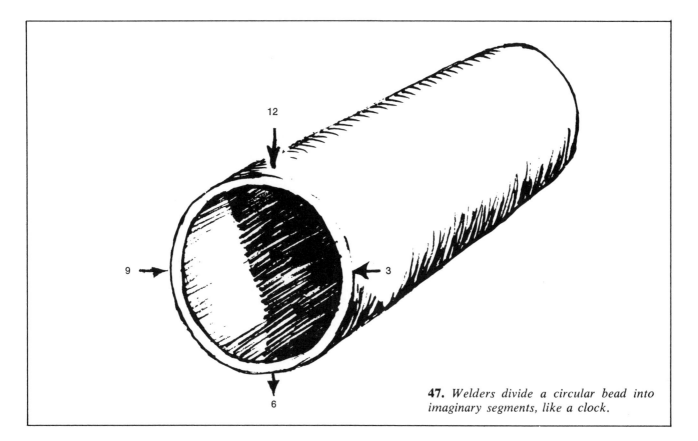

47. *Welders divide a circular bead into imaginary segments, like a clock.*

place. One is the tendency of the metal to cling to the half-molten metal around it; the other is that the pressure of the flame also keeps the metal on the work surface.

I learned pipe welding with a construction firm that has laid pipelines all over the world. The instructor who taught me was remarkably skillful. He could run a bead around a butted steel pipe (½″ thick by 8″ in diameter) with such precision that the weld seemed to have been done by mechanical means. I never became as good a pipe welder as that, but I learned enough to be able to handle all the position welding required for sculpture.

For your pipe welding, you will need some steel pipe 1 ½″ in diameter with a wall thickness from ⅛″ to ¹⁄₁₆″. Make absolutely sure that your pipe is not galvanized since the zinc fumes from galvanized pipe are poisonous.

For the first exercise, run several beads around the pipe before you attempt to butt two pieces together. Begin by placing the pipe on the welding table and propping it so that it cannot roll.

You weld the circular bead in four segments. Welders divide the circle into imaginary segments, like a clock (Fig. 47), so begin your weld at the top, starting at 11:00 o'clock, and running the bead to

2:00 o'clock. Rotate the pipe three "hours" at a time so that you continue the bead. In four moves, you complete the circle. Try this a number of times until you have a feeling for welding on the curved surface.

When you feel confident, you may go on to weld the bead *without* moving the pipe. Weight the pipe on the welding table so that it cannot move. The end of the pipe must project over the edge of the welding table so that you can work at each side, and also from underneath. If you let the pipe project out from a corner of the table, you will have more room to work with. Start your bead at 11:00 o'clock as you stand facing the table; run the bead over to 2:00 o'clock (Fig. 48). Kneel, facing the end of the weld, and run the bead down to 5:00 o'clock (Fig. 49). Here you must use the back hand weld. Care must be taken that the metal does not overheat or a hole will open up in the pipe. (Patching would be difficult and it would spoil the regularity of your weld.)

When you work on the underside of the pipe, more heat is absorbed by the metal because of heat's tendency to rise. You will have to hold your torch so that the flame goes upward, keeping the same angle to the weld as you do in horizontal welding.

At the 5:00 o'clock position, turn your body

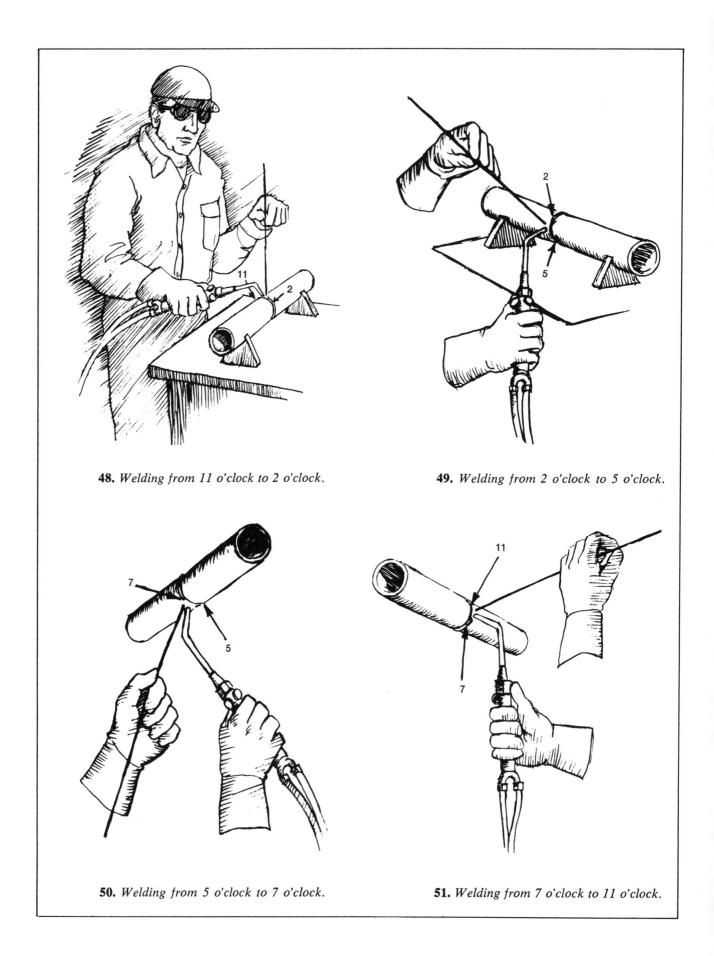

48. *Welding from 11 o'clock to 2 o'clock.*

49. *Welding from 2 o'clock to 5 o'clock.*

50. *Welding from 5 o'clock to 7 o'clock.*

51. *Welding from 7 o'clock to 11 o'clock.*

around so that you look upward toward the bead and so that your arm movements can continue in the proper direction. If you have difficulty in holding the rod in the right position, heat it a few inches from the end, and bend it to a convenient angle to work with. From the 5:00 o'clock position, run the bead across to the 7:00 o'clock position (Fig. 50). With a little practice, you will find that welding overhead is less difficult than welding vertical seams.

To continue, you must change position and face the weld, kneeling again. From 7:00 o'clock run the bead on up to the finish at 11:00 o'clock (Fig. 51). You can rise to your feet again when you get to the 9:00 o'clock position.

Position welding is not difficult to learn. It is a matter of understanding how gravity affects the molten pool. When you are making a vertical weld downward, it is best to retract the torch often in order to keep the metal from overheating, and to prevent too large a pool from forming. Too large a pool would run downward too fast past the heated area.

Welding an upward vertical weld is a little less difficult, but in this case the metal tends to run back on the bead rather than staying where you apply the heat. In either case, your control of the metal's hardening point is the controlling factor for a good weld; for example, the way to prevent the molten metal from running back down a vertical weld is to withdraw the torch frequently so that the pool does not overheat. Overhead welding is not as difficult as you might imagine; the hardest part about it is getting used to the fact that it is possible.

For making butt welds with pipe, you cut off some tubing, using a hacksaw to cut it into short lengths of about 2". Or if you have no hacksaw, you can use your torch for cutting by heating a spot on the pipe to red heat and letting it burn through. Adjust your torch to an oxidizing flame, then melt the metal all around in a circle. To cool the pieces, hold them under water with gas pipe pliers.

If the two edges are too irregular, they can be ground down on a grinding wheel, or filed. Bring the two ends together, propping them so that they are in line, and tack them in four places. Leaving a $\frac{1}{16}''$ space between the two pieces, run the first bead while you stand in one position and rotate the work. When you have mastered this, do some butt welds by working-around-the-clock.

When you have made a few butt welds with pipe, you will have gained enough experience to try mak-

ing pipe joints at various different angles. Begin with a right angle joint and then go on to different connecting angles (Fig. 52). I have made the illustration piece to show you the variety of ways pipe can be joined (Fig. 53). The chief care you must take is to fit each connection snugly by grinding off any excess metal in the joint.

☐ COMPOUND JOINTS

When you are able to weld the various seams, joints, and pipe welds described in the foregoing exercises, you will have the knowledge required for welding any imaginable shape. Your next task as a sculptor will be to learn the various problems of metal layout and metal fitting.

Any three dimensional compound shape can be made from flat sheet stock that has been properly laid out, cut, and fitted (Fig. 54). Whether the shape is concave, convex, pointed, or rounded, you can construct it with welding methods. Any curved shapes can be made by hammer forming and bending. In Chapters 3 and 4, you will learn how to make basic abstract and organic shapes. But as an experiment, I suggest that you try to make some simple compound shapes on your own. Try making a half moon, a half round bar, and a quarter slice of pie.

☐ CUTTING METAL

In cutting steel tubing, you used the oxidizing flame of your welding torch. This is a very useful method of cutting for the sculptor (Fig. 55). Often, when you wish to alter some shape you have constructed —to make it swell out more or to pull it in some— you use the oxidizing flame to cut a cross (+) in the area you wish to alter. This area can be hammered in or brought out to the shape you require. If you hammer it in, you only have to weld the seam together. However, if you want to bring it out so that the seam is expanded, pry open the cut, fit some metal into the expanded cut and then weld the seam again.

For metal up to $\frac{1}{8}''$ thick, you can do this type of cutting with the oxidizing flame. But for metal more than $\frac{1}{8}''$ thick, it is necessary to use the cutting torch (Fig. 56). You will need the cutting torch to cut steel bases, to cut steel for armatures, and to cut pieces from large steel plates for any heavy constructions you might wish to make. There are a few sculptors who use the cutting torch to

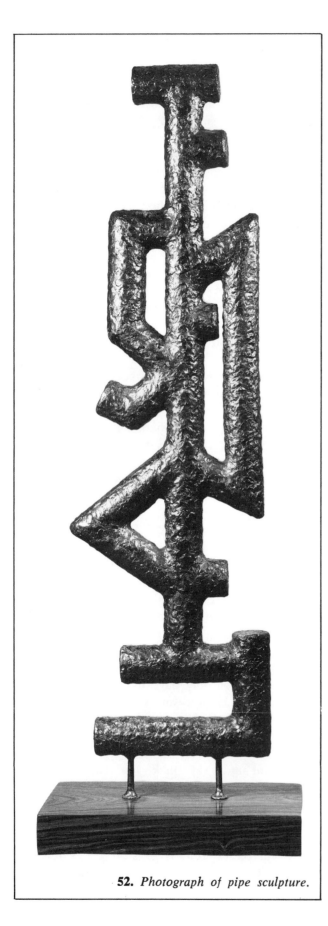

52. *Photograph of pipe sculpture.*

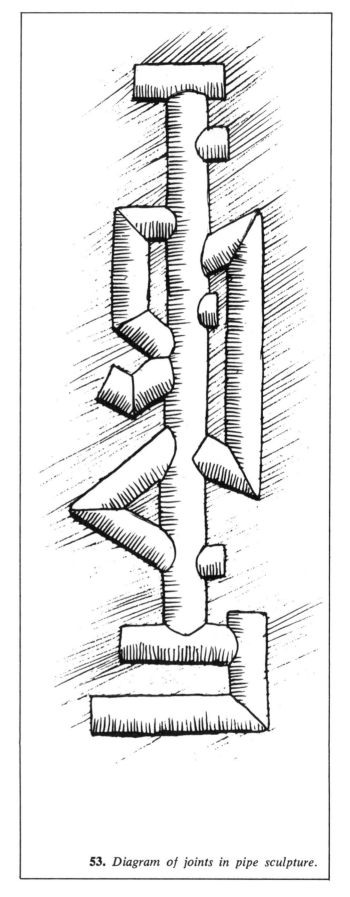

53. *Diagram of joints in pipe sculpture.*

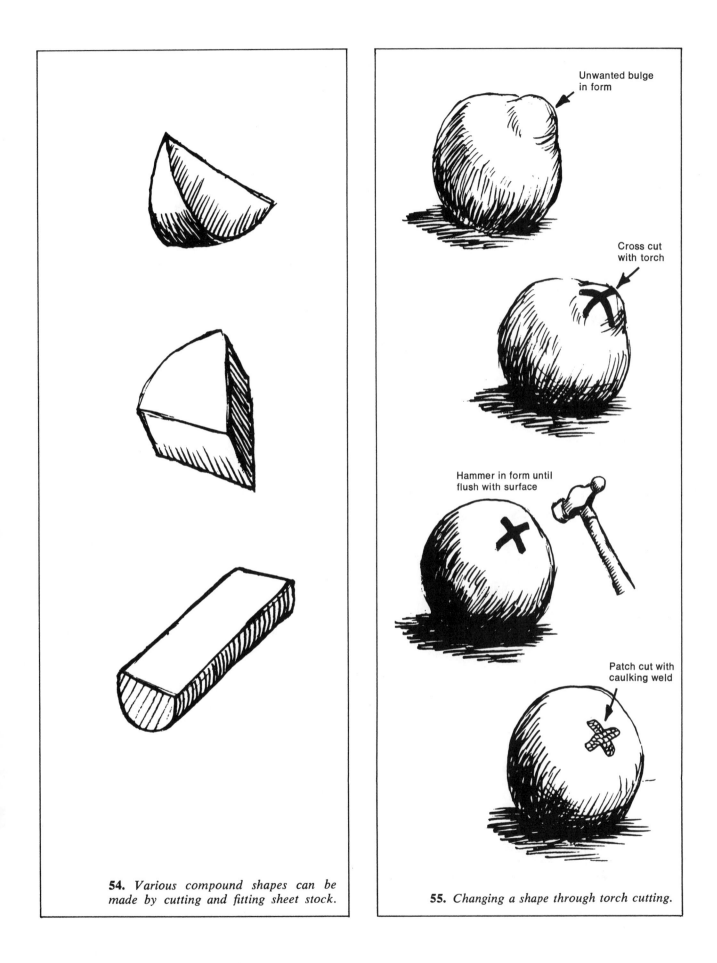

54. *Various compound shapes can be made by cutting and fitting sheet stock.*

Unwanted bulge in form

Cross cut with torch

Hammer in form until flush with surface

Patch cut with caulking weld

55. *Changing a shape through torch cutting.*

56. *Using cutting torch for metal thicker than ⅛". Arrow indicates direction in which torch moves. Note that metal overhangs table.*

make most of their sculpture by cutting shapes within a solid piece and texturing them. I will describe some of this work in the section showing the work of the major sculptor-welders.

The cutting technique is basically simple. Attach your cutting torch to the mixer handle and put on the cutting tip recommended for the thickness of metal you are cutting. I suggest a piece of ⅜" plate about 10" wide and long enough to project over the edge of your work table without falling to the floor.

Set the regulator pressure to the settings recommended by the manufacturer for the tip size (you will notice that the oxygen pressure is set *high* to supply the jet of oxygen that does the cutting). Open the oxygen valve on the mixer all the way, making sure that the valve on the cutting attachment is closed. Turn on the acetylene valve a turn and a half; open the oxygen valve on the torch just a fraction. Strike your lighter, and adjust the flames to neutral, the same as you would for welding. (By this time, you should have put on your welding goggles and gloves without my having to mention it.)

To prevent the flame from cutting into the table itself, the metal should be positioned so that the portion to be cut overhangs the edge of the welding table. I suggest that you weight the steel so that it rests securely on the table. Cut by moving the torch away from you. Keep your feet away from the area of the cut, since quite a shower of sparks and molten metal will fall; also, the metal that you are cutting will fall if the cut is made correctly. Be sure to check to see that there are no flammable things in the area.

To begin, bring the torch to the edge of the metal. Keep the flames just above the surface, and heat the metal to an orange red. Then press down the oxygen lever part way to begin the cutting. As you see the metal being cut, add the rest of the oxygen and move the torch forward along the line to be cut. If you move too fast, you will lose your heat. Then, you will have to go back to the place where you stopped, heat up the cut to red hot, and advance again. You know that the forward edge of the cut is hot when it has a bit of orange color to it. By experimenting with how fast you move your torch you will develop the proper feeling for cutting.

☐ WELDING VARIOUS METALS

Learning to weld steel creates a base of experience that enables you to weld other metals quite easily.

While all metals follow the same basic pattern as steel, at the same time, each metal has its own unique characteristics. This book is limited to exercises that introduce you to steel and then to nickel silver and manganese bronze.

Nickel silver and manganese bronze are almost identical to each other in welding characteristics. Both are somewhat similar to steel. However, there is a marked difference between the feel of these two metals and steel, since mild steel melts at 2730°F. and has a somewhat pasty consistency when molten. On the other hand, manganese bronze and nickel silver melt at about 1800°F. and have a softer, more flowing quality than steel. They do not spark when being welded, as steel does, although, unlike steel, they do give off zinc fumes.

To control fuming and to prevent oxidation of nickel silver and manganese bronze welds, the welding rods are dipped in brazing flux. The flux forms a glassy film over the weld metal and, by keeping out the air, prevents oxides from forming. The oxidizing flame used for manganese bronze and nickel silver seems contradictory to the need to keep oxygen out of the weld, but it is not; by forming a slight oxide film on the surface of the molten metal, the oxidizing flame prevents the zinc alloy in these metals from fuming out. The flux, in turn, prevents this film from entering into the weld.

Through the use of the flux and the oxidizing flame, beautiful welds can be made with these metals. They have a much greater responsiveness to sculptural handling than does steel.

Aluminum is another metal that can be welded with the oxyacetylene flame. Here the technique is similar to steel, but it has a very different feeling due to the metal's odd characteristics. A special flux is required because of the way the metal oxidizes. Since aluminum melts a little above 1200°F. and has no firmness or body in the molten state, it cannot be modeled or built up with the same ease as steel or bronze; it tends to fall apart if only slightly overheated. But beautiful welds can be made in aluminum through the use of the helium arc method (described in Chapter 7). With this method, even flammable magnesium can be welded with ease.

Stainless steel, which melts at a temperature of 2540°F., can also be welded with the oxyacetylene flame. The technique is similar to steel, but is again influenced by the unique characteristics of the metal. Stainless steel does not lend itself too easily to modeling, since it is composed of alloyed metals which tend to form oxides that cover the molten metal. The metal itself is rather hard and tough, and not easy to form. The best stainless welds are also done with the Heli-arc (a trade name) method.

Silver soldering is an extremely useful technique for the sculptor. It makes a very strong bond between surfaces, and it does not require the high heat that welding does; silver solders melt at 1200°F. to 1600°F. Where they are to join, the surfaces of the metal are cleaned, then coated with silver solder flux paste. The metal is then heated on both sides of the joint, rather than directly *on* the joint. As the metal heats, the flux paste drys to a white crust; as the heat rises, the paste turns into a transparent liquid. Just after this phase, the welder touches the joint with the silver solder wire which melts into the joint. As the metal flows into the joint, the welder follows the metal with his torch, adding slight amounts of the solder until the joint has been flowed with a thin coat of silver. It does not require much silver to make a remarkably strong and almost invisible joint.

But steel, manganese bronze, and nickel silver are the metals that are easy to work, inexpensive, and readily available. I recommend that work in aluminum, copper, and stainless steel be undertaken only by sculptors who have had a few years of experience with more workable metals. Learn the basic techniques, allow yourself time to develop your skills, and you will be farther on the road to being a sculptor-welder than if you experiment with metals haphazardly. By limiting yourself to the fundamentals, you will develop technique and skills within a reasonable time.

☐ **MELTING POINTS AND FLUX FOR VARIOUS METALS**

To summarize some of the technical data for metals I have discussed, the following chart, showing various melting points and need for flux, may prove useful.

METAL	MELTING POINT (F°)	FLUX NECESSARY
Steel	2730°	no
Manganese bronze & nickel silver	1800°	yes
Aluminum	1200°	yes
Silver	1200–1600°	yes

Study for an Architectural Panel, *steel, 7" x 18", collection of the artist. The vertical shapes were made one at a time from steel plate joined along the center line with rod. These twelve vertical elements were then placed together on a flat surface and juggled about until a suitable arrangement of shapes was found. They were then tacked together and four bolts were tacked onto the back for mounting.*

Now that you have some technical knowledge and some skill in welding, you are ready to learn the basic elements of welded sculpture. Welded sculpture in some ways resembles, in other ways differs from other sculpture media.

Welded sculpture is different from other media in its approach to form. When you carve stone, wood, or other material, the form is dictated by the size, shape, and quality of the material. Welded sculpture does not have this limitation; you can make either very small or very large sculpture. In the case of cast bronze, the original work is not done in metal but in clay; this work in clay goes through several processes before the piece is finally cast in bronze. A welded sculpture is the end product in itself; it does not have to go through several processes.

However, welded sculpture also has aspects *similar* to other sculpture media. In welding, the sculptor works on the original piece from start to finish, as in stone or wood carvings. In certain instances the carver can laminate wood to wood, or stone to stone, thus introducing the element of construction into carving; welded sculpture also uses methods of construction. But like the original clay of the cast bronze, the welded piece is modeled and the modeling is done in molten metal with the torch.

So welded sculpture involves both construction and modeling. In large work, the basic form is built up from shaped and fitted parts which are constructed into the whole form. This form is in turn modeled with the torch, which turns the metal into soft, fluid, responsive material. The form can subsequently be modified or reformed by hammering or cutting into the shapes, or by reconstructing some of the elements entirely. For these reasons, welded sculpture is the most versatile and advanced medium

for working in metal. It is not necessarily better than any of the other media; rather it is a distinctly new, separate, and revolutionary medium within the sculpture field.

But regardless of the fact that this is the first new medium in sculpture in over 2000 years, there are some aspects of sculpture common to all media such as understanding three dimensional shapes. For regardless of the medium a sculptor works in, he deals with the shapes and substances of nature. The things that change with different media are the tools, materials, and techniques used to make the shapes. Therefore, when we discuss the "logic of shapes" common to all sculpture media, we will discuss this logic in the light of welding construction and the modeling of molten metal.

□ FIVE CATEGORIES OF ABSTRACT SHAPES

Almost everyone has played the game, "Animal, Vegetable, or Mineral" at one time or another. And anyone who has played this game knows that these three words are used to define different types of shapes. Sculptors do the same thing, in a sense; they decide which category of form, or abstract family, an object belongs to. Then they make the form according to the rules of structure that apply to that category, because all members of the category have basic features of form in common.

But actually, for the sculptor, there are five major categories of forms in nature: animal forms, plant forms, hard forms of the elements (rock, crystalline, gravel, and sand), water forms, and aerial forms (cloud, smoke, and other atmospheric patterns).

Each of these categories of form has many variations and sub-families in it. But in each family there are qualities that remain the same for every member

of the form. In the animal forms, all the members—from the tiniest microscopic creature to man—are freely motile (even though they might be fixed to one place, like a barnacle) and pulsate in a four beat rhythm. Their forms are organized in a head-to-tail direction (from mouth, to organs, to anus) and they live in the delicate, balanced biosphere on the surface of the globe (Fig. 57). As these forms go up the scale of evolution, they become more complex; but regardless of how complex they become, they still possess the basic traits of organic form. Man and the one celled creature follow the same abstract pattern.

Closely related to animal forms are plant forms (Fig. 58). All those that concern the artist have a basic pattern that begins with the seed. The forms root into the earth and rise up, branching into the air above. They grow, mature, blossom; in some cases, they bear fruit and seed. All of these actions in some way alter the basic form or extend it. Most plants have a numerical pattern in all these functions; a certain number of petals or leaves, a numbered branching pattern, or a spiral organization of the parts. Because these forms have definite patterns of shape and growth, they can be understood and constructed by the artist, and understood by the scientist. I do not give much time to the subject of plant forms in this book, but I encourage you to try to study these things directly and make discoveries for yourself.

The realm of hard forms of the elements includes crystal formations, rock forms that have been created by fracture and erosion, and pulverized material that takes on the patterns that gravity, wind, or water dictate (Fig. 59). Sand can easily be changed and formed by the weather, but so can mineral rocks, although it takes a longer time to reshape them. No form in nature seems quite permanent, so all these forms are subject to time's change. But living forms are aware of the forces acting upon them, and this shows in their responsiveness. Since the non-living form does not react in this way, changes wrought upon its face by nature reflect the existence of the elemental forces over long periods of time.

The fourth and fifth categories—water and aerial forms (Figs. 60 and 61)—are the most lively and fleeting of all. Water is even more responsive than a living organism, and air is even more responsive to change than water. Yet both air and water possess definite form patterns: eddies, swirls, the vortex or cyclonic pattern, the wave pattern, and interpenetrat- ing wave patterns all belong to these two realms. These are the most gentle forms in nature, and yet they are also the most powerful. These forms can speak with the ferocity of a hurricane or with the gentleness of a breeze blowing the sand. But of course, even gently blown sand will, in time, erode whatever opposes it.

☐ STATES OF FORM

This brings us to another aspect of form that relates to all five categories. I will call this aspect "the states of form" (Fig. 62). All five categories of form can exist in a number of different conditions. Nothing in nature remains the same forever. There is an ebb and flow, a constant process of emerging, maturing, ripening, and decline. Even the hardest, most unyielding substances expand and contract with heat and cold, gradually soften and change shape. Under high heat, the hardest substance will melt and become a liquid, responding to the laws of form that apply to liquids. Under even higher heat, the substance will become a gas, responding to the laws of aerial form. With intense cold, gases and liquids become solid and crystalline. *Our* standard, of course, is the state of these forms under normal life conditions. But when the conditions of environment or inner balance fluctuate, this affects form to a greater or lesser extent. The "state of the form" shows what is happening to the form.

The ancient Greeks considered the states of form to be basic elements rather than merely phases that matter goes through. Their four elements were air, water, earth, and fire (Fig. 63). But of course *we* recognize these as *qualities* of the elements; they are the gaseous, liquid, solid, and burning states of matter. And related to these states are their milder expressions which prevail under normal conditions; warm, moist, cold, and dry. These are the subtle expressions of states of form.

In the processes of life, living things show these states of form in a marked way which has a great deal to do with the work of the artist. Artists must not only be able to analyze and construct forms, but they must also be sensitive to the expressive states of form. Unlike the other forms, which are hot or cold according to the temperature of the atmosphere, an animal form maintains a steady level of warmth within its own organism. But in the case of the human being, a person might be emotionally hot or cold; seem earthy, airy, fiery; or be watery,

Rear

Front

Forward direction
of movement

Simplified diagram

57. *Basic life form.*

Spiral organization
of leaves
and branches

Spiral organization
seen from top

Basic tree form

58. *Basic plant forms.*

Some basic crystalline shapes

Natural crystal fragment

59. *Crystal forms.*

warm, or dry. All these qualities are states of form which, even though they might not change the shape in a very noticeable way, they give the form its mood and bearing in a subtle way. These things express a form's state of being, its aliveness and responsiveness to the environment.

Plants also respond to the environment and express various states of form. In summer, the leaves of trees reflect the changes in the weather. They are lifeless and droop when it is too dry, or are heavy and full if it has been too wet; but on a fine day, they are lively and dancing. Otherwise the trees show the seasonal response and the four beat cycle of form change: the sap rising in the spring, budding, blossoming, and pollinating; maturing and bearing fruit; again losing leaves; finally, becoming dormant in the winter. All these functions alter the form slightly, and are emotionally moving states that show a pulsing response to earth, air, water, and heat.

Since the states of energy in the environment never remain the same but are in a constant state of becoming, rising to a peak, leveling off, and declining, there is a basic quality of movement in existence than constantly affects and modifies all form. Animals pulsate visibly in response to the atmospheric energy in their environment. Plants react to the weather. Even the stone-like shells of bivalves show the shape of the living tensions within them, the organ movements, the thrusts, the swirls, the gatherings of energy and sensitivity.

Of course non-living forms do not show this awareness and quick responsiveness. A crystal form or a granite boulder hardly seem to be affected by anything at all. Yet even the hardest rock, broken from some granite cliff, with its edges sharp and angular, will in time respond to the wear of the weather (Fig. 64). First some of the sharp edges will wear off. Next the persistence of heat and cold will crack and break the stone into smaller pieces. Finally, it will be washed to the sea as grains of sand. And when it is cast up on some shore as sand, it will blow, drift, and change form until it finally dissolves into pure energy.

Sculptors—good ones, that is—feel the poetry and emotion of forms. They see forms as expressive shapes having a history—past, and future. They see organic shapes as part of the living process of growth and becoming. Through your determination to observe form intelligently, you will learn that all forms are modeled and directed by energetic forces that are planetary and even cosmic in scope. There is no

Train of vortices created in a stream as water flows by rock

Jet of water shooting
into still water

Vortex or whirlpool form

60. *Water forms.*

Storm clouds

Cirrus clouds

Twister

Form pattern of
spiral galaxy and twister

61. *Aerial forms.*

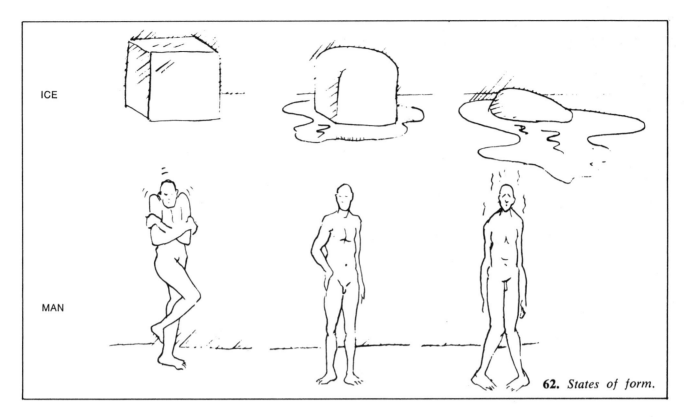

ICE

MAN

62. *States of form.*

meaningless shape or texture in nature; everything is functional and expressive. If you observe these things well, you will be able to impart some of them to your sculpture. With experience, this will become an automatic process.

I can only point out those functional processes in nature that will enable you to begin to *see the processes of form*. Seeing and understanding will depend on your own drive, initiative, and capacity. This is a years-long, perhaps a lifetime task. It is not always pleasant, sometimes it is dull, plodding, even painful. But you can be assured that the results of the search will be all yours, part of your fiber, your character, your work.

□ CONSTRUCTING GEOMETRIC SHAPES

Geometric shapes, as we see them drawn or printed on paper, or constructed in sculpture or architecture, are man-made shapes that have no exact parallel in nature. Geometry is an invention of man, which he uses to *approximate* the shapes and structures that nature creates. In nature, these forms are created by internal and external workings of cosmic energy; but in man's geometric measurement of nature's forms, these energetic functions are entirely left out. Geometry only approximates the empty space that form fills, and it can do this very well.

But of course the *surface* or *skin* approximation of geometry is not the whole meaning of any form in nature. Beware of geometric facility that gives all the outer appearance of form, but leaves out all the lively inner content. Become skilled in geometric construction if you can, but try to remember that even the same types of form in nature always vary from one individual object to another, and that all individual things are slightly askew. Nature's forms always have individuality, uniqueness, and character. If you keep this in mind, along with what I have said about states of form, you should be able to survive geometry and turn it into your tool, rather than becoming a mere geometric formalizer.

63. *Greek elements and their qualities.*

53

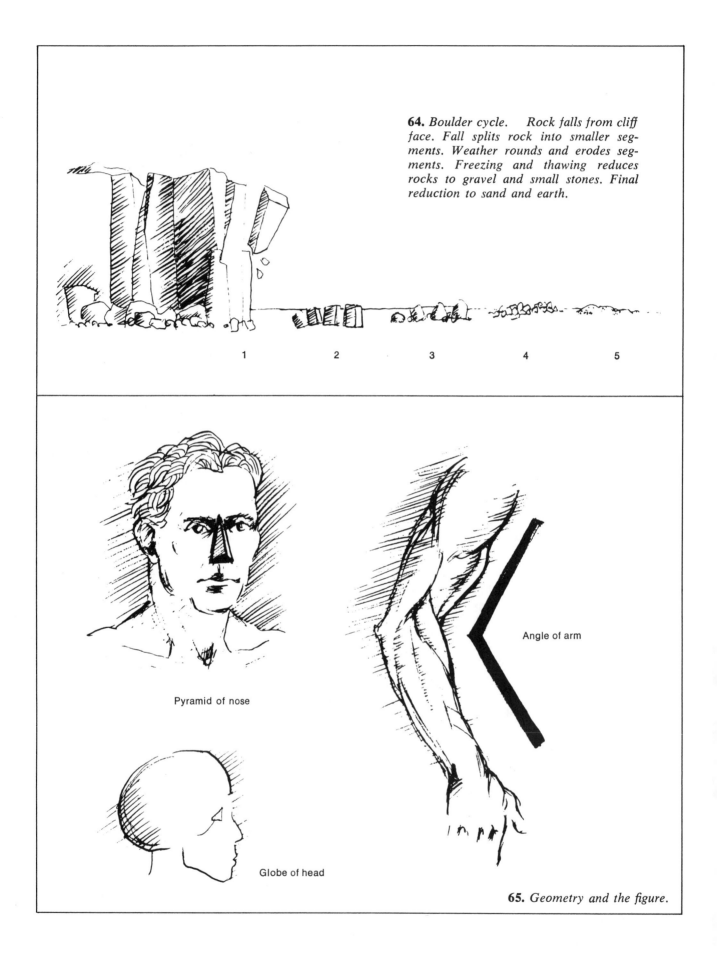

64. *Boulder cycle. Rock falls from cliff face. Fall splits rock into smaller segments. Weather rounds and erodes segments. Freezing and thawing reduces rocks to gravel and small stones. Final reduction to sand and earth.*

1 2 3 4 5

Pyramid of nose

Angle of arm

Globe of head

65. *Geometry and the figure.*

A sculptor may use geometric shapes to compare the shapes of nature for the sake of convenience (Fig. 65). For example, he may feel the pyramid shape of a nose, or the globular shape of a head, or the angularity of an arm; but he will realize that these shapes or movements are only boxes in which to put the real shapes and movements, until they can really be analyzed properly. A nose is, after all, a profound organic shape that has nothing whatever to do with mathematical measurements.

□ CONSTRUCTING A CUBE

Now that you have been warned about the evils and shortcomings of geometry, let me say that it is also an indispensable tool for building shapes. The human organism has certain built-in functions that enable us to think in geometric terms. We will go into these functions when we deal with organic form construction. But now you will construct a cube . . .

I suggest 5″ squares as the basic measurement of the shape. Begin by cutting six 1/16″ thick pieces of stock into 5″x 5″ squares. These will have to be cut with a shear, as it would take too long to cut them with a hacksaw. If you do not yet have a shear, go to the local metal shop and see if they will cut the parts for you. Or perhaps the local high school has a metal shop with a shear you can use.

After you have cut the pieces, put them on a flat surface to check their evenness. If there is any irregularity, use a hammer to straighten the curves by pounding them out on the flat surface. Your next step will be to fit them together and tack them.

When you weld any shape, you have to reason out the steps of construction so that you know all the steps of the process *before* you begin (Fig. 66). The reasoning for cube construction is simple. All the sides of the cube fit together at 90° angles and all the pieces are the same size.

Begin by tacking any two square pieces together. I clamp both squares to a piece of angle iron 1/4″ thick, 2″x 2″ on each angle, and about 1′ long; the squares fit edge to edge, meeting at the angle. This assures an accurate 90° fit. The two squares should be tacked in about four places along the seam.

Next, tack together the third and fourth squares in the same manner as you did the first two. When this is done, both L-shaped pieces can be fitted together so that they form a box, open at each end. Use the angle iron to clamp the pieces at the corners to be tacked, and tack each joint in turn.

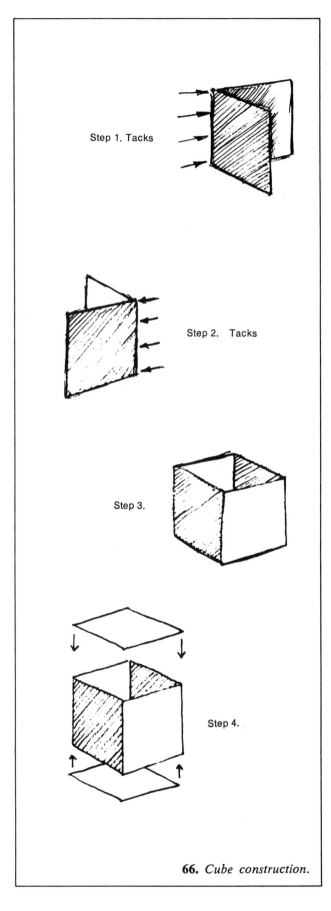

Step 1. Tacks

Step 2. Tacks

Step 3.

Step 4.

66. *Cube construction.*

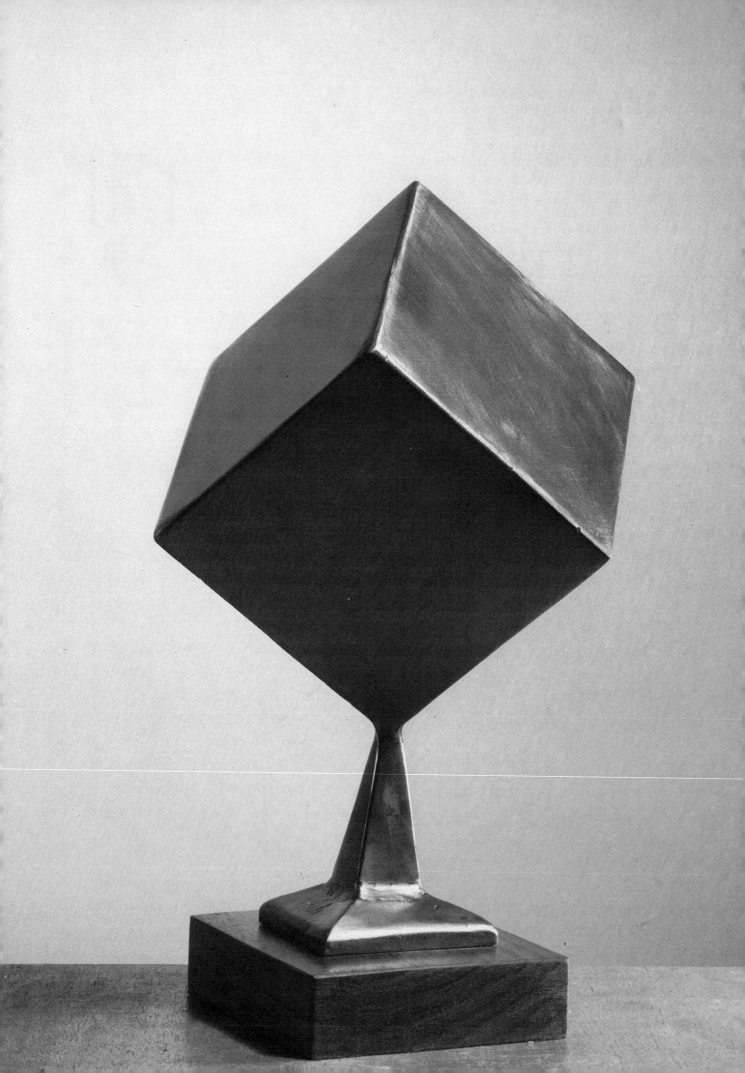

When the box has been tacked together, simply set the fifth square on the open top, weight it down, and tack it all around. Then turn the box over and tack on the sixth piece. In tacking these last two squares, it may help you to do all the corners first, and then to do the middle parts of the seams. This prevents warping, and heat distortions. The same applies to the welding of the seams: if you do one seam and *then* do the seam on the opposite side of the cube, the cube will stay in its proper shape.

When the seams are all welded, you will have a fairly accurate cube. This same process can be used for all rectangles, too. The illustration piece (Fig. 67) was made in this manner; the welds were filed down, the surface was sanded, and then the piece was mounted and based.

□ CONSTRUCTING A TETRAHEDRON (FOUR SIDED TRIANGULAR SHAPE)

The tetrahedron is the geometrical shape that has the least number of plane surfaces; it has four triangular surfaces. I once modeled an accurate cube in plasticene so that I could dissect it to find if it was constructed of a more basic shape. I found that if it were cut in a certain way, it could be reduced to five tetrahedrons. Four of these are right angled and are all part of the outer surface; the inner tetrahedron, the fifth one, is an obtuse-angled shape that is entirely enclosed.

A crystalline shape found in nature, the tetrahedron is a basic structural shape, able to stand up under tremendous pressures. Buckminster Fuller, the well known American designer, has evolved many architectural structures using the principles embodied in this shape. When a sculptor calculates weight and stress, he often uses his feeling for this shape to solve his problems. This tripod shape can be adapted into compositions in many ways.

Construct your tetrahedron by cutting out four equilateral triangles of the same dimension (Fig. 68). (In an equilateral triangle, all the sides measure the same length and all the angles measure 60°.) Use $\frac{1}{16}''$ stock, and let each side of the triangle measure 5″.

Since all the triangles are the same size, and all the edges are of identical length, number the pieces from 1 to 4. Tack triangles 1 and 2 together so they meet at an angle of 60°. The remaining two pieces

67. *Cube—filed, sanded, mounted and based.*

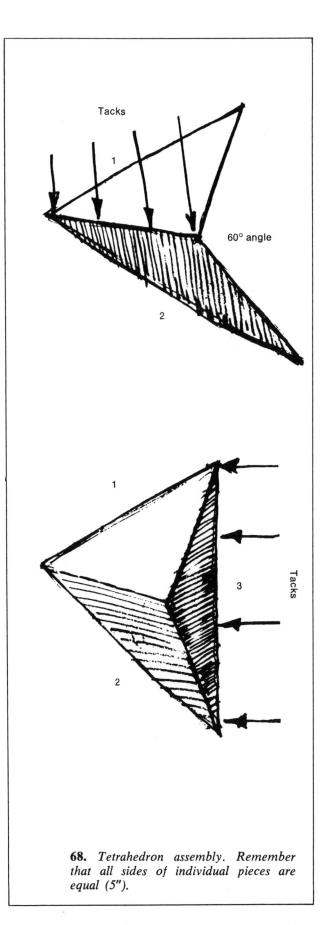

68. *Tetrahedron assembly. Remember that all sides of individual pieces are equal (5″).*

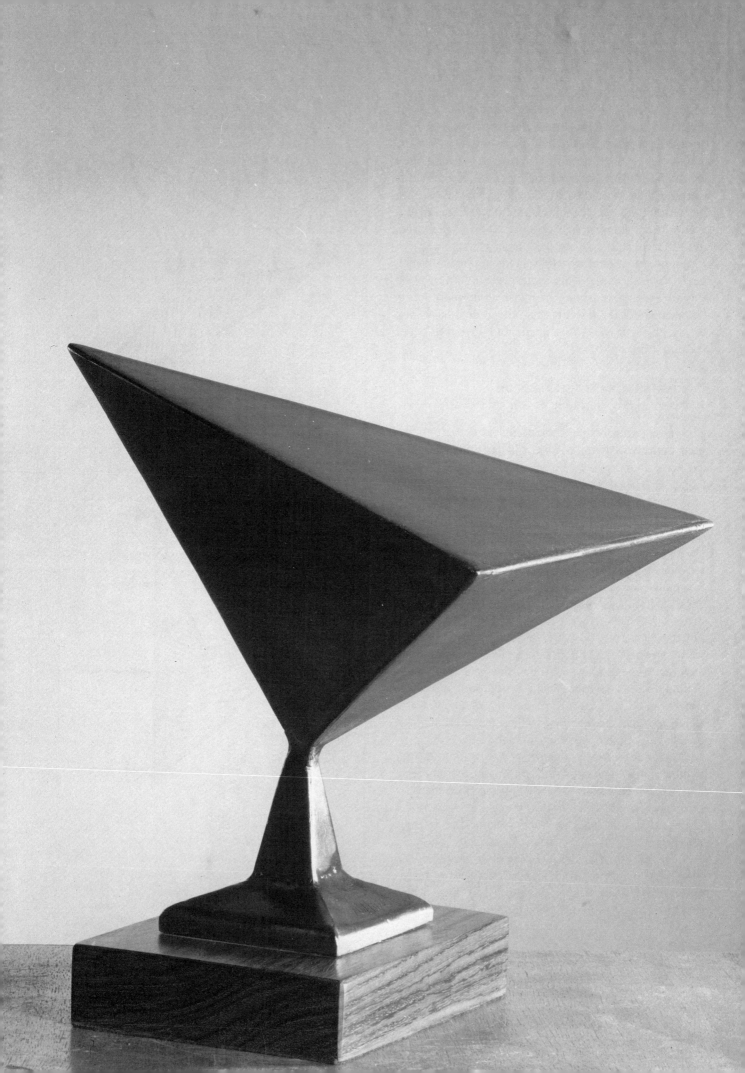

will fit right into this open angle, and will close in the form. Tack the third and fourth pieces in, and weld the sides. This will be a four sided form, as opposed to the six sides of the cube; therefore, it will have six seams to weld, as opposed to twelve on the cube. (See the tetrahedron illustrated in Fig. 69.)

To make tetrahedrons built of isoceles (two equal sides) or scalene (no equal sides) triangles, cut out two triangles of the same shape and tack them together. You can use this as a form to cut the proper pattern for the remaining triangles (place the piece on the sheet steel, and trace off the borders of the open spaces. A straight line will close up each shape. Then simply cut the pieces out and tack them.

□ COORDINATE PLANES

At first glance, the globe seems a particularly difficult shape to weld, but in your experience with the shapes of nature you have already unconsciously learned the principles necessary to solve this problem. For example, an orange can give you all the logic you need; for, by cutting an orange in a certain way in your imagination, you can gain the geometry needed to construct a globe.

Visualize an orange standing upright so that its stem end is on top. Imagine that you are making a vertical cut downward through the center. If you then pulled the two halves apart, the flat inner face of the cut orange would be a plane—called a cross section by engineers—which we shall refer to as a coordinate plane. With the two halves together again, imagine making another cut from top to bottom, this time cutting at a 90° angle to the previous cut. Finally, a third imaginary cut is made *horizontally* through the center of the orange like the earth's equator, cutting through both previous divisions.

If you can picture the interior flat surfaces produced by these three cuts, you can see the three imaginary planes we shall call coordinate planes. By referring to these planes, you can locate any point in the orange or, for that matter, on any globe. You can use the same principle to build oval shapes, eggs, or even more complicated shapes.

A further point: if you keep the pieces of the orange together in your mind's eye, you will see that its surface is divided by three circles from the imaginary cuts you have made. Seeing the relationships of these circles is just a step away from realizing that

you can make three similar circles in steel—all the same size—and tack them together in the same relationship; thus, you will have a simple armature on which to make a globe.

□ CONSTRUCTING A GLOBE

Now, you are going to use this concept of coordinate planes to construct a globe. The globe might seem a difficult shape to weld, since you use flat stock to construct the shape. But once you know the procedure, it is as simple as any other kind of shape. You merely have to follow the steps.

Begin by cutting ten strips of $\frac{1}{16}$″ stock to 1″ x 10″ dimensions. Next, inscribe a circle 5″ in diameter on the top of your workbench or on a flat piece of board. Use a compass if you have one. If not, pound a nail where you want the center of the circle. Then use a pencil tied to a piece of string, which you tie to the nail, leaving 2½″ for the radius. Hold the pencil straight up and move it around the nail. Another way is to drive two nails 2½″ apart, through a piece of wood; using one nail for a pivot, scratch the circle on the board with the tip of the other nail.

Draw a vertical line through the center of the circle, cutting it in two (Fig. 70, a-b). This will be the vertical coordinate plane for your globe and will give you a North and South pole. At right angles to this vertical plane, draw a horizontal line through the center (Fig. 70, c-d); this is the horizontal coordinate plane. The third coordinate plane is represented by the line that defines the circumference of the circle. Now visualize these three lines as three circular planes. (Again refer to Fig. 70; in this figure, I have also shown how this concept applies to a rectangle.)

In the case of the globe, these three planes all intersect at 90° angles. But in your imagination, you can fit these planes into almost any shape that you have to analyze. Sometimes you have to bend the lines a bit. Sometimes they are easier to use as intersecting lines rather than planes. One way or another, the sculptor must use these coordinate planes every time he constructs a form. It is done either consciously or unconsciously, but if it is not done at all, the shape will be either an amorphous blob, or an odd attempt to connect small areas of surface form merely copied from the model.

Now you will construct three circular bands, and fit them together so that they intersect in the same relationship as the three coordinates.

69. Tetrahedron—filed, sanded, mounted, and based.

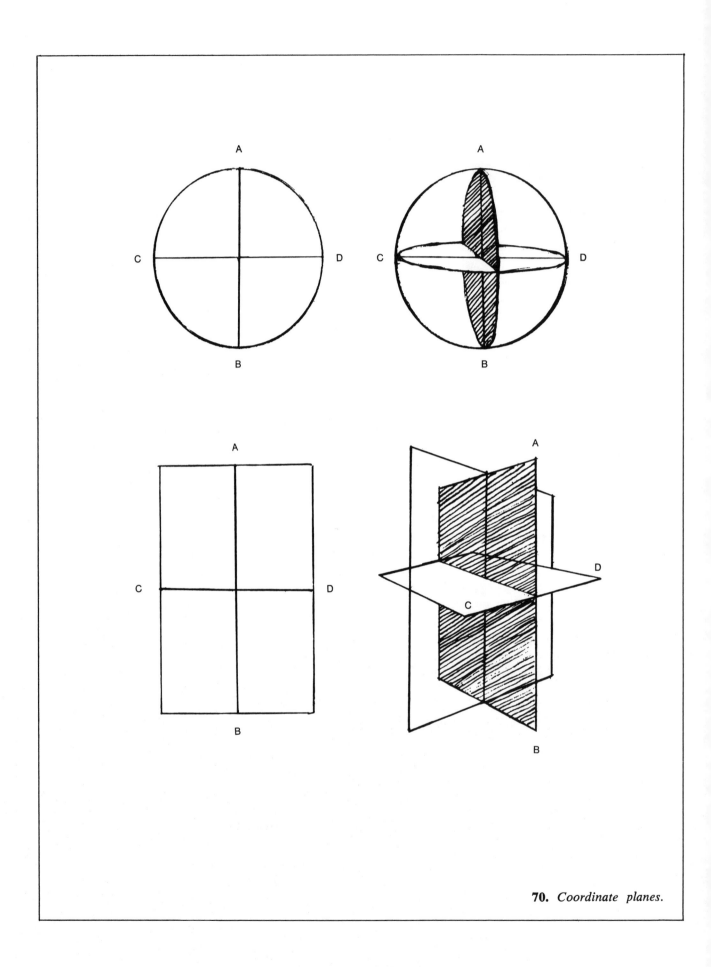

70. *Coordinate planes.*

Bend a piece of 1″ x 10″ strip in a half circle that will fit the curve of the circle you have drawn. To bend the metal strip, hold it by one end with your pliers while the other end rests at an angle on an offset surface. An anvil has such an offset where its rectangular top ends and its horn-like tapered part begins (Fig. 71). Rest the lower end of the strip on the offset opening and start tapping it with the peening end of a hammer. The hammering will curve the metal. Keep tapping as you move the entire strip over the offset. This will make a very even arc.

Once the half circle is curved, fit it to the circle. If the piece needs to be bent more, tap over it again with the hammer. When it fits properly, make a second piece, in the same way, to close the circle (Fig. 72). The circumference of a 5″ diameter circle is 15.708″, so cut each piece so that it fits exactly to the half circle mark, and save the scrap for later use. Tack the two pieces together and weld the seams. This will be the first coordinate, the north-south plane.

The second circle you make will correspond to the equatorial plane (Fig. 73). Form the arcs the same way, making two equal sides; but this time, cut each side one inch shorter. This allows for the thickness of the first circle, so that when you tack-weld the equator pieces in place, both circles will remain the same size.

In the same manner make the third coordinate (Fig. 74). This will be a longitudinal plane that crosses the equator at 90°, and cuts through the north-south axis plane at 90°. This time, the piece will have to be cut in quarter circles to allow for crossing the equator circle and the north-south circle. Follow the marks on your pattern for each piece, but subtract 1″ from each quarter circle. This will make the third coordinate circle come out the right size.

Tack all the pieces in place, and weld the seams. You will notice that the addition of the third coordinate really gives the piece form, and it is easy to visualize the spherical piece as finished and solid.

Two additional longitudinal circles should be made which, when attached, will divide the quartered globe into eighths (Fig. 75). These are formed in the same fashion as the third coordinate and are the same length, but each quarter piece will have to be cut at an angle at one end so that it fits into the angle at the pole. Fit each piece to the area where it belongs, as the measurements may vary slightly for each piece. As you tack each piece in place, fit the

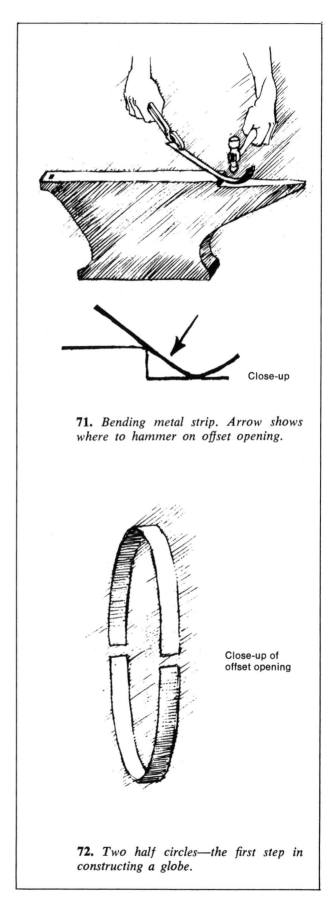

Close-up

71. *Bending metal strip. Arrow shows where to hammer on offset opening.*

Close-up of offset opening

72. *Two half circles—the first step in constructing a globe.*

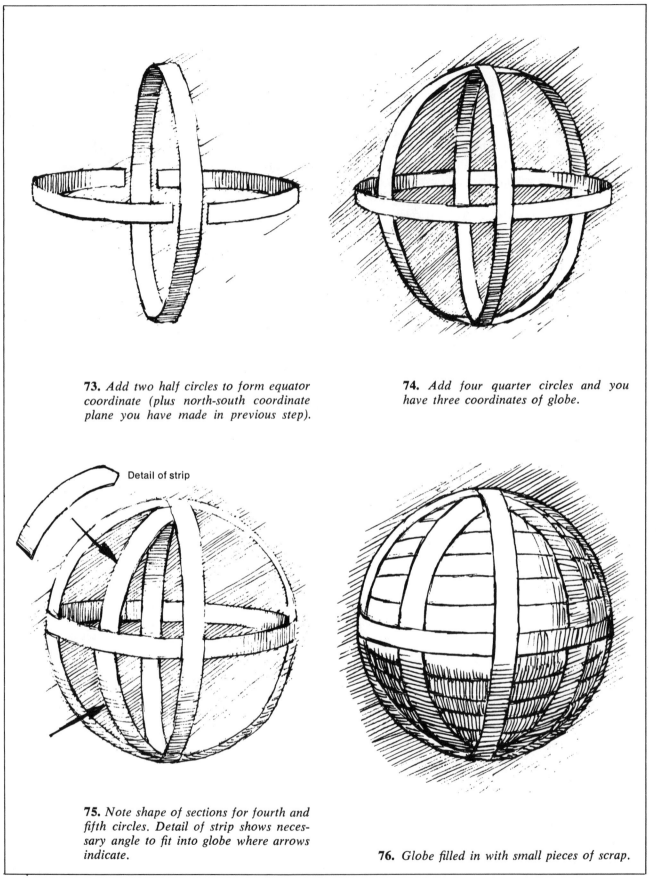

73. *Add two half circles to form equator coordinate (plus north-south coordinate plane you have made in previous step).*

74. *Add four quarter circles and you have three coordinates of globe.*

Detail of strip

75. *Note shape of sections for fourth and fifth circles. Detail of strip shows necessary angle to fit into globe where arrows indicate.*

76. *Globe filled in with small pieces of scrap.*

77. *Globe—surfaced with a layer of fused rod, ground, sanded, buffed, mounted, and based. (right)*

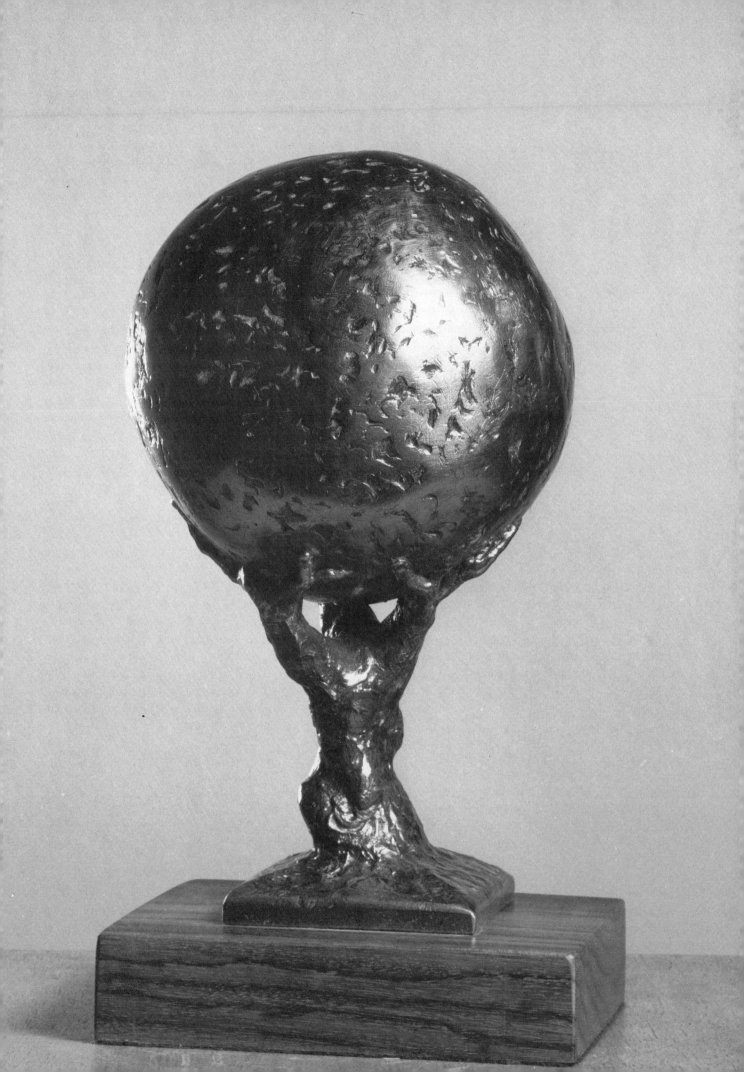

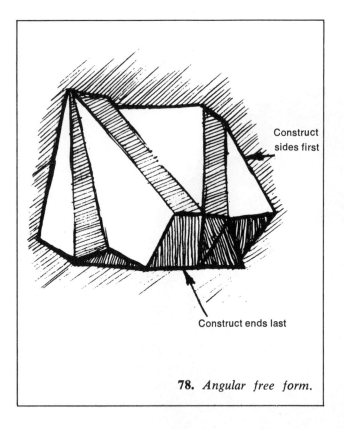

Construct
sides first

Construct ends last

78. *Angular free form.*

opposite piece to prevent the globe from warping.

To fill the remaining openings, fit and cut the small pieces of scrap so that they run parallel to the equator. When the entire globe has been filled in (Fig. 76) you will have a fairly round steel ball if you have fitted the parts with reasonable care. But if there are areas that rise noticeably above the proper curve of the surface, use the torch to cut a cross into the surface at that point. Then tap down the rise with a hammer and reweld the seam. Low areas can be filled with rod if they are not too deep. If they are too deep, cut the area out altogether, and fit it back in the proper relation to the surface.

The entire surface of the globe will be covered by a network of seams. In order to obliterate this pattern, which distracts the eye from the form, cover the entire surface with a layer of fused rod, as I did in the illustration piece (Fig. 77). The surface can then be ground down, sanded, and buffed. The result will be a reasonably globular shape, perhaps not one you would care to play billiards with, but nevertheless round.

□ **CONSTRUCTING AN ANGULAR FREE FORM**

The shapes that make up the illustration piece (Fig. 78) for this exercise are all triangular and rectan-

gular. I constructed the piece from scraps that were at hand in the studio. The purpose of this exercise is to give you an opportunity to compose and construct freely within a simple geometrical concept. This form will have something of the cube and something of the tetrahedron, but it will be much more imaginative and sculptural. It will give you an opportunity to make a few decisions for yourself, as well as creating a few self-induced problems.

Since you will be constructing this form yourself, I cannot give you exact directions, but will only outline the procedure. I suggest that you use pieces 9″ long for the first part of the operation. Make these pieces rectangular strips and acute triangles of various patterns. By tacking these together, you construct the main body of the form. The pieces may go in and out a bit, but the object is to work them around so that the last piece you add can be connected to the first. The result of this should be an irregular form about 9″ wide that circles around and connects with itself, and has two open ends, like a skirt. The sides can go in and out in any fashion you choose. Be inventive, but avoid over-complicated constructions. When you get to the point where you are ready to reconnect with the first piece, be sure to take care in fitting the last connecting pieces. The object of this form is to have no curved and no bent pieces. When the form is all connected, weld all the seams.

The open top and bottom will suggest the triangles and rectangles which you will add to close these parts of the form. You will have to fit and cut these pieces to the size indicated by the side form. Filling in these spaces is a good deal like working a jigsaw puzzle; only the right shape will fit. The good thing about this is that it will test your skill in recognizing shapes and in fitting them. But remember, it is *cheating* to bend, curve, or force a piece into a place where it does not belong.

The finished piece can be surfaced with rod, ground down, and buffed. This was done with the illustration piece. When mounted, this sort of shape comes very close to being sculpture (Fig. 79). Once you understand the ways of this technique, this kind of piece is fun to do. I suggest that you do several as an exercise, to help you learn fitting.

79. *Angular form welded, surfaced with rod, ground down, buffed, mounted, and based.*

Ariadne, *steel, 11″ high, courtesy Midtown Galleries. This head was done in the same manner as* Daedalus. *The shapes of a woman's hair arrangement afford a certain amount of free form play with interesting possibilities for the welder, but one must first work out the shapes in a sketch, as the key to a hair arrangement is its pattern.*

Daedalus, *steel, 11″ high, private collection. This head (not a portrait) was begun by making a framework of welding rod, consisting of a profile and a front view of the head outline, connected by cross sections of rod. Pieces of plate were welded to this to fill out the form in a manner similar to the fish exercise in Chapter 4. The ears, eyes, and other details of the features were then modeled onto the form by building up beads of weld metal into the desired shapes.*

Organic shapes differ from geometric and non-living shapes because organisms are capable of two kinds of movement: movement through space, and the living movements (pulsation) within the organism itself. The main body of all organic shapes, containing the organs with their mouth entrance and anal and genital exits, is generally rather egg-shaped (Fig. 80). And this shape is in turn modified by the way the organism has oriented itself to the biosphere and the forces of gravity.

Within the soft egg-shaped organic form dwell the living processes that motivate the organism through the biosphere: reaching for food, desire for contact and copulation, and search for comfort, as well as movements made for the sheer pleasure of being alive. All these are *expressions* of organic forms as well as *functions* that model the shape of the form. If you look at forms going up the scale of life, they vary in many ways, but their underlying functions are always the key to solving the meanings of the shapes. Sculptors look for these expressions of the form's aliveness and not just the skeletal framework or outward shell.

If he is to understand the shape, the sculptor must learn to read the form's intent of movement, its internal pulsation, and the states of its feeling. Only after these things are grasped can the sculptor's created form have any meaning.

□ CONSTRUCTING AN EGG

The simplest organic shape is the egg. You began life from the processes set in motion from the meeting of sperm and egg within your mother. Therefore, you have a great deal in common with eggs. (See Vigeland's *Infant,* Fig. 81.) You are the embodiment of egg development and you will pass on to succeeding generations all the logic of the egg. For convenience of study, you can examine the hen's egg. The egg shape is the perfect housing of life functions, and even the shapes of later development have something of the original egg form: the head, rib cage, female breast, testicles of the male, etc. So sculptors use the egg shape as a basic analytical form.

It is best to use simple organic forms such as the egg, worm, jellyfish, fish, or organ shapes as standards of analysis. When *geometrical* shapes are used to construct organic forms they "kill" the living aspects of the forms. Make it a rule to keep organic forms within the organic logic of structure.

If you are to weld the egg shape correctly, you must analyze it correctly. An egg is not a circle, nor is it an oval, but it is a little of both: and no two eggs are shaped exactly alike. Notice that one end of the egg is rounded, almost circular, while the other is more pointed, or parabolic.

Draw a vertical line 8″ long (on your workbench or on a board) to represent the axis of the long dimension. Next draw a cross-line, or equator, to represent the widest part of the egg. Make this line 3″ from the bottom and extend it 3″ on either side of the long axis.

Using the point where the two lines intersect as a center, draw a half circle with a 6″ diameter, starting from one end of the cross-line, touching the bottom of the long line, and finishing at the opposite end of the cross-line. This gives you the round bottom part of the egg. For the top part of the egg, draw a duplicate of the lines you have drawn so far (on a piece of paper) so that you can make a pattern. Sketch the top parabola in, freehand, folding the paper along the vertical axis line to make sure that each side matches. Cut this out with scissors and trace it into the original drawing to complete the egg.

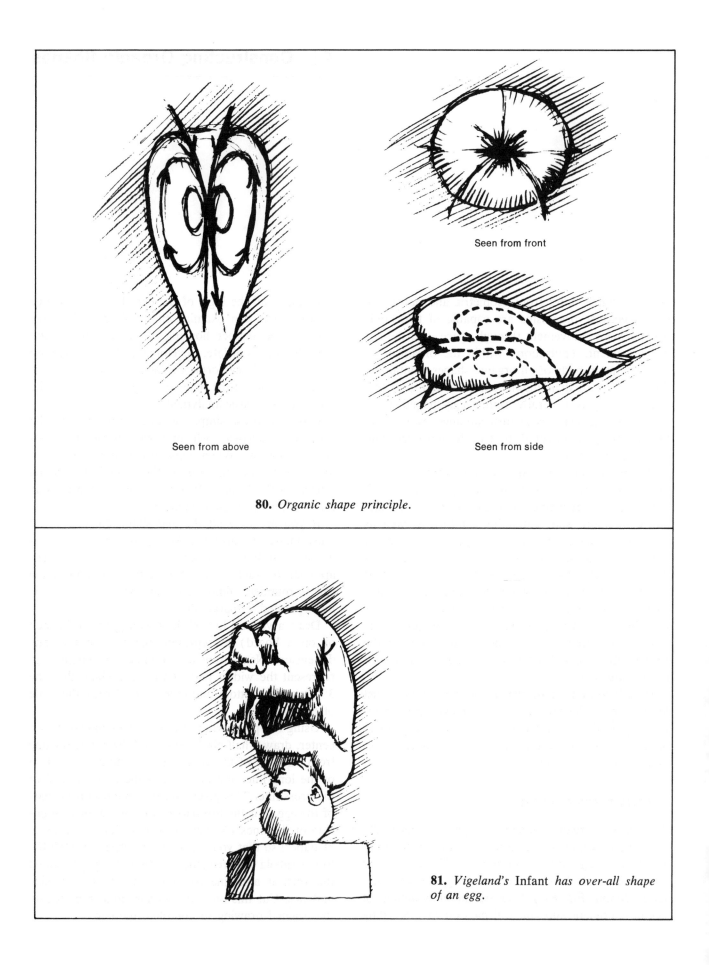

Seen from front

Seen from side

Seen from above

80. *Organic shape principle.*

81. *Vigeland's* Infant *has over-all shape of an egg.*

With these coordinate planes, you have the necessary planes to construct the egg shape.

The welding procedure (Fig. 82) is the same as it was for the globe. Use ¹⁄₁₆″ stock, 1″ wide, to make the first longitudinal egg shape in two halves. Tack them together and weld the seam. Make the equator by making two halves for a 6″ circle. Be sure to deduct 1″ from each half to allow for the thickness of the first coordinate. Then weld the circle on at the cross-line. The second longitudinal egg shape goes in at a 90° angle from the first coordinate. The third and fourth longitudinals follow in the same order as when you constructed the globe. From there you close up the form. The more careful you are in fitting, the less you will have to rework the form when it has been filled in. When all is filled in, the surface can be welded over and finished in the same manner as the globe. (See Fig. 83.)

☐ CONSTRUCTING A TREE FORM

You will notice that I have used the tree form as part of the mounting for the globe and the egg. This seemed a suitable way to demonstrate the tree form without going too deeply into plant forms, which are an involved and interesting study in their own right. But as the object of this book is to concentrate on the forms of the human figure and those abstract forms used in its construction, I will only briefly discuss branching forms and suggest that you use the principles I describe as a basis on which to investigate plants on your own.

In the basic form of the tree, and most plants, the trunk or main stem is the core and the vertical axis (Fig. 84, a-b). The entire system of branches comprises the upper form, which may be round, oval, fan-shaped, pointed, etc., depending on the type of tree. The widest point of this shape will be the cross-line or equator (Fig. 84, c-d) (not necessarily a circle). By approximating this equator shape, and then cutting it in halves at the widest point, you establish the coordinate planes for the form. From the over-all shape, you construct the individual branching forms.

Branching is a form common to plants, but also common to organic forms. The veins, arteries, and nerves of an organism all branch or divide from larger sources. But they reconnect within their own systems, so that they actually form a network. This is called anastomosis. Actually, the only genuine tree-like branching is done by the bronchial tubes within the lungs (an interesting fact, as both tree branch and bronchi are forms related to the air).

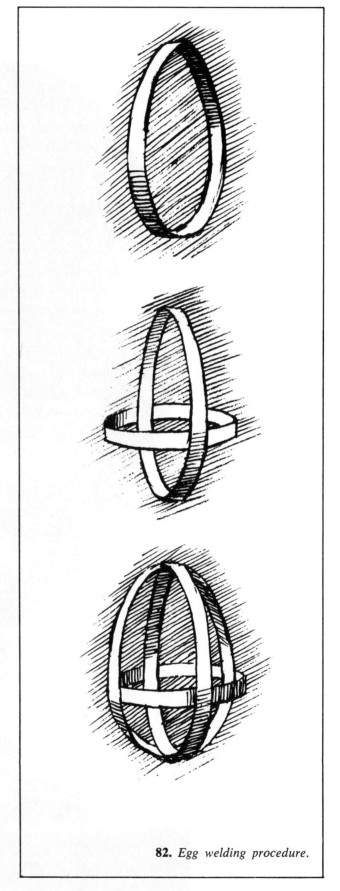

82. *Egg welding procedure.*

Branching in trees and plants is a process of segmentation in which one part of the plant matures and then sends out a new part. In organic forms, the spinal column is also an expression of segmentation, although the whole creature develops in one continuous process, rather than sending out arms and legs as shoots and segments after the spinal column has matured. But in trees, segments grow out from the trunk in succeedingly smaller branches; the root system grows in a similar pattern.

In certain trees like pine, aspen, hemlock, and firs, the trunk grows straight upward like the mast of a ship or a flagpole, and the smaller branches grow outward from all sides (see Fig. 85). Other trees, like the oak, elm, walnut, cedar, willow, apple, and maple, branch out from a shorter main trunk into secondary branching systems that make the typical tree form. There are many variations of this form, and there are many other forms which have not been mentioned. So I will not venture into a more elaborate description. Rather, I will explain a simple way to make tree forms.

Use several pieces of $\frac{1}{16}''$ stock, cut in strips of $\frac{1}{2}''$x 3''. Tack six or eight of these together, so that they make a trunklike form (Fig. 86a). Weld the seams and then add weld metal to the entire surface. This will be the trunk, which must now be shaped by tapering, gnarling, and bending. To taper the form, make four cuts with your torch from the top down to the middle, so that the piece is quartered (Fig. 86b). Hammer the metal inward, and reweld the seams (Fig. 86c). This will taper the trunk slightly, but it will still be rather stiff and straight. To make it curve, cut it entirely through the center (at a 20° angle) with the torch (Fig. 86d). Fit the two pieces together again so that the trunk will be curved; then reweld the seams (Fig. 86e). You can give the trunk a gnarled look by modeling on nobs and swirls with a torch (Fig. 86f).

The secondary branching system of segments is made with strips of $\frac{1}{16}''$ stock, $\frac{1}{2}''$x 2'' (Fig. 86g). Tack three or four of these together, and weld the seams. The form can be modeled and shaped by the same method you used for working the trunk. Make three of these segments of varying shapes, join them together, and attach them to the trunk (Fig. 86, h and i). Fuse rods around the joints where they are connected to the trunk. Try to give the branches a

83. *Egg sculpture—covered wtih fused rod, finished, mounted, and based.*

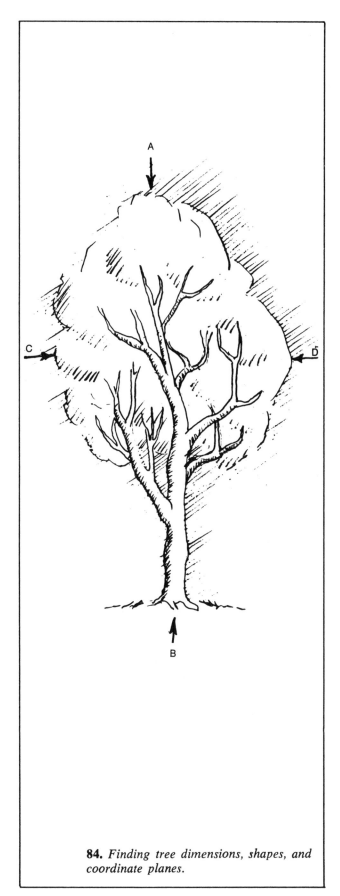

84. *Finding tree dimensions, shapes, and coordinate planes.*

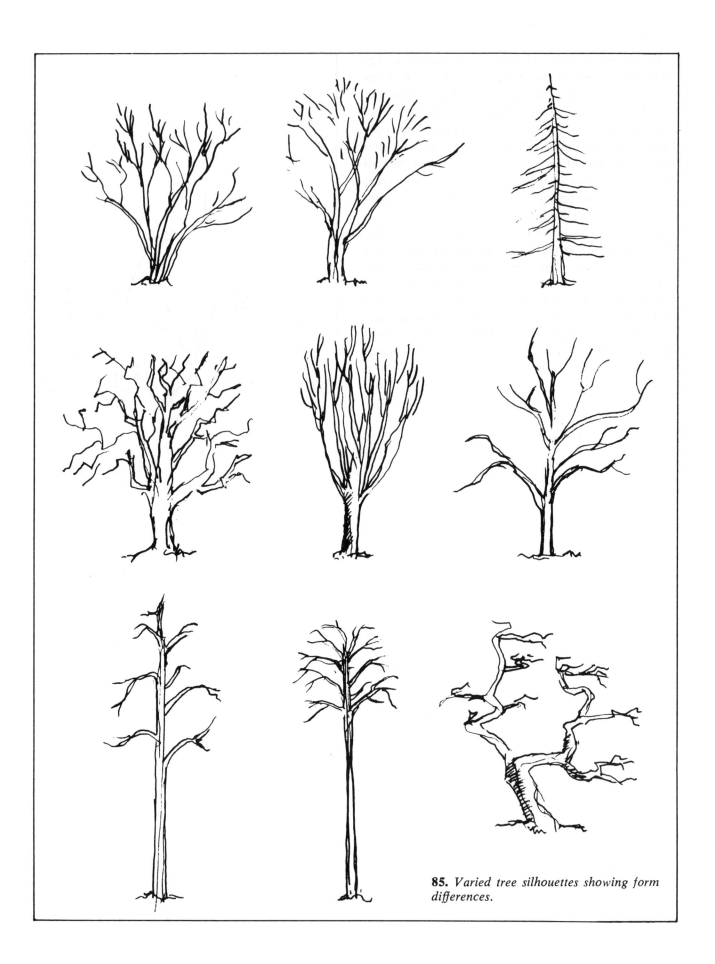

85. *Varied tree silhouettes showing form differences.*

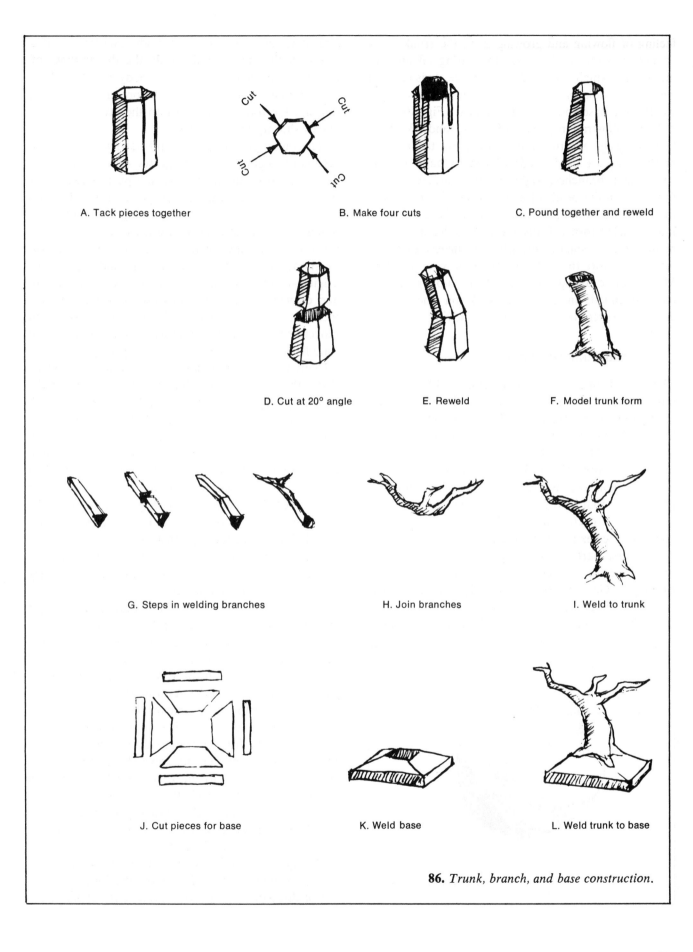

A. Tack pieces together

B. Make four cuts

C. Pound together and reweld

D. Cut at 20° angle

E. Reweld

F. Model trunk form

G. Steps in welding branches

H. Join branches

I. Weld to trunk

J. Cut pieces for base

K. Weld base

L. Weld trunk to base

86. *Trunk, branch, and base construction.*

feeling of flowing and growing from the trunk. Any change in form can be made by cutting off and re-mounting, which may add the more twisted and weathered look of reality. Now the trunk can be welded to a base and root forms added (Fig. 86, j-1).

In the illustration pieces, (Figs. 77 and 83) I attached the egg and the globe to their tree trunk bases at this stage. I used beads of rod to build up the subsequent branches, right on the surface of the forms. I ran the beads of metal in the direction I felt the branches would grow; then I built these beads up into modeled forms. From these, I modeled out segments of even smaller branches. I suggest that you make an effort to study the trees in your locality. Make some drawings of them. In the bibliography, I have included an excellent book on the artistic anatomy of trees that is well worth studying.

☐ CONSTRUCTING AN ONION

There are forms that resemble abstract life form almost perfectly, such as the kidney, heart, avocado seed, apple, pear, onion, etc. The shapes all show the life form's direction of growth, an entrance end, and an exit end. They all show the swelling, full shape of pulsation. From these shapes, I have chosen the onion for you to construct, as it is a rather common-place shape that is worth re-examining. You must get used to looking for the meaning that lies in all the commonplace expressions of nature.

The first part of the sculptor's job is always to analyze the form. Anatomize; look into the meaning of shapes. Go buy yourself two big, fat, juicy, Bermuda onions and cut one in half from top to bottom through the center (Fig. 87). There are three prin-

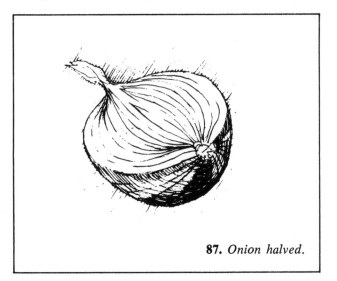

87. *Onion halved.*

cipal parts of an onion: root, body, and leaves. The onion, in the store, retains only the dry vestiges of the roots and leaves, while the body is full and intact. Perhaps you know that before the onion was dug up, the roots expanded into the ground and the leaves shot up green above.

The onion grows upward and downward from the seed-core beginning. As it grows upward, rings of flesh grow from the inner core and push outward. As they expand outward, new rings are formed which grow out from the core, thus forming the body of the onion. But they also draw inward again, closing off the form and allowing for the movement of growth to shoot upward to reach the air and light. This origin—from a small core of energy, swelling out and drawing in to shoot forward—is a basic move-ment of life. This basic swelling, pulsation, and movement forms a major expression you must try to establish when you construct all living shapes.

Using your cut onion and the whole one as models, draw the outline on a board or on your work-bench, giving it a 5″ diameter. Use strips of $\frac{1}{16}$″, $\frac{1}{2}$″ wide, for construction, and follow the same pro-cedure as for the globe or the egg (Fig. 88). With these strips, make two identical outlines of the onion and join them at a 90° angle (Fig. 88, a and b). The horizontal coordinate plane is almost perfectly round (Fig. 88c). The longitudinal shape should show the knob of the dried roots on the bottom and the sprig of dried leaves at the top. Just as before, make four additional longitudinal pieces (Fig. 88d). When the framework is complete, fill it in with fitted pieces; try to avoid any large, flat planes.

When the form is solid, the bottom root knob should be modeled so that it is raised slightly from the main body of the onion. The dried leaves at the other end can be modeled, using the same method you used for the tree form. But here you must follow the shapes of your model. You might let some of the shape taper into single thicknesses of metal, bent and textured to look like wisps of dried leaf.

To finish the form, weld metal over the surface to fill any depressions. Grind down the surface. Small roots can be added to the root knob by tacking on bits of $\frac{1}{16}$″ welding rod. Be sure to notice that the dried roots on your model show a pattern and direc-tion like an old man's beard. The leaves on top can be left textured. (See Fig. 89.)

Always try to visualize the inner core and axis of energy of living forms. This gives the form the feel-ing of direction and growth and a sense of its pulsa-

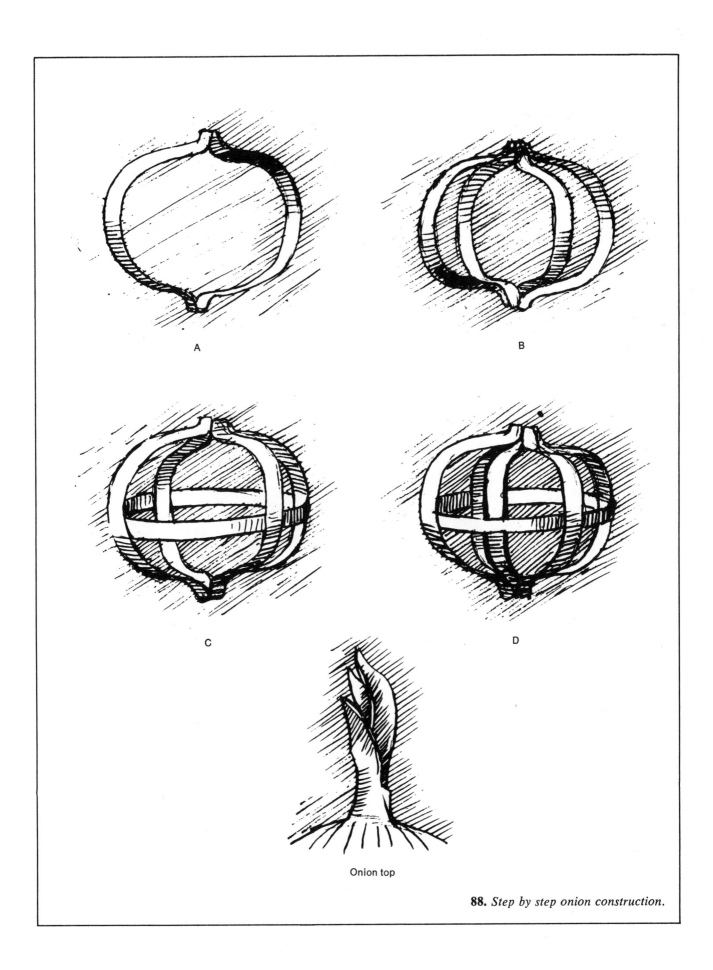

A

B

C

D

Onion top

88. *Step by step onion construction.*

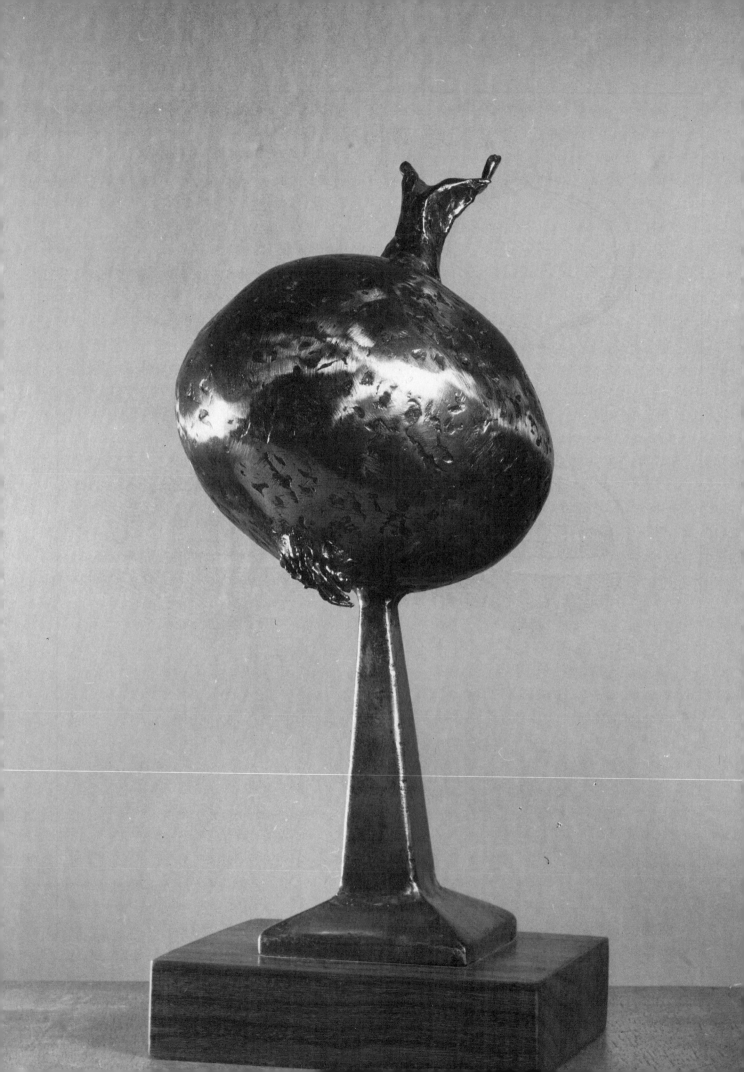

tion. It would be a good thing for you to find as many simple forms as you can which express the same movement as the onion. Construct some of them. Do an apple, a squash, and a beef heart. Dissect and analyze the shapes; when you do, you will begin to see and *feel* the logic of living forms.

□ CONSTRUCTING A CLAM

This form was chosen because it is deceptive. It seems to be a simple form, and for the organic world it is; but it is simple in a very profound way. Unless you see the inner logic of the shape, you cannot possibly duplicate the form. The clam shell is formed by the processes of the creature's internal organs and the shell is a reflection of the clam's organic movements and functions. What you see as the shell is the sum total of the clam's history and way of life.

So first I suggest that you go to the local fish market and buy a live clam to use as a model. If you are squeamish about having the live creature around, boil the clam, clean the shell, let it dry, and then glue it back together.

When you have the real thing before you, the complexity of this simple shape is evident (Fig. 90). I am sure you would have difficulty analyzing its shape unless you are a marine biologist or a professional clam-digger. Even if you are very familiar with these shell shapes, you do not often really examine them or try to understand them. The clam shape consists of two equal, or nearly equal, sides. This is called bilateral symmetry; many organisms, including human beings, are constructed in this meaningful two sided pattern.

Although most people would sense no kinship with the clam, you can understand the clam's shape by comparing its anatomy with your own. Scientifically, this is called comparative anatomy, but artists often use their own body and its functions as the instinctive measuring stick for other forms of nature.

The clam shell resembles our anatomy in several ways. The part where the two shell halves join and are hinged is functionally similar to our spine. At one end of this hinge is the head, and at the other end, the tail. When the clam opens its shell, it can extend a siphon from the "head" end for filtering water; at the other end of the open shell, it can extend a "foot" for locomotion.

89. *Onion—finished, mounted, and based.*

If you look at the spine area, you will see the growth lines radiating upward and outward, on both shell halves, toward the head end. These lines seem to swirl from the head, down the front of the clam, and back to the bottom of the hinge. At the lower end of the hinge, the forms swirl around both sides so that they resemble human buttocks, below which is a small heart shaped form. If you hold a clam so that the spine is vertical and you are looking at the back, the whole form very much resembles the rear view of the earliest known sculpture made by man, the *Willendorf Venus* (a prehistoric carving of a bounteously formed female, Fig. 91). Once you have seen this resemblance, you will never again be able to think of a clam as lacking personality.

As you may know, a clam shell grows as the organism adds a secreted substance to the inner surface of both shell halves to enlarge the shell. You can actually see the growth rings on each side of the shell (Fig. 92). By following these rings back to the "buttocks" of the Venus, you can see the outline of the tiny clam that once existed before the growth rings were added. Before you begin the construction of this form, you should carefully examine your model, and try to grasp the basic form as well as the direction of growth.

As you can see by observing the growth lines, the clam's structure is the same whether the clam is large or tiny. The only change that seems to occur is enlargement; remember this when you are laying out the shape for construction. It means that you can enlarge the shape easily, once you have understood the basic coordinate planes.

To lay out the profile of the clam, you use four measurements (Fig. 93). The first is the line of the back, a slight curve, although it is the straightest line of the profile (Fig. 93, a-b). This line goes from the apex of the buttocks to the point at the head (a) where the form breaks and turns toward the front. The second line is the short one from the apex of the buttocks to the point of the small heart shaped form that meets the front curve (Fig. 93, b-c); this is a short, concave line. The third line is the sweeping front curve of the shell (Fig. 93, c-a). This is a somewhat crescent shaped curve. These three lines can be used to construct the profile, if you use the center line of growth (the fourth line, Fig. 93, c-d) for reference. This fourth measurement line is a curve that starts at the apex and goes toward the front of the shell along the widest part of the clam. Using these lines, lay out the profile so that the

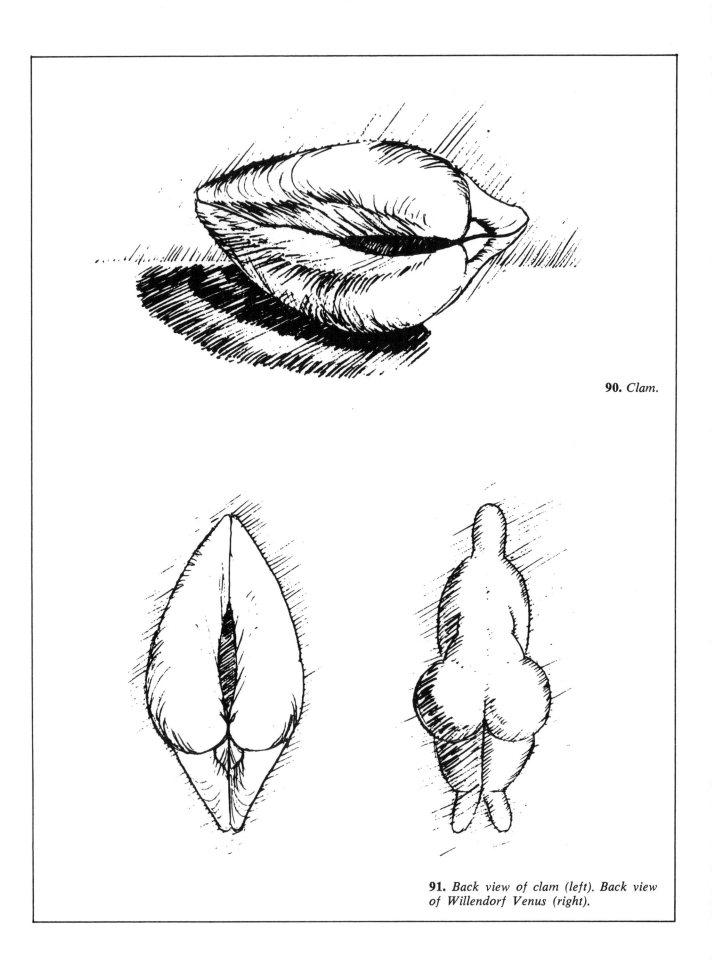

90. *Clam.*

91. *Back view of clam (left). Back view of Willendorf Venus (right).*

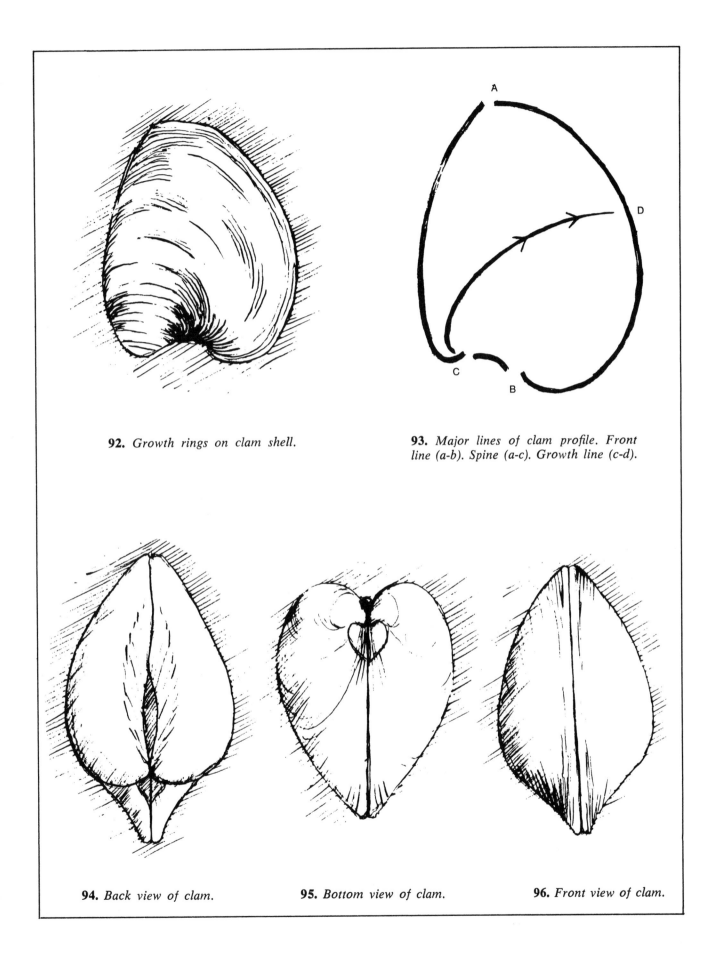

92. *Growth rings on clam shell.*

93. *Major lines of clam profile. Front line (a-b). Spine (a-c). Growth line (c-d).*

94. *Back view of clam.* **95.** *Bottom view of clam.* **96.** *Front view of clam.*

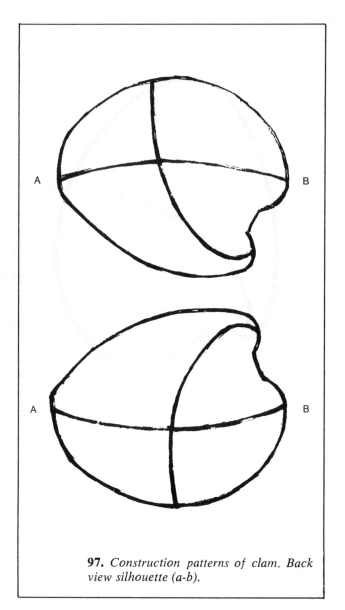

97. *Construction patterns of clam. Back view silhouette (a-b).*

Using strips of $\frac{1}{16}''$ stock, $\frac{1}{4}''$ wide, make the profile shape (Fig. 93, a-b, c-a) according to your pattern. Bend two pieces of $\frac{1}{8}''$ welding rod in the shape of the line of growth (Fig. 93, c-d) and tack these in place on each side of the profile. Make sure that each of these lines curves inward and meets at the apex of the spine (Fig. 93c). Make a two piece pattern of the back view silhouette (Fig. 94) and tack these patterns on each side of the profile piece (Fig. 97, a-b). Do the same for the bottom view silhouette (Fig. 95), and for the front view (Fig. 96). You will have to cut these pieces and fit them, when they intersect with one another.

When the framework has been constructed, fill in the open areas with pieces of $\frac{1}{16}''$ stock, cut to size and hammered into the proper curve. Observe your model carefully, and correct any errors in the construction. Note the ridge of the spine, and how the form breaks on either side of it. On the bottom side, work in the little heart shaped form beneath the buttocks shape. You may have to cut out the metal here and set it in a bit to get the proper inset. Make two parallel beads along the front, running from the head down to the little heart shape. This will define the right and left sides of the shell. All these forms should be blended in with the torch so that they all seem part of the same organism.

You may feel like throwing up your hands in despair over this form, but you can look on this as a turning point. If you can do this shape well and really understand it, you will have developed enough skill to reconstruct almost any organic form. I suggest that you make clams until you can do the form with ease. When you have done a good one, surface it with welding rod, grind it down, sand it, and buff it. You will be amazed to find that this shape has a life-like quality to it, a mystery and a vitality that has much more feeling than the other shapes you have done. (See Fig. 98.)

☐ **FISH FORM**

The fish form is a shape midway between egg and man. This shape has the simplicity of the other organic forms that you have done, yet it also has all the essential qualities of the forms of the higher vertebrates: the three interlocked segments of head, body, and tail. The fins are similar to arms and legs.

longest line (head to foot, a-b) measures 8", the length of the back measures 6½", the apex to foot measures 2¼", and the growth line measures 6".

In order to construct the form in three dimensions, you will also need the outline shape of the back view (Fig. 94), the bottom view (Fig. 95), and the front view (Fig. 96). Lay these out in pencil, with an axis line down the center to divide each half of the shell. The back view resembles a long valentine heart. The bottom view is also valentine shaped, with a little heart within the larger. The front view is a compound of a heart shape, with its point at the head end, and two concave lines that start at the widest part and converge in a point at the foot. Draw all of these shapes in the same scale so that they fit within the profile pattern.

98. *Clam—finished, mounted, and on base.*

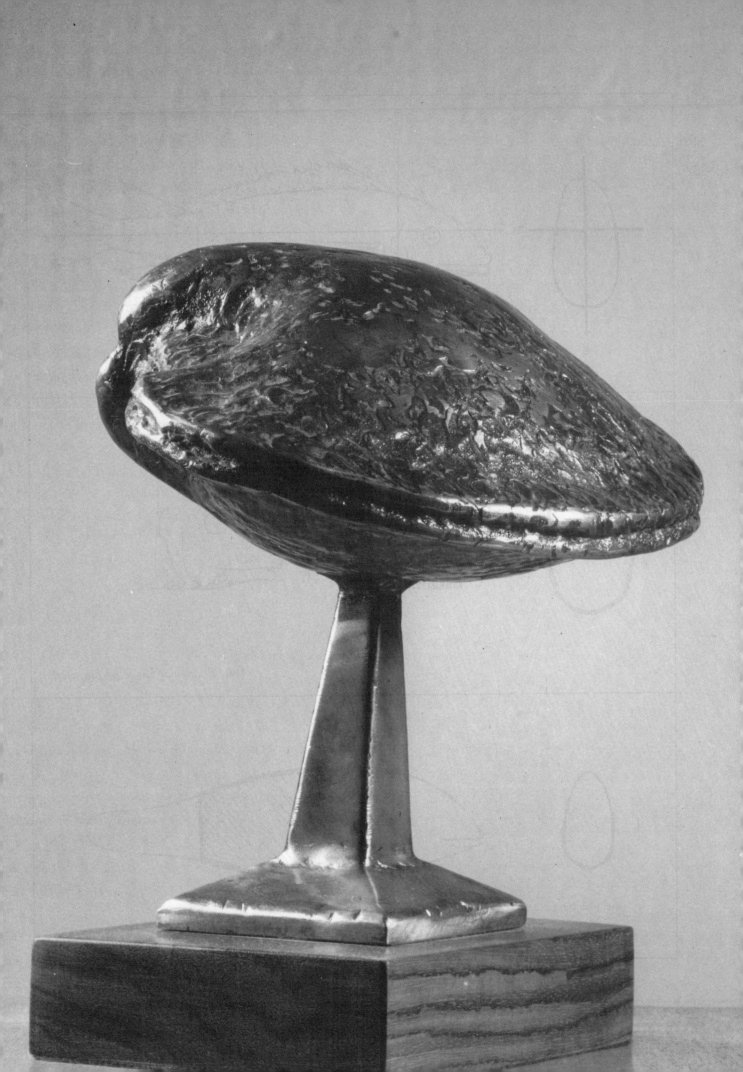

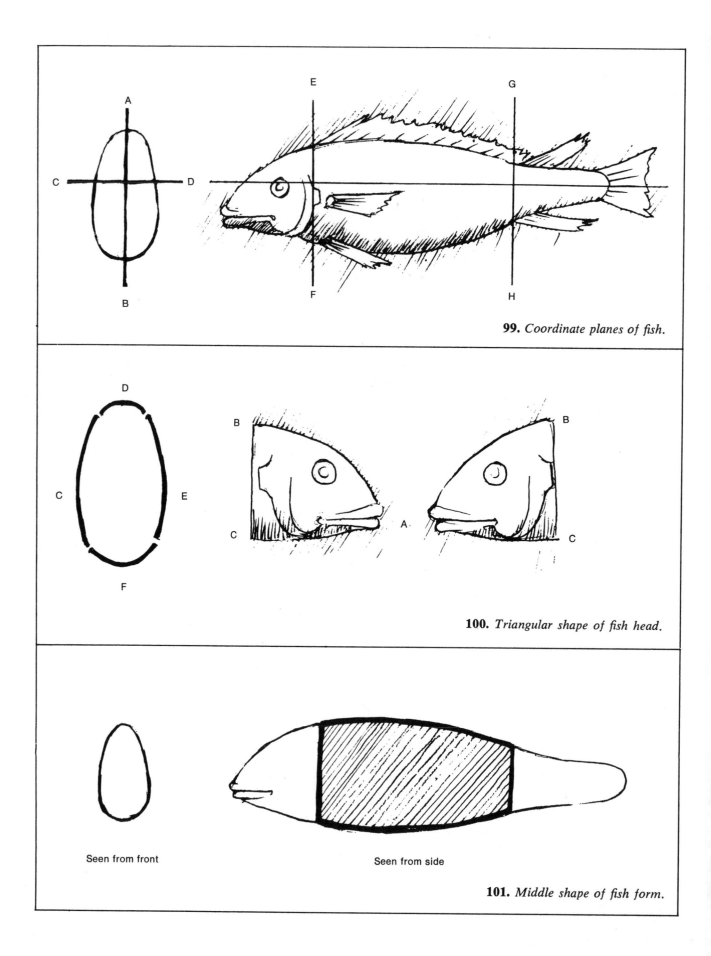

99. *Coordinate planes of fish.*

100. *Triangular shape of fish head.*

Seen from front

Seen from side

101. *Middle shape of fish form.*

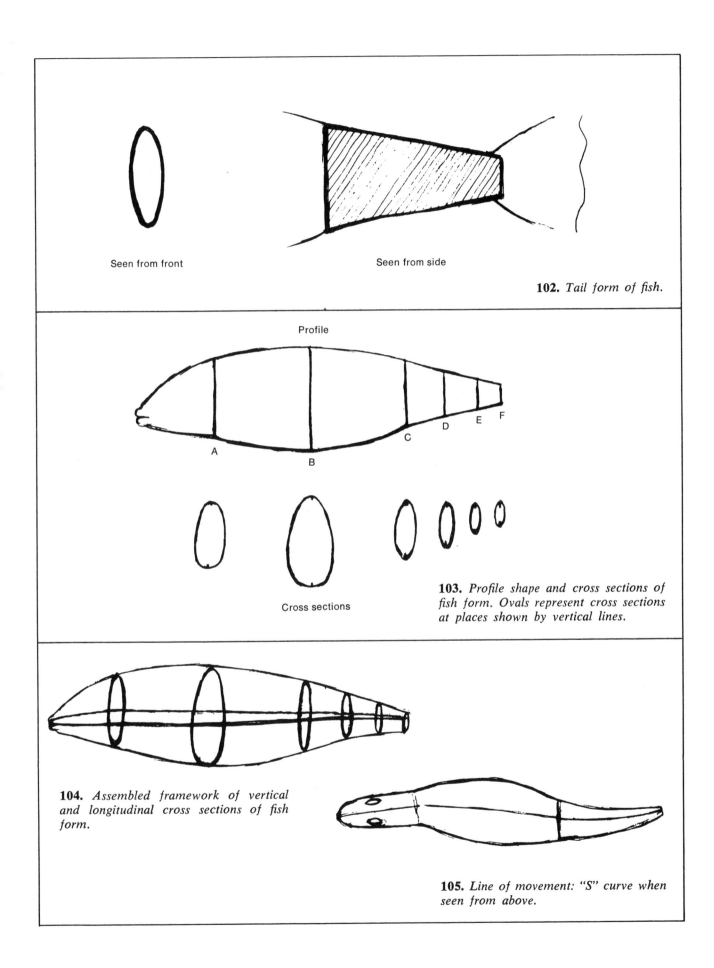

Seen from front

Seen from side

102. *Tail form of fish.*

Profile

A B C D E F

Cross sections

103. *Profile shape and cross sections of fish form. Ovals represent cross sections at places shown by vertical lines.*

104. *Assembled framework of vertical and longitudinal cross sections of fish form.*

105. *Line of movement: "S" curve when seen from above.*

In all, the fish form has a structure similar to the human figure.

To analyze this form, you must start from the basic organic elements, as you did with the clam. There are three large masses: the head, body, and tail; these are all built on the axis of the fish's spinal column. The spine extends from the back of the head to the tip of the tail.

Imagine the fish swimming towards you; holding a knife point upwards, slice the fish in equal halfs from nose to tail. This cut is the first coordinate plane (Fig. 99a-b). Now imagine the fish again swimming towards you and that you are holding a knife parallel to the ground; slice the fish from nose to tail once again at a 90° angle to the first cut. This cut is the second coordinate plane (c-d). Finally, if you imagine cutting off the fish's head—making a straight cut that severs his head from his body—this cut is the third coordinate plane (e-f). And for the sake of easy construction, you can make a fourth imaginary cut dividing the tail from the body, at the anus. This is the fourth coordinate plane (g-h).

One of the reasons that the fish is a higher form of organic life than the clam is that it has these more detailed built-in coordinate planes. These allow the fish to function with a sense of space that an organism like the clam does not have.

A fish head is a mass of bones and cartilage. It is joined directly to the body and the spinal column without a neck. The head (Fig. 100) is the first of the three major masses and is generally triangular in profile, but it varies a lot among different species. The lips of the mouth are generally the front point of the triangle (but there are exceptions like the shark and sturgeon). From the front point (Fig. 100a), one line runs upward to the back of the head (Fig. 100b); the other slopes downward and back to the gills (Fig. 100c). The line of the gills (Fig. 100, c-b) closes the triangle. None of these lines is straight, however, and the triangular shape is only an approximation. The head mass is generally one fourth of the body length, excluding the tail fin. As you face the fish, nose to nose, the top of its head is oval (Fig. 100d). The two triangular sides of the head are a curve that slopes from side to side (Fig. 100e); the underjaw is generally a flatter curve (Fig. 100f).

The middle mass of the fish (Fig. 101) contains all its vital organs. This is a swelling oval shape, extending from the head to the tail. From the muscles of the spinal area, the form swells out and becomes quite rounded on the under side. A cross sec-tion of this mass would be egg shaped; the rounder end of the egg is on the bottom.

The tail portion consists of powerful muscles which generate the side-to-side movement of the fish's tail (Fig. 102). This mass tapers down from the center mass toward the tail fin. It does not always end in a point as a triangular shape, but in some cases this mass is shaped more like a quadrilateral, when seen from the side. In cross section the form is a flattened elipse.

All these masses vary with different types of fish. As a matter of fact, fish forms are some of the most strangely variable in the vertebrate world. There are some extremely odd forms among the fish. In comparative anatomy, one learns a great deal about creativity in nature and the extremes to which it may sometimes go. I believe that the artist should understand the consequences that arise when certain boundaries of form are crossed. To illustrate, I quote the biologist, Herman Popplebaum, from his *A New Biology* (Rudolph Steiner Press):

From all this it appears that Nature has bestowed on birds strange features indeed, but has remained amiable and playful even in extreme cases. She has not always, it is true, kept within the limits of good taste, as the lemon-yellow wattle dangling from the neck of the Maribu stork proves. But she has never stooped to corruption. The metamorphic antics of the fish-forms, however, lack all reserve and moderation. They point to a spastic search for originality which leads into bottomless malice, into an embarrassing silliness in which there is nothing comic left. Here we look into a realm of uncanny possibilities, among which the basic pattern is ruthlessly tossed about and forced into painful distortions from which there is no way back into balance, sobriety, and decency.

But the basic fish form in its purest expression provides a basic pattern for all higher vertebrates. I used a black sea bass as a model for the illustration piece. I suggest that you buy one from your local fish store to use as a model. Work rapidly, and complete the framework on the first day. When you are finished, wrap the fish in wax paper and freeze it, and you will be able to use it for subsequent sittings.

Draw the profile shape (excluding fins), enlarging it to about a foot in length (Fig. 103). Make sure to define the three masses. Next draw the cross sections, one at the junction of the head and body (Fig. 103a), one at the center of the belly (Fig. 103b),

one at the line of the anus (Fig. 103c), and three that show the form of the tail (Fig. 103d, e, and f). Using ⅛″ welding rod, make the profile shape without the fins. When that is completed, make the cross section pieces (Fig. 103, a through e) and tack them in place. They will all have to be made in two pieces, one for each side of the cross section. Using pieces of rod that you fit to the curve of the center mass, connect the cross sections together on each side of the form. I suggest that you tack on these connecting pieces so that they are level with the spinal column, on each side of the form. With the addition of these connecting pieces, you can begin to see the body form (Fig. 104).

I suggest that you give the body some movement by bending the head slightly toward the left and the tail slightly toward the right. This will give the body an S-curve, side-to-side swimming movement (Fig. 105).

With this framework it should be quite easy to fill in the mass with curved pieces of 1/16″ stock cut to size. The simplest mass is the tail form, which is all muscle and bone. This portion should be given a taut, firm look to show the power of the muscles in this area. The center mass, the area containing the vital organs, should be given a rounded, full quality. The head is somewhat more complicated.

The head should be constructed first as a featureless shape that extends from nose to gills (Fig. 106). When this shape is filled in, locate the line of the mouth and make two light beads, one for the upper and one for the lower lip. Make sure that the lips are the same height on each side of the head and that they extend back to the same point on each side. Next locate the eye centers on each side and build up two circular forms to represent the eyes. The lower lip and the forms of the jaw and gills are all interwoven shapes that you must study on the model.

Examine your model closely and locate the gill line at the back of the head. Run a bead—on each side of the head—that follows this gill line. This bead should be built up by making a second pass with the rod over the line. Then blend in this raised bead on the head side, leaving a pronounced line on the body side. The lower part of the gill connects into the lower jaw, which can be done by modeling the two together with a bead of metal. By adding metal and blending it in properly, you can accentuate any of the features.

The fins are made with 1/16″ stock. Each fin is cut to its size and shape before it is welded to the body

106. *Details of head.*

form (refer again to Fig. 99). Follow the pattern of the fish's fins, but before you weld them on, go over their surface with the welding flame to give them some texture on both sides. Weld on the tail fin first and give it a direction that continues the body movement. Next, weld the dorsal fin along the back, followed by the two fins in front of the tail. Finally, add the two side fins in back of the gills and the two that fit underneath behind the lower jaw.

For display, the fish should be suspended by light wires (in which case you can make several fish and have a school of them), or it can be attached to a coral-like form and put on a base, as was the illustration piece (Fig. 107). But if you do base it, be sure you attach it in a lively, swimming angle, or it

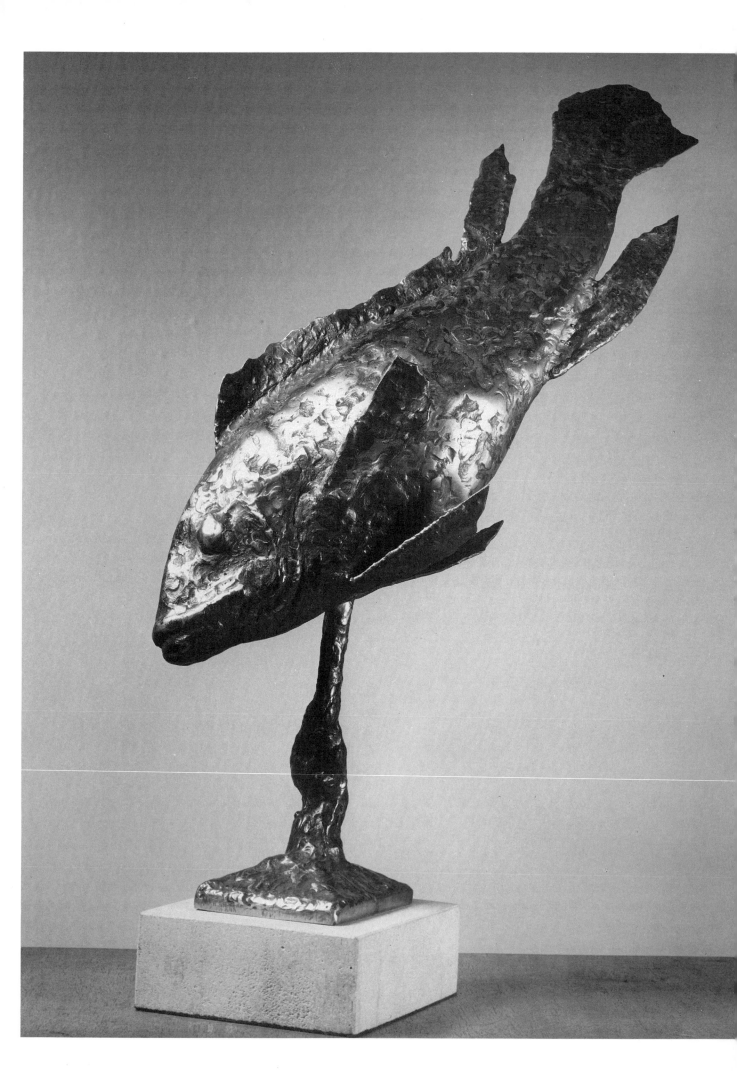

will look like a stuffed trophy. Some of the surface can be ground down, but actually, the weld ripples give the effect of scales if they are lightly sanded and buffed.

☐ A FINAL NOTE ON THE PITFALLS OF GEOMETRY

By now, you should have some sense of the difference between geometrical shapes (Fig. 108) and the organic shapes of living things. Because you have made some of these shapes, you can begin to understand that organic shapes follow the laws of living energy and are expressions of life functions. This does not mean that you have had enough experience to understand the whole complicated picture, but it does mean that you have made a start. If you work to learn the facts about shapes and then construct these shapes, you will gain insight into the processes of growth and form, as your experience grows. You have probably seen academic public sculpture that seems to have all the shapes right, but lacks life and vitality. This emptiness occurs when the sculptor has no deep understanding of organic form. Such sculptors, underneath it all, may rather dislike life's expressions. Sculptors like this generally make "high-minded, idealized, or classical" forms rather than forms with any human warmth. Of course, this type of artist may have a great deal of technical skill, making it almost impossible to detect what is wrong with the work. This is true with much of the academic work used for political and military ends.

But you will learn to know what is wrong with this type of art if you will examine it from the point of view of your tenderest feelings. You may find that it really repels you and does not warm you. A good understanding of organic form, its pulsating meanings and purposes, will, I hope, save you from these academic vanities.

There is, of course, another kind of artistic vanity, equal (though opposite) to that of the scowling general on horseback. This is the "abstract" artist who has no understanding of what abstract reasoning is. He will claim his work is "abstract" or "organic" because it is constructed of amorphous shapes. There are all sorts of tricks that this rascal can play, including surrounding whatever he does in a fog of words and "theory." Such fakers have an unfortunate appeal for people because they generally claim to be *new, revolutionary, avant garde,* and *misunder-*

107. *Fish mounted on base at lively, swimming angle.*

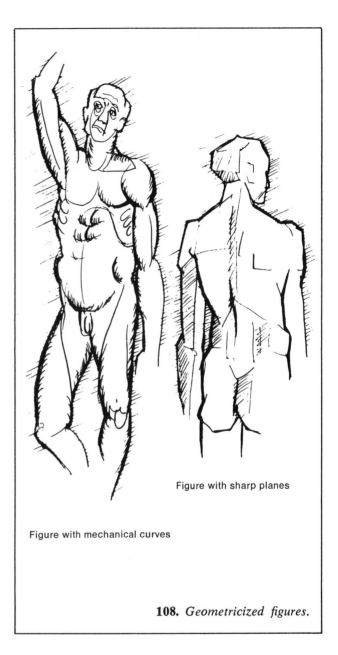

Figure with sharp planes

Figure with mechanical curves

108. *Geometricized figures.*

stood. This would be no problem if it did not make things doubly difficult for the genuine innovator. There is little difference between the art which uses empty realism and the art that uses meaningless abstraction; both are misleading. They are both guilty of the same artistic sin: infidelity to nature's forms.

To repeat, it is the harmony of living functions that makes for the balance called life. The dynamics of the functions of life must be felt in all of the artist's being: his hands, eyes, heart, gut, genitals, and brain. In other words, the artist should be able to understand and value the meaning within himself: since this is the basis for his understanding of nature outside his own body.

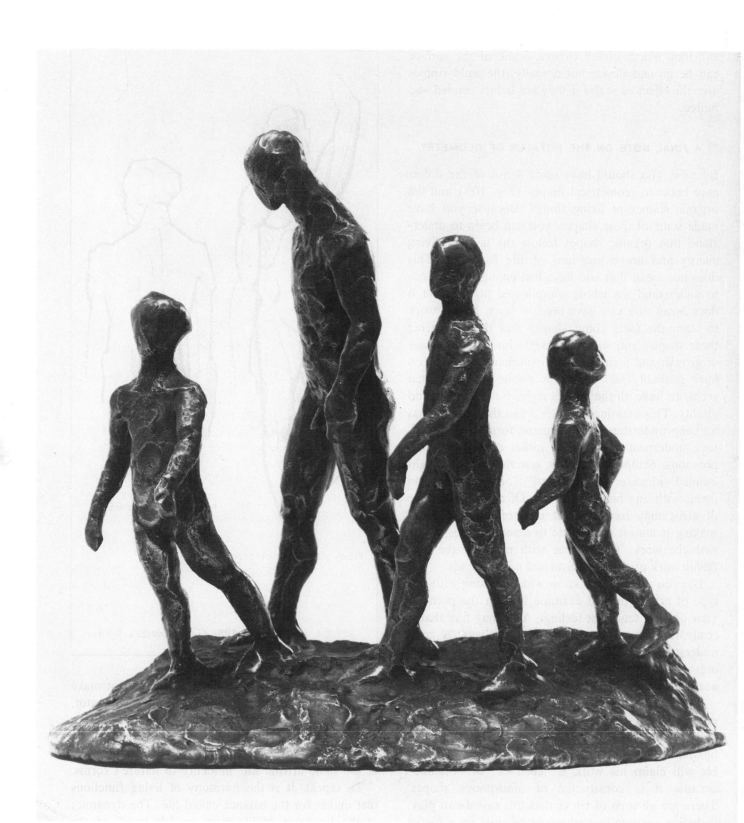

Strollers, *manganese bronze, 8" x 7", private collection. This is an extremely simple composition, based on the repetition of the arm and leg movements of walking. The sense of movement can be strong even if both feet of a figure are welded to the base. In this case, only the last figure has one of its feet off the ground.*

You have now constructed some of the basic shapes found in nature and learned the methods of constructing hollow forms. It follows that you should apply this knowledge to the construction of the human figure and solid forms. In sculpture, it is always good to limit projects to a scale that can be easily handled at first, rather than starting large works with no preparation. Use a size that you can "think" in or readily alter, a size in which you can work out your larger compositions.

The small study is the thinking tool of the sculptor in the same way that a drawing functions for the painter. All large works by professional sculptors— Rodin's *Burghers of Calais,* Vigeland's great monolith, or the huge stone carvings of the Nile Valley— were done originally as small studies. When you can handle the small scale expertly, you may then do larger works with ease.

Over a period of years, I have developed a method of modeling small solid figures in bronze or nickel silver with the welding torch. This technique can be used to make small finished works, studies for larger works, or architectural commissions; or it can be used to model details on larger welded works. This is the method you will learn in this chapter.

The figure described in this chapter requires only an elementary knowledge of anatomy which you can get by studying books such as *Drawing Lessons from the Great Masters* by Robert B. Hale.

□ TOOLS

You will require a supply of manganese bronze or nickel silver welding rod (⅛″ diameter). Ten pounds will be more than sufficient for one figure, and will give you enough material for a few experiments. A small cast iron turntable—the kind potters use—will be your work surface. I use a piece of steel on top of this, 4″ x 12″ and about ¼″ thick. This keeps enough of the heat away from the turntable to prevent the lubricating oil from burning. The turntable allows you to reach the piece quickly from any angle.

You will need brazing flux, two plumber's gas pliers, electrician's pliers, long nose pliers, a lighter, and a hand shear (or hammer and cold chisel) to cut the rod. Use your gloves and goggles at all times. And of course you will need your cylinders, regulators, hose, and torch. You will need welding tips Nos. 2, 3, and 4 for this procedure.

You can do most of the work while you sit at your welding table. But as you will have to concentrate for long periods, make sure that your chair is at the proper height so that you work with minimum strain. You will often find that you have to work on a figure for two hours of direct concentration, without stopping. So see that your working conditions keep you as comfortable as possible.

□ ARMATURE

The first step is to construct the armature (Fig. 109). Make the armature from the welding rod of the same material you chose for the finished figure (manganese bronze or nickel silver) and use this material consistently throughout. Bend the rod into a U shape, 6½″ high and 1½″ wide. Bend the rod and shape it with electrician's pliers, which you can also use for cutting. On the turntable, place the U and adjust it so that it lies perfectly flat. Then make the insides of the legs, shaped like an inverted V inside the inverted U. The inside line of each leg is made with a piece of rod, 4″ long. Tack the first inside leg piece to the left foot of the U; adjust the piece so that the upper end is on the center line. Then tack

109. *Standard armature for adult male.*

the other inside leg piece at the crotch, and again at the remaining foot of the U. This makes a standard armature for the adult male figure.

☐ MEN, WOMEN, AND CHILDREN

When completed, the adult male figure measures about 8″ high. This is about the maximum practical size for the solid welded figure; weight and welding problems multiply with large, solid masses. For larger works, it is more practical to use the technique for welding hollow forms. I have taken the 8″ armature size from my own pattern armature, based on a number of years of experimentation. On this same armature, I have notches which indicate the height of female figures, adolescents, small children, and infants. The scale chart (Fig. 110) shows these size relationships.

The female figure armature is slightly smaller—6″ high and 1¼″ wide—but this can vary, just as it does in life. If I want to make a short, squat male or female figure, I determine its size by relating it to the basic adult male armature. The accompanying chart shows the armature sizes I have developed from my study of anatomy, but this chart is not absolute; you may wish to change some of these relationships after you have studied anatomy and growth patterns yourself. Artists like Rodin, Michelangelo, and Leonardo spent their lives studying the figure anatomically, and your own work can only advance with the amount of time you give this study. As this chapter goes along, I use some anatomical terms (with diagrams) to help you become familiar with them and the shapes they represent.

☐ FILLING IN THE VOLUME

Place the armature flat on the work surface, and fill the inside part with pieces of rod cut to about 1″ (Fig. 111). I use small shears for cutting the rod, but a cold chisel or a large wire cutter will also work. I also use a small tin can to collect the pieces as they fall; this saves stooping and hunting for the pieces. If I intend to do a *group* of figures, I will cut enough pieces of rod to fill the can; but for one figure, you will require the cuttings of only two rods. Pieces of scrap will not do, as scrap often does not have the same metallic composition as the rod, which has a different melting point. Your object is to make a homogeneous mass when the rods are fused. So when you have placed one layer of rods evenly in the

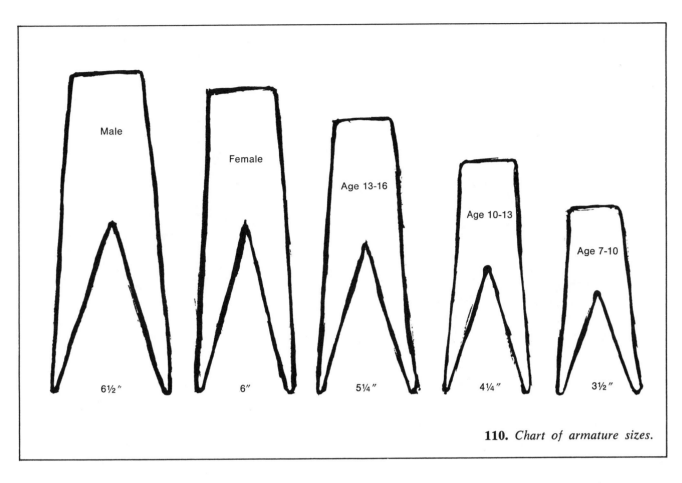

Male

Female

Age 13-16

Age 10-13

Age 7-10

6½″ 6″ 5¼″ 4¼″ 3½″

110. *Chart of armature sizes.*

armature, place another layer on top of the first. Now you are ready to fuse this mass into one solid piece.

Using a No. 2 tip, set your regulators to the recommended setting. Light the torch and adjust to the neutral flame, and then add just a bit more oxygen. Take a stick of welding rod in your left hand; flux it to be ready to add to the pool. The object is to fuse the metal and to retain the shape of the armature. Start at the foot nearest your left hand; run the pool up to the hip bone, or greater trochanter. You can control the shape by adding the filler rod at the times when the bits of metal draw up and leave an open space.

When the metal becomes too hot, the shape disintegrates and gets out of control; raise the torch off the work for a moment or two until you see the heat diminish. By adding metal from the filler rod, or by retracting the torch at the right time, you gain modeling control. Watch the color of the metal and its consistency. Do not be discouraged if you are not able to control the metal and you burn through the armature. You will have to make some of these mistakes or you will never have the basis for under-

standing what welding is all about. You have to see burn-throughs or overheating in order to know what they look like. When they occur, just stop and set things up again.

When the two legs are filled in, go on to fill in the torso (Fig. 112), making sure that you are fusing the metal and not just lapping it on. When one side is done, turn the piece over and fuse the other side, again starting with the leg on your left. You will find the second side a little easier because the other side has been fused.

The thing to look out for now will be overheating. When this happens, the form collapses. You will be able to anticipate this by watching that the metal does not reach an incandescent orange-red. But if it does happen, remove the flame until the metal looks silvery again.

The worst thing to do is to go on welding and adding metal to the hole. This causes an unwanted blob of metal to form on the other side of the hole. If you wait for cooling and then patch with filler rod, you can go on to finish the fusing with no more difficulty. Then go over both sides to smooth over any burn-through lumps or other imperfections. The

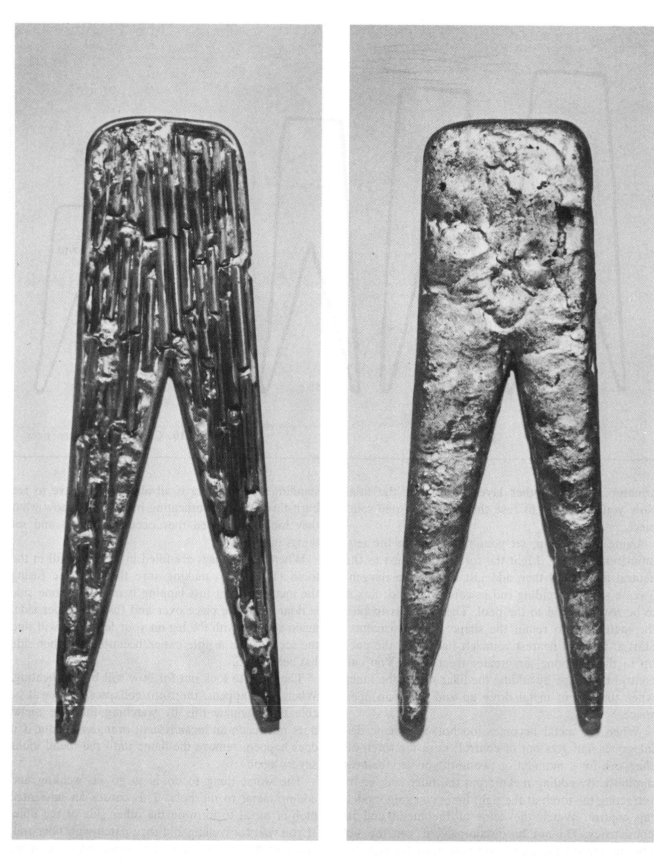

111. *Armature filled in with pieces of rod.*

112. *Armature filled in and fused.*

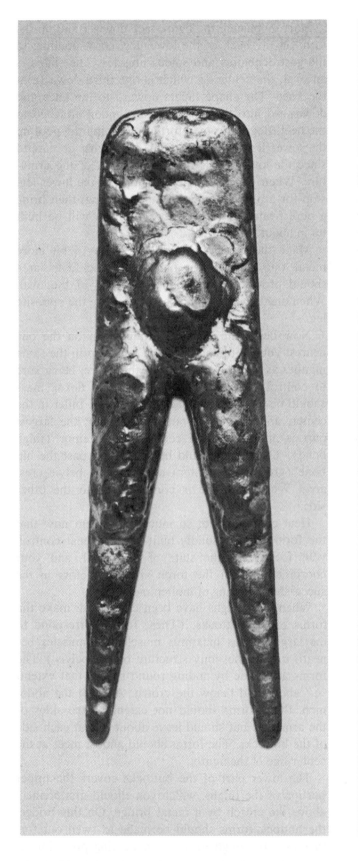

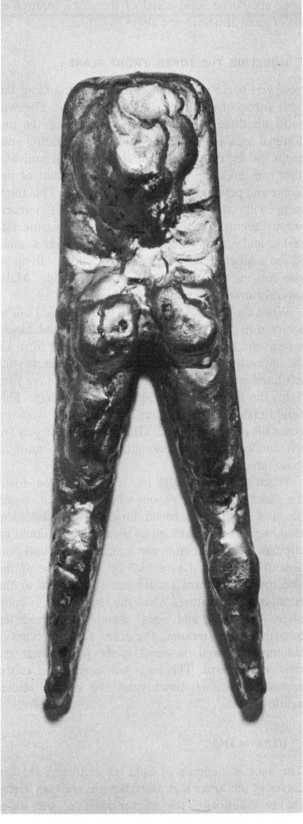

113. *Adding front plane forms: two thighs and abdomen.*

114. *Adding back plane forms: calves, flexors of thighs, buttocks, spinal erector mass, rib cage.*

piece should be solid metal of the same contour as the original armature and about ¼″ thick.

☐ MODELING THE TORSO: FRONT PLANE

Now you begin to build up the figure by adding the basic forms of the front plane of the body. You will build up three forms: the two thighs and the abdominal area (Fig. 113). With the figure facing you, begin the leg on your left at the mid-point and add filler rod; build up the form toward the joint of the femur and pelvis (where thigh meets hip). This thigh form will correspond to the quadriceps femoris group: rectus femoris; vastus medialis, vastus lateralis, and vastus intermedius; sartorius; and some of the adductor mass. Try not to build it all up in one run, or the pool will run over the side. Make several runs to build up the form.

When the form of one leg has been rounded out to a nice, full oval that swells at the center and tapers toward the knee and pelvis, begin the same form on the opposite leg. You begin with the leg nearest your left hand because, if you began with the leg on your right, the flame would tend to heat both legs. This would make the leg on your left too hot to work on when the other is finished. (But, of course, if you are left handed, you will automatically reverse most of these directions.)

When the second thigh has been completed, focus the flame on the torso about where the navel should be, and build up a round form for the abdomen. Build up this form as high as the thighs. It should be circular and reach from the crotch to the mid-portion of the torso. Leave ¼″ on either side of the abdomen. The form should not spread out to the edges of the armature. When the round form is complete, you may add some metal up toward the breastbone or sternum; the form then becomes a sloping oval from the navel to the place where the ribs arch upward. This form will correspond to the rectus abdominus muscle and the organs underneath.

☐ BACK PLANE

The back is made up of eight major forms: the two calves of the lower legs, the flexors of the two thighs, the two buttocks, the erector mass of the lower spine, and the rib cage (Fig. 114). Later you will refine all these masses into smaller units, but begin with these eight.

Start by placing the figure face down. Build up the form on the back of the lower leg, corresponding to the gastrocnemius and soleus muscles. The shape is an oval, the center of which is one third down from the knee. The shape tapers upward to the knee and downward into the long Achilles tendon attached to the heel. Begin this oval form by running the pool up the lower leg to its mid-point. You must be careful since the lower leg is the thinnest part of the armature. When you reach the mid-point of the lower leg, stop for a moment and allow for cooling; then bring a pool from the knee down. The form will be built up in about four runs.

Make the muscle body by depositing a bit more metal one third down from the knee. This area should protrude more than either end of the oval. When one lower leg is finished, complete the opposite leg.

Now begin the thighs, starting again on the one nearest your left hand. Run the metal up in the same manner as you did the front of the figure, being sure to control run-offs. The shape of the flexor mass should be flatter at the back of the knee, fuller in the center, and should fill out into the hip; the largest part is an oval at the center of the femur (thigh bone). The shape should be carried up past the hip bone (greater trochanter) and onto the pelvic crest area. When one side is complete, go to the other side.

Heat control is not so much a problem now that the form is more solidly built up. But heat control, your feeling for the state of the metal, and your coordination with the torch are key factors in the successful modeling of molten metal.

When both thighs have been completed, make the forms of the buttocks. (These forms correspond to the large gluteus maximus muscle, the muscles beneath it, and the bony structure of the pelvis.) The forms are made by adding round shapes that extend ½″ above and below the crotch. As with the abdomen, these forms should not extend to the sides of the armature but should leave about ¼″ at each side of the buttocks. The forms should almost meet at the center line of the figure.

The lower part of the buttocks covers the upper portion of the thighs, which you should first connect above the crotch by a metal bridge. On this bridge, the buttock forms should be made to swell out further than the thigh forms. The welding procedure is to start a pool at the center of the area where the circular form will be; then add filler metal until the

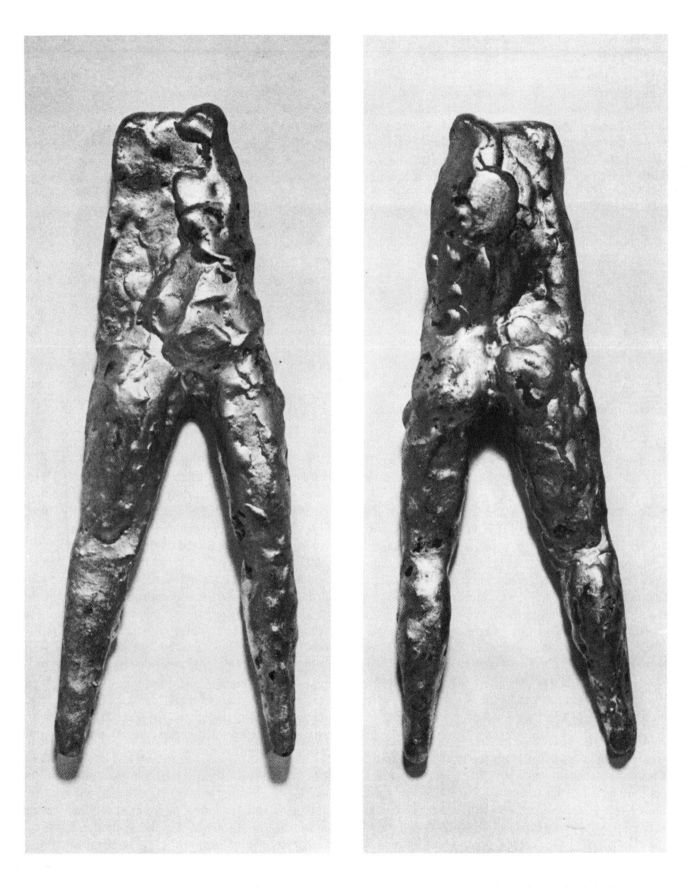

115. *Modeling front body contour.*

116. *Modeling back body contour.*

pool grows outward. Make sure the metal has fused; go around the outer edge of the forms with the torch until the metal blends.

For the rib cage, make a long, oval shape that starts at the upper end of the armature and runs two thirds of the way down. The shape stops one third above the crotch. Begin at the upper edge—on the center—and run a wide pool down to the two thirds mark. As you run several pools down, add more filler metal at the center of your run until you have a nice oval that rises as high as the buttocks. Do not forget that the back area is the *last* thin part of the armature; it can melt through if you do not watch the heat.

☐ BODY CONTOUR

Up to this point, you have been modeling shapes on an almost rectangular basic form. You must now blend the metal of the rectangular form into the raised, organic forms that have been superimposed upon the armature. The two legs now have to be modeled to show the three muscle groups of the lower leg, the knee, and the three muscle groups of the thigh. The pelvic forms must be indicated, as well as the muscle groups and forms of the torso.

To model and blend in the excess metal of the armature (Figs. 115 and 116), hold the figure with the plumber's gas pliers in your left hand, while you hold your torch with the right. Both hands must work together: the left hand rotating the work from side to side, and up and down; the right hand flowing the metal with the torch as the form is turned, withdrawing the flame when necessary. *Before,* you modeled by adding filler rod; *now* you melt the metal that is already on the figure, and control its flow by hand manipulation. Gravity now becomes a modeling agent, as you tilt the figure at various angles to direct the flow of the molten metal.

Ankle to Calf: Take hold of the figure's right ankle with the pliers, so that the left leg is held uppermost. Focus the flame on the outer side of the left ankle. As the metal becomes molten, let the ridges of metal on the side flow together. You will find that the pressure of the flame is sufficient to smooth and round the forms. As you proceed up the outside of the lower leg to where the calf should be, stop your pool and start it again at the knee, bringing the pool down to the calf. This will remove the excess metal from

the knee, will define the shape, and also will add form to the calf.

When the outer side of the lower leg is done, follow the same procedure on the inner side, but flow the metal from the front to the back of the leg. The inner side of the tibia is not covered with muscle, but lies right below the skin. So use the melted metal from the tibia area to increase the calf. And instead of bringing metal downward from the knee—as you did on the outer side—bring it down from a point just below the knee, and flow it back onto the calf.

On the inner side of the leg, the calf should extend downward for two thirds of the distance; the remaining third should indicate the slight rising form of the flexor muscles and the inner ankle. Coming from beneath the gastrocnemius and the soleus, this form is behind the tibia, and its tendons all meet and flow down behind the inner ankle. These forms take a bit of practice; you will have to study your anatomy to do them well. You cannot make shapes that you are not familiar with. Just try not to overwork the forms at this point; a rough approximation is good enough. You will refine the shapes as you continue.

Thigh: The thigh follows a similar procedure (Fig. 117). You begin with the outer portion. Of the three muscle groups of the thigh, the outer side of the leg shows part of the quadriceps group of the front of the thigh, and part of the flexor group of the back. This outer side has no major forms of its own; but it can be treated as a curved oval. Where the two great muscle groups meet at a point three quarters toward the back of the leg, an indentation marks the meeting of these groups. When you approach the area of the buttocks (gluteus maximus), model the excess metal from the thighs back onto the buttocks form, as this muscle actually flows around and onto the leg from its origin on the iliac crest, sacrum, and coccyx.

The inner thigh is also simple: it has one large muscle group, the adductor mass. This is a large triangular mass that runs straight down from the crotch to the knee, and slopes onto the front and back masses of the leg.

Rib Cage: The excess metal on the torso can be handled by dividing it into two sections: the rib cage and the abdominal area. Start at the upper corner where the shoulder will be, and melt the metal toward the mass of the back. This requires several runs, each stopping at the bottom of the rib cage form (Fig. 118). When one side is sufficiently modeled, proceed with the other side and model it

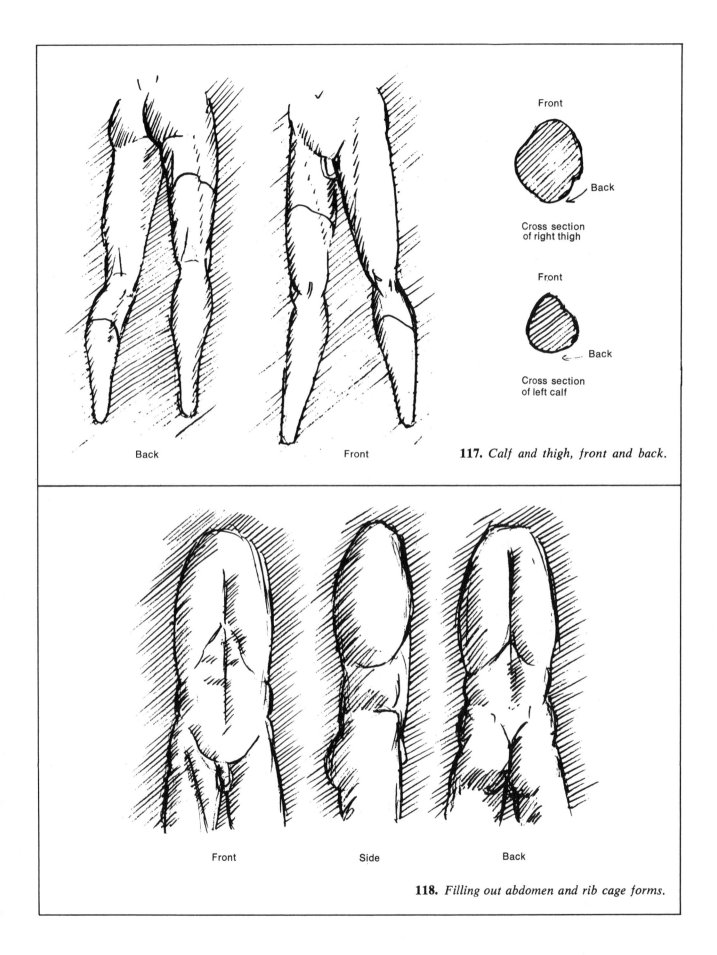

Front

Back

Cross section
of right thigh

Front

Back

Cross section
of left calf

Back

Front

117. *Calf and thigh, front and back.*

Front

Side

Back

118. *Filling out abdomen and rib cage forms.*

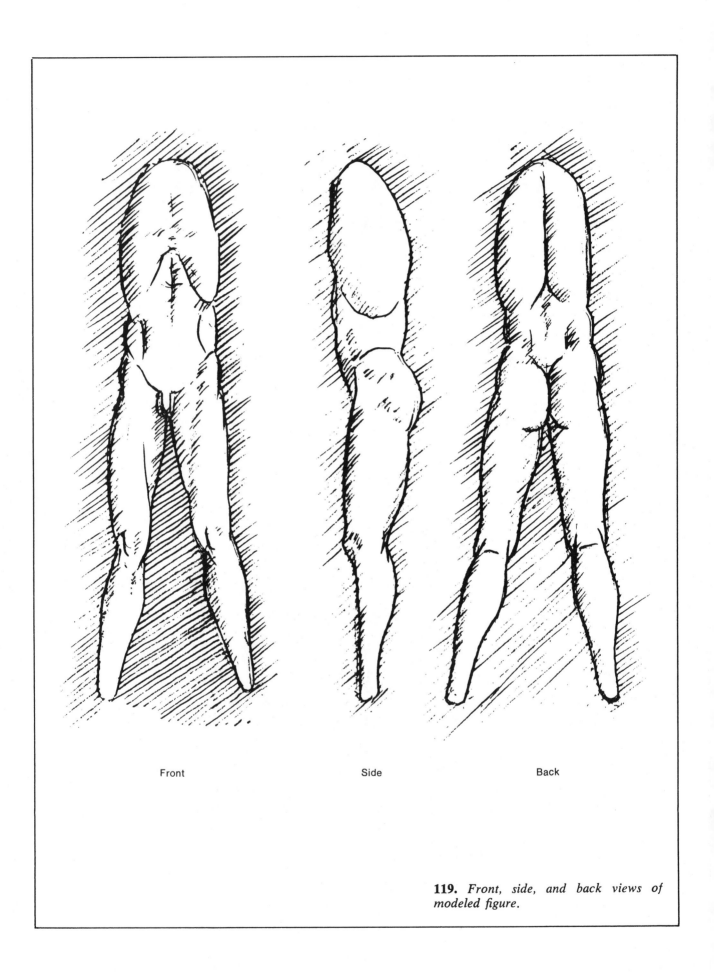

Front

Side

Back

119. *Front, side, and back views of modeled figure.*

symmetrically. The rib cage should be egg shaped; the narrow upper end represents the upper ribs *minus* the shoulder girdle of clavicle and scapula.

The metal remaining below the rib cage is modeled forward onto the abdomen and lower thorax (Fig. 119), except for a small quantity (about one eighth). This remaining portion can be run back on the spine so a ridge of metal extends from the rib cage down to the buttocks. This ridge represents what should be the lumbar portion of the spine and the erector spinae muscle group.

The effect of the modeling should give the curve of the spine: it rounds *out* from the back of the rib cage, curves *in* at the lumbar region, and rounds *out* again at the sacrum and buttocks. The forms at the front of the rib cage should remain incomplete until the next step has been finished.

☐ HEAD AND NECK

While the metal is still hot from modeling the torso, hold the figure shoulder end down, resting on the work surface. Melt some metal from each side of the rib cage, allowing it to run down and form a neck. The neck should slope slightly forward, not run straight up and down. When you hold the figure to melt the metal, the front plane should stand at an angle of about 75° in relation to the work surface. That will give the neck a 15° forward slope in relation to the center line of the figure. Once you get the neck started, rest the figure (face up) on the turntable and prop up the legs so that the body slants 15° up from the work surface and the neck is level (Fig. 120).

Now you can model the neck with filler rod. You can treat the neck as a simple cylinder, and later add the sterno-cleidomastoid forms on each side, and the trapezius at the back. The neck should be about ⅜″ long. While the neck is in this position, you will tack three bits of rod, 1″ long (slightly smaller for the female head), onto the neck (Fig. 120b). You can use the filler rod itself and cut it with the torch. Place the rods side by side like the pickets in a picket fence. When these three bits of rod are fused together at the ends, add a second layer of rods on top of the first layer, and fuse them all together in the same way you did the armature at the beginning. This is the head armature.

Then turn the figure and fuse the reverse side. If the armature and neck appear to be out of scale for the body, they should now be adjusted. Getting a good feeling for the scale of shapes is a matter of practice and perseverance with anatomy. (Figs. 121 and 122 show stages in this process.)

This head armature projects forward at the same angle as the neck. You must add metal to represent the jaw (Fig. 123) and the front of the face, as well as to show the back of the head. At the end of the neck, where the jaw should jut forward, build up the jaw until it projects as far as the forehead (Fig. 124). Then fill in the front of the face between jaw and forehead. Do not try to do the sides of the face or features; just add the triangular form of the jaw. When this part of the face is completed, turn the figure over and build up the back of the skull as a flat circle (Figs. 125 and 126).

When the first stage is completed, you should have the shape of the head in flat profile like a cut-out; the rounded forms are not yet built out at the sides (Figs. 127 and 128). At this point, you can correct the profile for proper contour, or make further scale adjustments. When you have made these corrections, you can model both sides of the head; prop the figure on its side on the turntable or lift it with the pliers, as the modeling demands. Turn it from side to side so that you can correct the shape from all angles, including the top view. (Remember that sculpture is three dimensional and must be checked on all sides.)

You now have a roughed out figure that is armless, standing with both legs separated at about a 15° or 20° angle at the crotch. Now is the time to go over the figure and make the forms more defined. The chest should be modeled so that the over-all form is filled out. From the opening of the ribs, the abdominal form should come down in a slight swelling arc to the bowl of the pelvis. Indicate the rounded forms of the external oblique muscles on each side of the abdominal form between the rib cage and the pelvic crest.

The back should show the indentation of the spine from the nape of the neck to the sacrum. On each side of this indentation, the rib cage should swell out. Below the rib cage, the erector spinae muscles should extend on either side of the spine.

The genitals can be modeled now by building up the simple round form of the testes at the crotch, over which you add the form of the penis. Retract the torch carefully to prevent fusion of these two forms. Do not feel awkward or shy about modeling the sexual characteristics of the male or female figure. The artist has the God-given right to study and express the beauty of all of nature's forms.

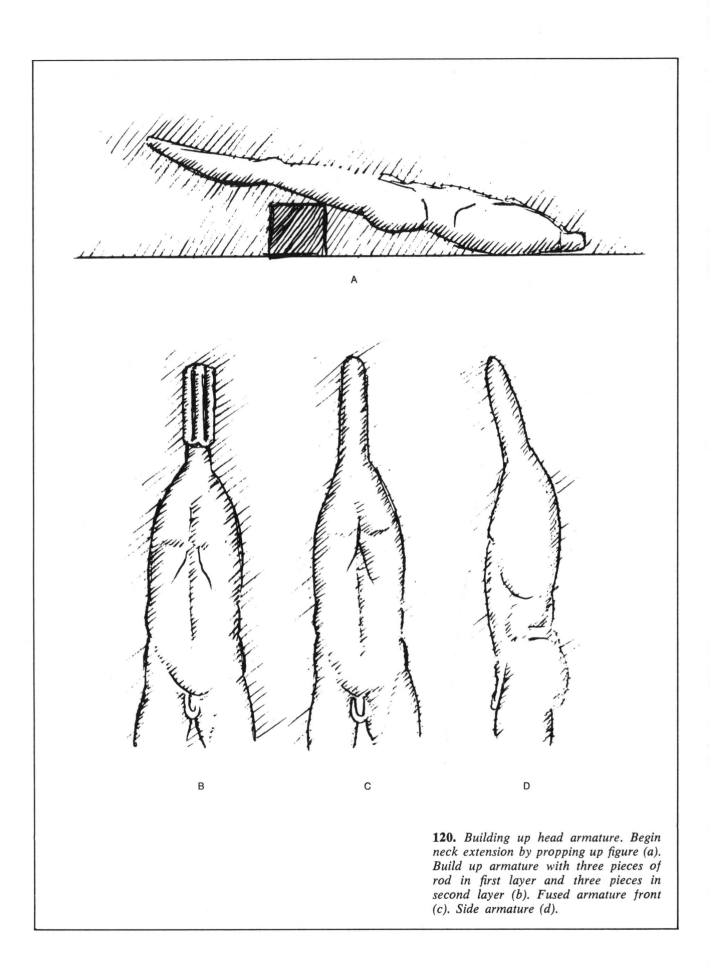

A

B C D

120. *Building up head armature. Begin neck extension by propping up figure (a). Build up armature with three pieces of rod in first layer and three pieces in second layer (b). Fused armature front (c). Side armature (d).*

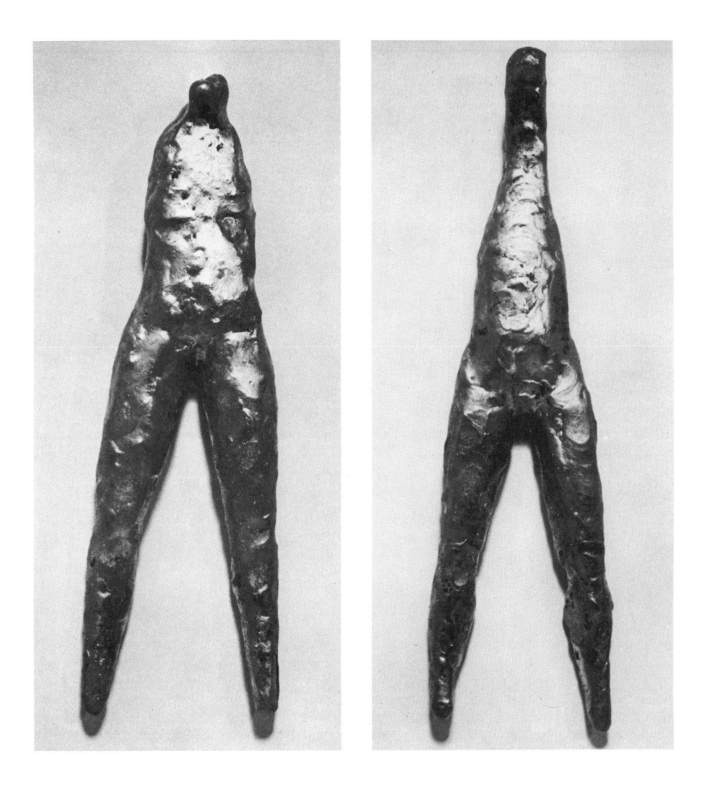

121. *Beginning neck.*　　　　　　　**122.** *Extending neck and head.*

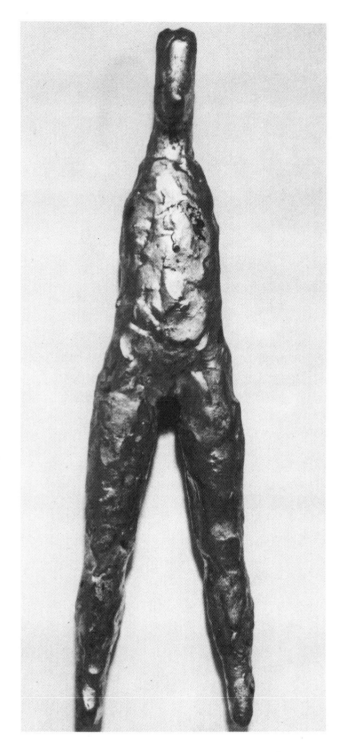

123. *Forming jaw.*

124. *Adding jaw form to armature, side view, figure lying on back.*

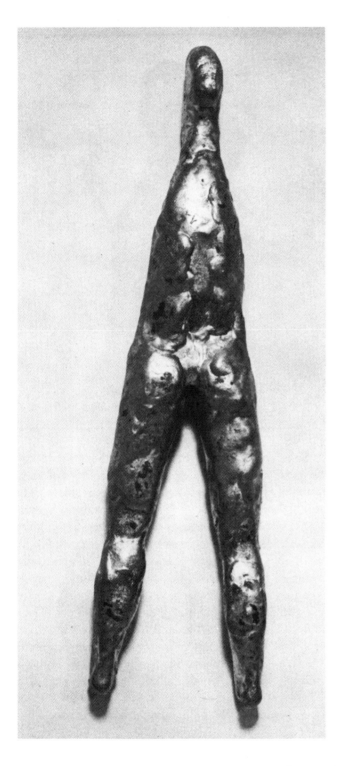

125. *Building up back of head.*

126. *Modeling form of back of head, side view, figure lying face down.*

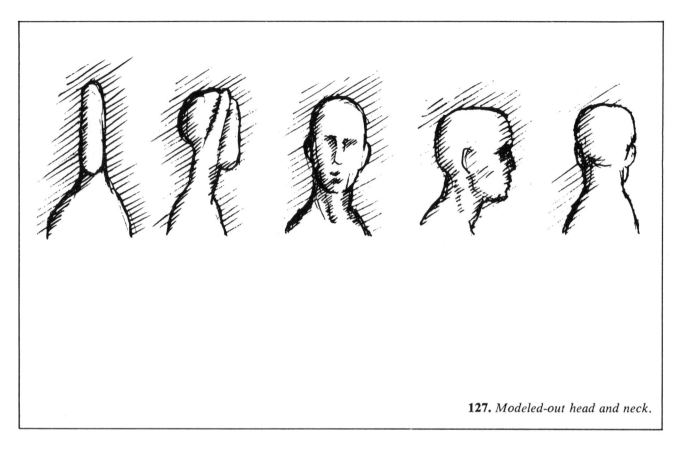

127. *Modeled-out head and neck.*

☐ POSITION AND MOVEMENT

At this time, you must decide several things about your figure: his age and vitality, his emotional state, and the kind of movement his body is expressing. For this exercise, we will say that our figure is a mature man of average build and vitality, who is pensively walking along (see Fig. 147). His weight is on his right foot; his left foot is coming forward toward his center of gravity, in preparation for his next stride. His rib cage is tilted slightly forward and slightly toward the right. His gaze is also directed toward the right; his face is on a plane a little farther right than his rib cage. His arms will be in the normal position indicated by his gait and the direction of his spine: his left arm forward and his right arm behind his center of gravity. His chest is not held high and out in the military manner, but shows that his breath has expired. Let the figure be relaxed, human, full of feeling.

When you make a moving figure, you must make all these decisions. They are based on the laws of anatomy and organic movement. Both these subjects are factual, and if you want to do believable representational figures, you must give some time to learning these facts.

Some art teachers believe that the student can "suggest" these things or give the "feeling" of them without having *studied* anatomy or movement. The results are generally stick figures, formless expressions, or blocked-in figures with no sense of life. The student does well to remember that knowledge of anatomy and organic movement is a hard-won heritage, the result of intensive study. Even geniuses like Leonardo, Michelangelo, and Rodin had to pursue these studies, often at great personal cost. These subjects require practice and concentrated effort before they become part of your personal background. If you do not learn anatomy and movement, you will make effigies or symbols, as primitive men did. These may be quite charming, but they will lack the deep contact with reality that anatomical study can give.

The first step in positioning the figure is to place the legs correctly. The weight is on the right leg, so this leg must stay on the same plane as the torso, but be moved in to the center line of the body. To begin, focus the flame on the area of the hip joint (greater trochanter) until the metal reaches red heat. Use a No. 3 tip. Then, holding the figure with the pliers, melt out a wedge-shaped notch from the side and cut two thirds into the thickness of the leg. (See notched

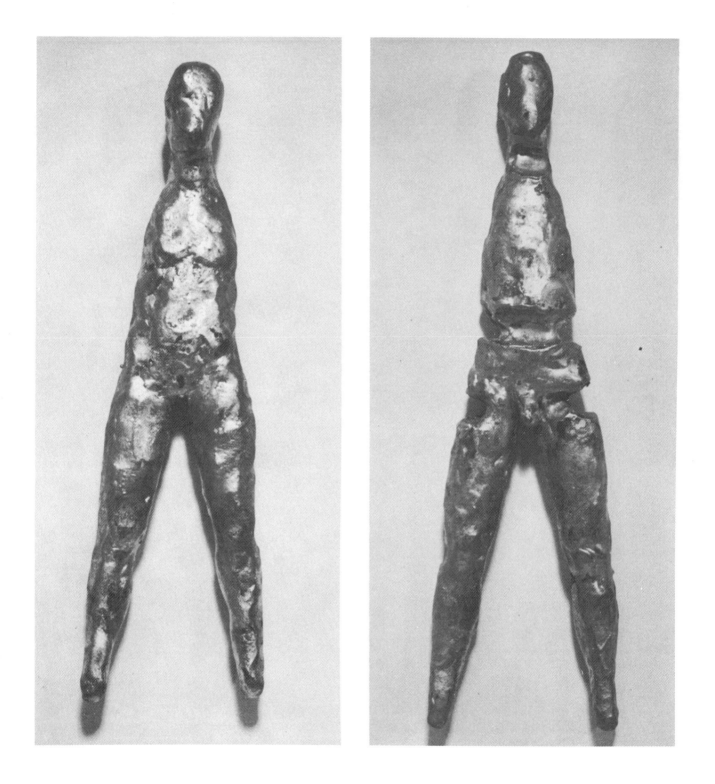

128. *Beginning to model head, neck, and body forms.*

129. *Notched figure, front view.*

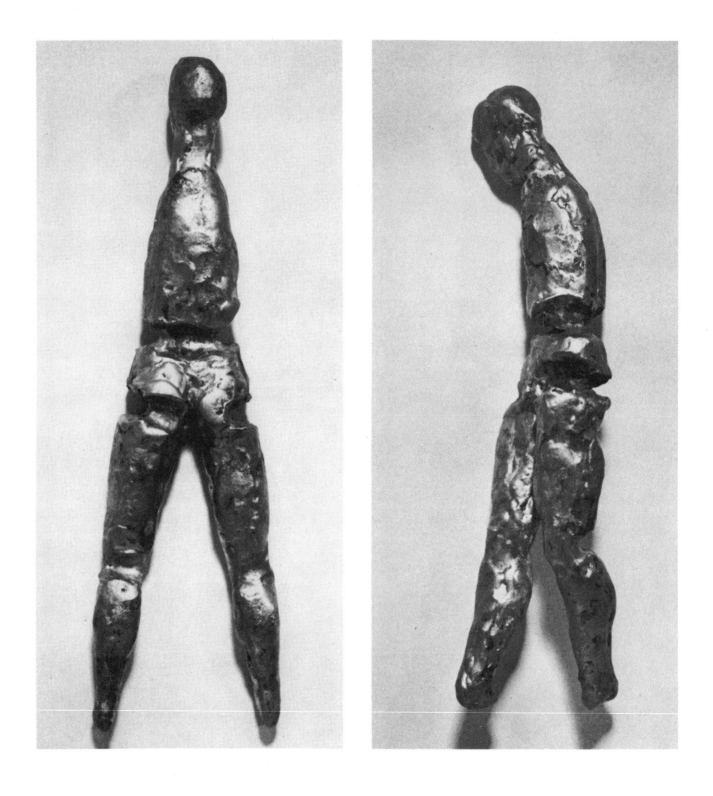

130. *Notched figure, back view. Note that leg is notched at knee.*

131. *Figure bent into position, side view.*

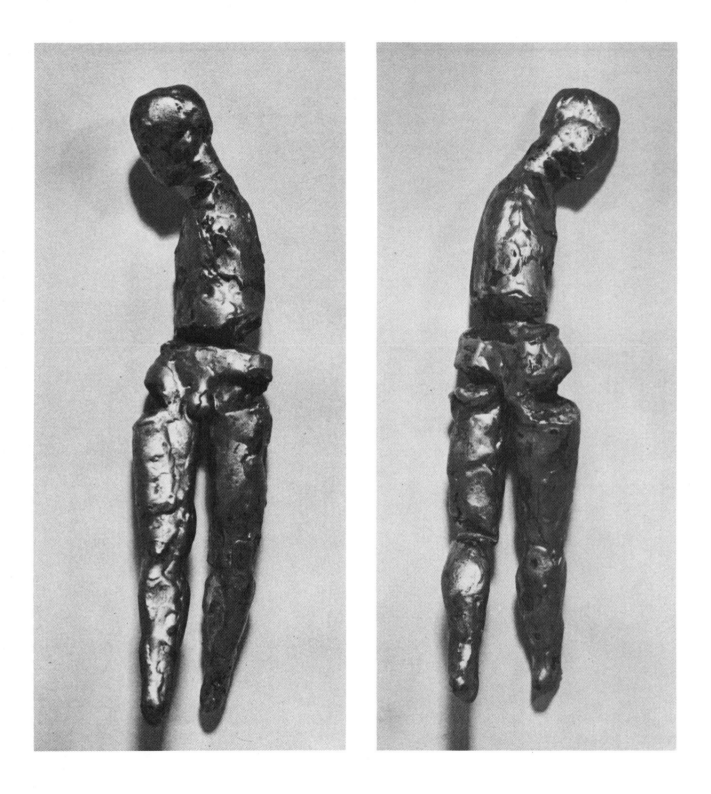

132. *Figure bent into position, front view.*

133. *Figure bent into position, back view.*

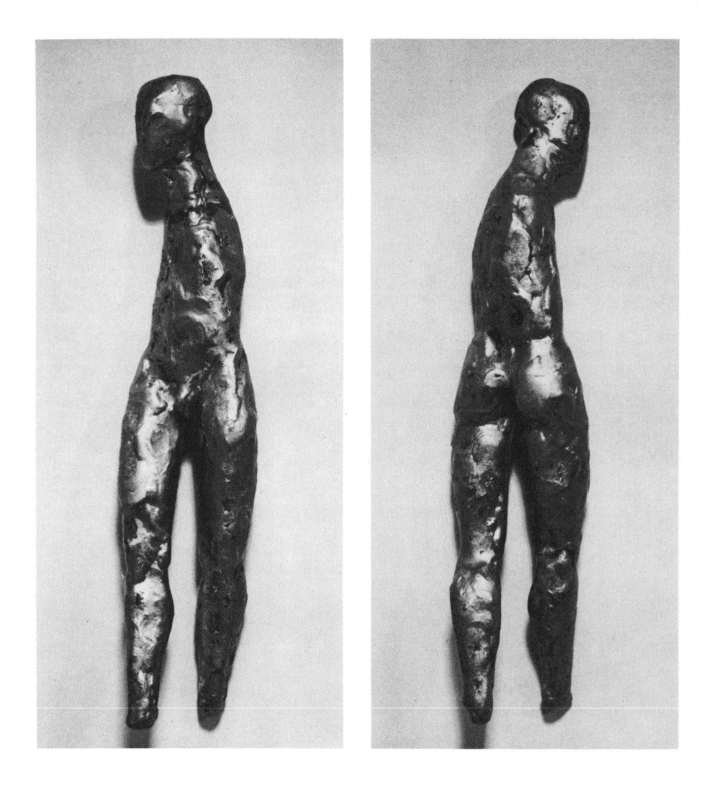

134. *Notches modeled in, front view.*

135. *Notches modeled in, back view.*

areas in Fig. 129.) When this is done, the leg can be bent into position (manganese bronze bends more readily than nickel silver). Then, add filler metal to close up the notch.

The left leg must first be bent into the center line of the figure and then bent backward at the hip. The same procedure is followed: a notch is made first from the side; *then* another is made on the front and another on the back. Each of these notches is a quarter of the thickness. You make this kind of notch so that the limb can retain its natural position as it is bent; the metal at the joints acts much as the femur would. The joint is heated, bent to the center line, and then bent backward about 10°. The notched areas are then remodeled with filler rod. But notice that in bending bronze or nickel silver, small cracks occur at the bend point. Be sure to seal these cracks by fusing the metal, using a liberal amount of flux.

The lower portion of the left leg should be notched at the knee (Fig. 130). Then the leg should be bent backward so that, when the foot is modeled, it will clear the ground. You will find that the lower leg will look more natural if you also bend it in toward the center line of the figure. When this is done, model the notch with filler rod.

To move the rib cage, make the torso notch at the waistline (the area between the pelvis and the rib cage). The notch should go half way in to the front of the torso. Next make a notch across the back (at the waistline) that goes one quarter of the distance in. Then bring a notch in on each side of the waistline, a quarter of the distance into the torso. All the notches should link up and leave a solid section in the middle of the figure to serve as the lumbar spine. This solid section will limit the movement of the rib cage in much the same way that this movement is limited in the body.

The rib cage is now bent 10° to the right and then slightly forward. Put the rectus abdominus back in, then the external obliques on the side, and finally the lumbar portion of the back with the erector spinae. By notching the front of the neck, you can give the head a slight turn to the right, to give the figure some added movement. (Figs. 131, 132, and 133 show views of figure from side, front, and back. Figs. 134 and 135 show bent figure with notches modeled in.)

☐ ARMS

Man uses his arms to balance himself as he walks along on his "hind" legs. The arms always follow the movement of the spine, legs, and head; the arms coordinate to keep control of the center of gravity. When the figure is standing, this center of gravity falls in a straight line from the pit of the neck to a point midway between the heels.

When the figure is walking, the center of gravity is in constant change. The arms make counter movements to the legs to maintain balance: when one leg goes forward, the *opposite* arm goes forward too, while the arm on the same side moves backward as a counterbalance. Since the spine and leg positions of your figure have already been defined, the arm positions can easily be determined; simply assume the same position with your own body.

But first you must make suitable arms (Fig. 136). Begin by measuring the line from the pit of the neck to the crotch; then cut four pieces of rod this length. Armatures for each arm are made by tacking two pieces of rod side by side at top and bottom. Then, weld these pieces the same way you did the body armature, using a light flame and doing both sides. As you develop the forms step by step, perform the same operation on one arm and then on the other, so they grow uniformly. If you construct the arms separately, you may find that they differ a great deal.

Outer Side: Begin the modeling by doing the outer side of each arm from shoulder to wrist, using a No. 2 tip; the hands will be added later. First, thicken the upper arm by adding metal down the front of the arm to the point where the elbow joint will be. Next, suggest the deltoid (shoulder muscle) with a rounded shape that comes down one third of the way to the elbow.

Arm Back: On the back of the arm, add metal to show the triceps form down to the elbow. Next, widen the lower arm, near the elbow, to represent the brachioradialis and the extensor muscles of the lower arm. This form should rise from the elbow and taper gradually as it reaches the wrist. Do the same to the other arm. Then turn both arms over and strengthen their forms.

Elbow: Now hold the arm with pliers while you heat the elbow joint; then bend the arm about 15°. As the bending will round off the elbow, some metal should be added to bring out the point of the bone. When both arms are done, they are ready to be modeled more fully. Take great care to control the heat, though; the arms are very small forms and are easily overheated. When they become too hot, pause a moment for the heat to dissipate.

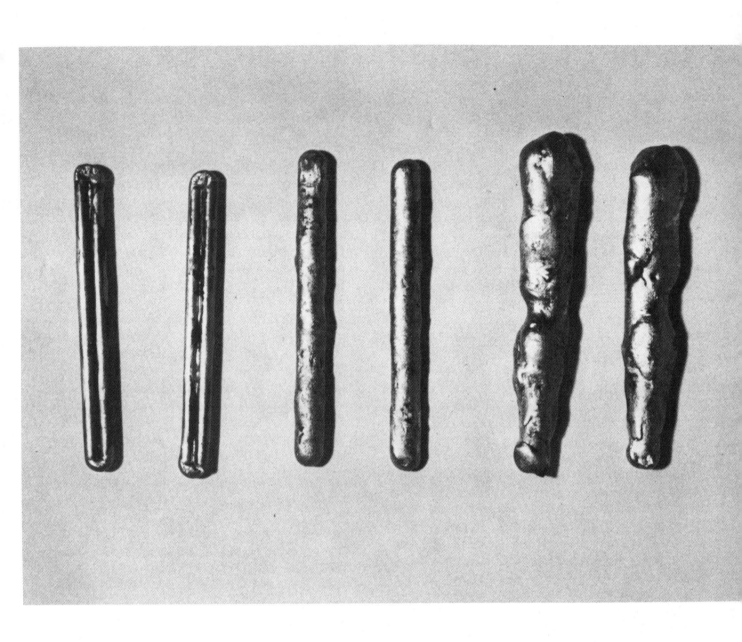

136. *Sequence of arm modeling.*

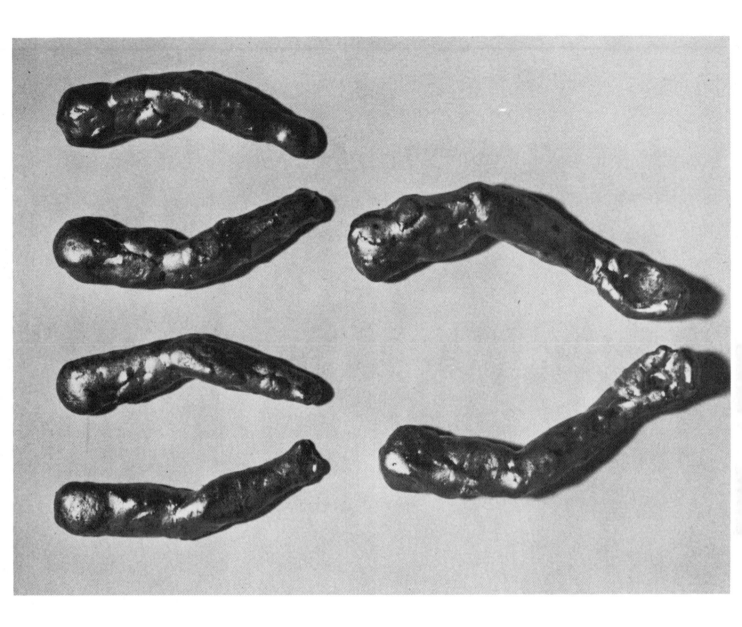

137. *Arms modeled with muscle groups added.*

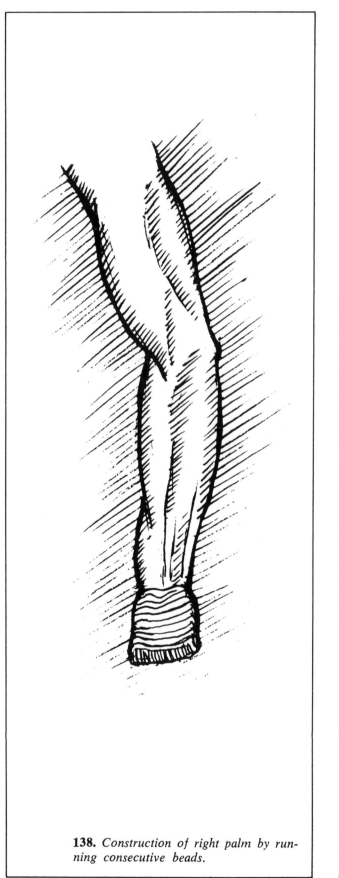

138. *Construction of right palm by running consecutive beads.*

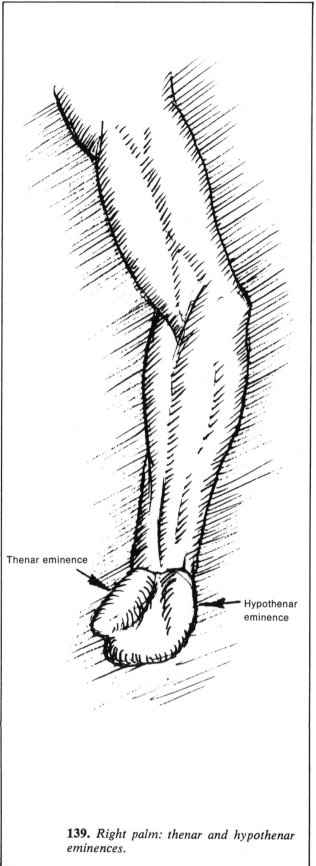

Thenar eminence

Hypothenar eminence

139. *Right palm: thenar and hypothenar eminences.*

Upper Arm: There are three major forms of the upper arm: deltoid, biceps, and triceps (which you have already indicated). As the deltoid covers the other two at the top of the arm, you must model these two first. For the biceps, add an oval to the front of the upper arm as you prop the arm on the work surface. The bulk of the biceps is in the lower third of the upper arm. The bulk of the triceps is one third down the upper arm at the back. The triceps can be formed by making a long oval reaching to the elbow. Over the biceps and the triceps (on the outer side of the arm) the roundness of the deltoid inserts between the biceps and triceps, one third from the top of the arm.

Lower Arm: The lower arm has two major forms that correspond to the two muscle groups: the extensor mass which comes from the outer side of the arm, a little above the elbow, and runs down to the wrist and the back of the hand; and the flexor mass which comes from the inner side of the arm, at the elbow, and runs down to the wrist and the palm of the hand. The extensors can be done as an oval mass, then modeled down to the box-like shape of the wrist. The flexor mass falls more toward the middle of the underside of the arm; the flexors should be tapered toward wrist and elbow. Do both right and left arms at the same time and in the same sequence.

Remember that success in modeling with the torch requires lightness of touch and sensitivity to the fusing point of the metal. You will not be able to do everything on the first trial; you will require practice and time to allow your skill to develop.

☐ HANDS

Hands and feet present the smallest forms of the figure, aside from the features of the head. It should be clear by now that you cannot model such small forms as fingers or toes directly in this scale; the heat required to melt the basic forms of hands and feet would tend to draw the smaller forms (fingers and toes) into the larger mass. Yet a certain amount of delicate modeling *is* possible, and your skill at this will increase with experience.

Small details can be achieved by chasing (filing and hammering), as is commonly done with cast bronze pieces. I have never chased any of my welded pieces because, having originated this technique, I prefer to develop the modeling possibilities as far as I can. So, in these small welded works, I abstract the

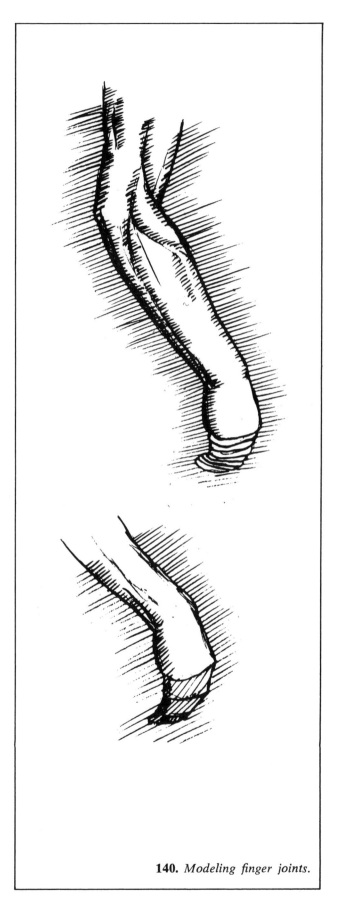

140. *Modeling finger joints.*

forms of hands and feet, give them as much detail as I can, and rest content with that. But if I *were* to chase one of my small welded pieces, it would be impossible for an expert to tell it from a casting. In any case, you will have to work through the abstract form of the hand, whether you intend to refine it further or not.

The form of the palm (Fig. 138) is a curved square that fits onto the end of the wrist, generally at an angle of about 20°, although the wrist can be extended or flexed in a range of nearly 150°. The palm is modeled by running a succession of tiny beads, building outward from the wrist. Use very low heat and retract the torch often. The palm is about one third the length of the forearm.

When you have finished the palm, blend in the metal on each side. Next, add the forms of the palm (Fig. 139): the mound of the thumb, called the thenar eminence; and the mound of the little finger, called the hypothenar eminence. These mounds are modeled by the most careful addition of filler rod. The hypothenar eminence is but a slight mound, while the thenar eminence is somewhat higher, and creates the plane of the thumb and forefinger.

The fingers (Fig. 140) are now added in the same careful manner—a series of small beads—the whole length of the fingers being one quarter less than the length of the palm. Vizualize each row of joints as a separate plane, as in the drawing. Look at your own hand as a guide.

When the general hand shapes are finished, smooth them out and add a bit more to the thumb. Do not be discouraged, as fingers are very difficult to do the first few times. I have included some illustrations of hands (Fig. 141), very delicately modeled with the torch, to show you what can be done with welding.

□ POSITIONING THE ARMS

To position the arms, hold the figure erect and move the arms about until you discover a pleasing relationship. (For an example, see Figs. 142 and 143.) Then prop the figure on the turntable and apply heat to the shoulder area. You may want to add a little metal to represent the muscles that lie under the shoulder and are attached to the humerus from the scapula and rib cage. If so, add a drop or two of filler rod, fused onto the area of the first, second, and third ribs. Use a No. 3 tip.

When you are welding a smaller object to a larger

one, concentrate the heat on the larger form. When the heat on the rib cage begins to glow red, hold the arm in position with the pliers. When the pool forms on the shoulder region, direct some heat onto the arm at the deltoid so that metal flows onto the pool on the torso, making a joint. Withdraw the heat while you check and correct the position of the arm.

Next, add filler rod and model the deltoid into the torso on the scapula and clavicle. Bring the pectoralis major across the chest and onto the arm at the deltoid insertion; the teres major, teres minor, and infraspinatus are brought from the scapula; and the latissimus dorsi is brought up from the back. (See masses on front and back of figure, 144.)

□ FEET

The feet can be modeled in two ways: the whole foot can be modeled separately—as when the foot is held above the ground—or the foot can be modeled onto the base and fused with the figure. In modeling the foot (Fig. 145), in either case, first check the proportion of the lower leg to the upper leg and make any necessary adjustment by taking off or adding metal. Next, add the ball of the heel (Fig. 145a). Make sure that part of it stands a little behind the Achilles tendon. Then add the arch (or tarsal bones) under the tibia and fibula (Fig. 145b). Add a piece of rod (Fig. 145c) to the inside of the foot to represent its length and direction. This extension should be reinforced; then model on the metatarsals and toes (Fig. 145, c and d), which radiate from the ankle. The entire foot will be three quarters of the length of the tibia. Use a No. 2 tip for all these operations.

When you are finished, smooth out the form with the flame, and add the ball of the great toe on the underside. Next, add some additional metal to the top of the foot where it joins the leg; note that the form of the arch is higher on the *inner* side of the foot than on the outer. If necessary, the arch can be hollowed out by running metal from it onto the heel or toward the toes.

On the foot that will be fused to the base, make the ball of the heel (Fig. 146). Position the figure on the base, and hold it there with pliers. Hold the flame on the base where the toes should be. When the pool forms, run it back to the ankle, where the ankle is fused with the pool. Proceed around the entire foot, fusing the metal on the inner and outer

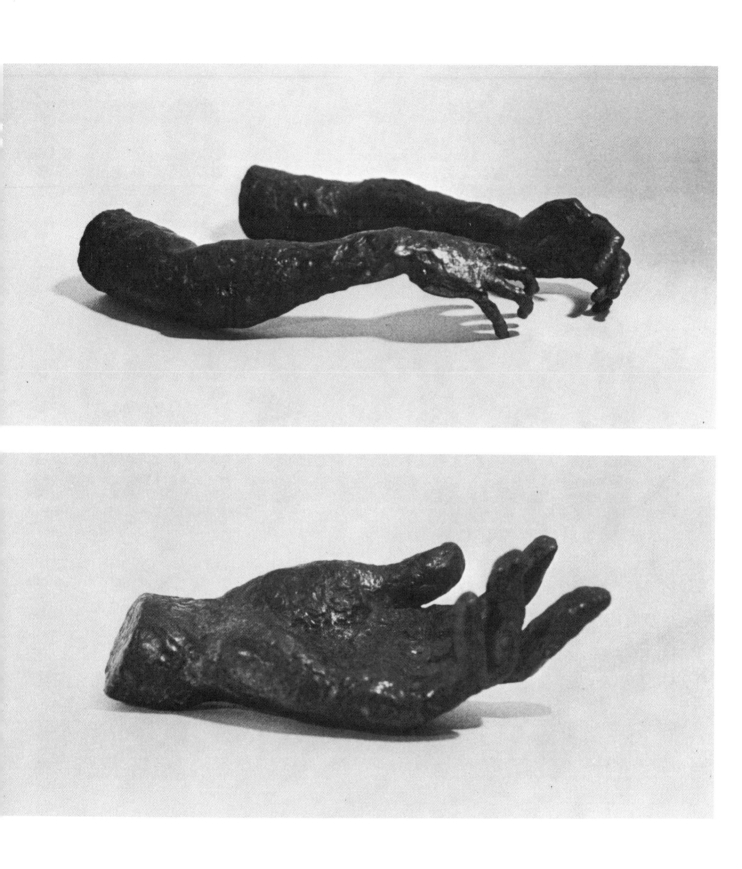

141. *Welded hands and arms.*

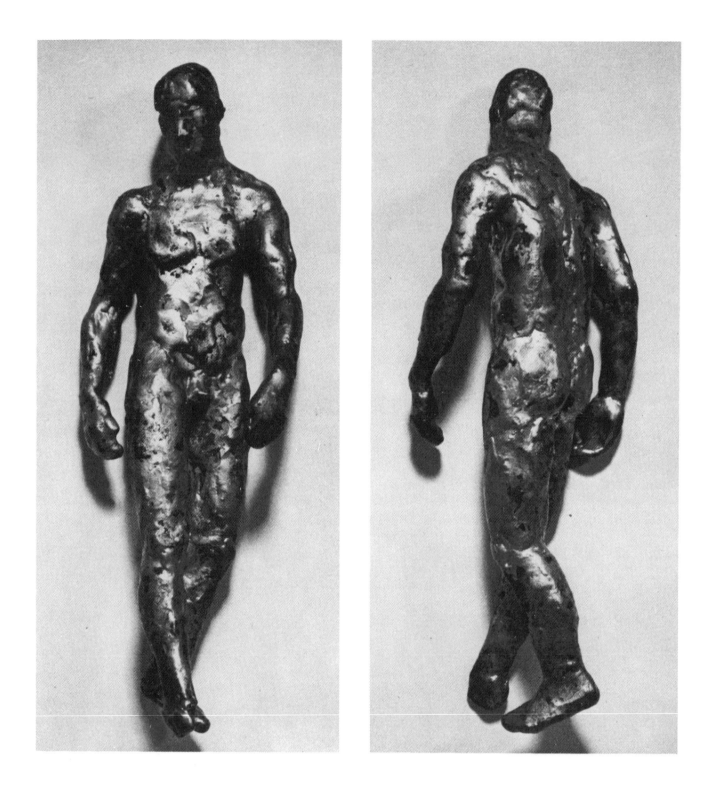

142. *Figure with arms, front view.*

143. *Figure with arms, back view.*

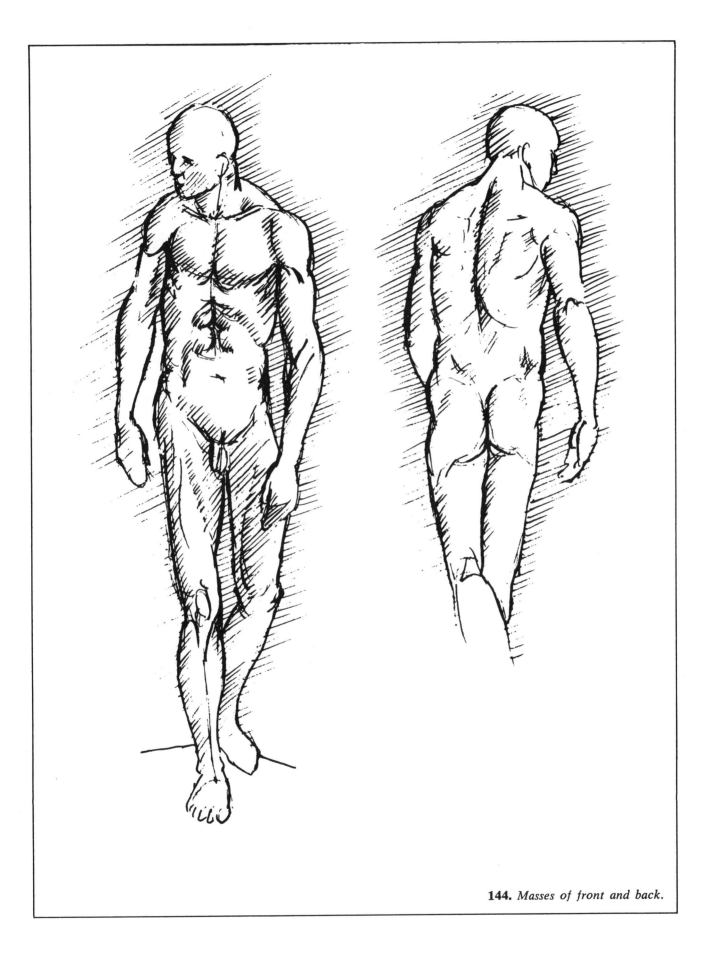

144. *Masses of front and back.*

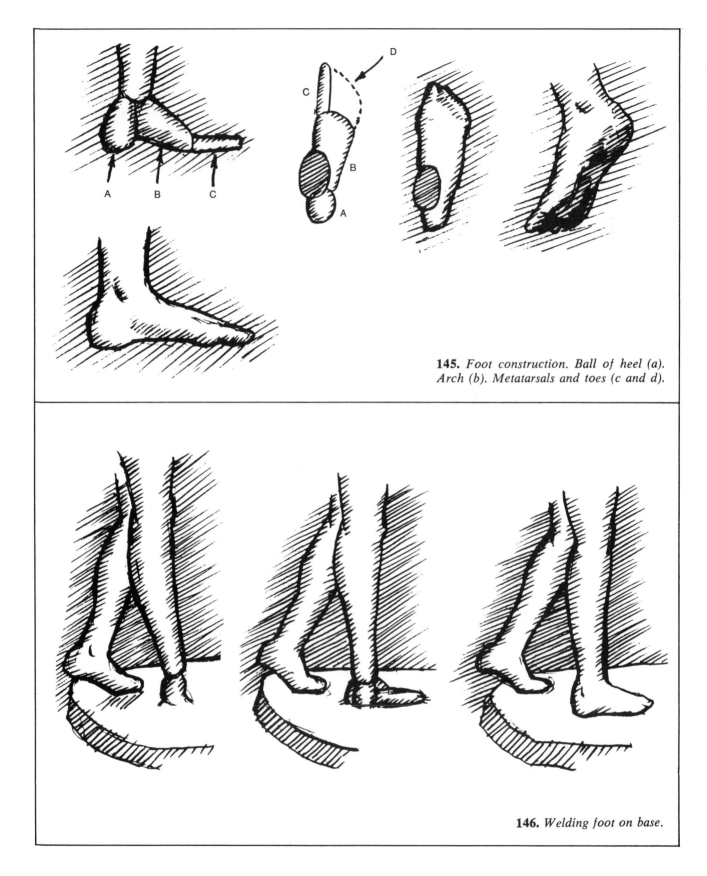

145. *Foot construction. Ball of heel (a). Arch (b). Metatarsals and toes (c and d).*

146. *Welding foot on base.*

147. *Finished welded figure mounted on base, front view. (right)*

side. If both feet are on the base, attach the other foot in the same manner. Then check the position of the entire figure in relation to the base plane, and alter the angle by heating both joints if the angle is incorrect. Next, model the shape of the foot directly onto the base. Trace the contour of the foot in one thin layer of metal; then build the rest of the foot onto this.

With a figure that has only one foot on the base, hold the figure with pliers and then prop it up so that you have both hands free to hold the torch and rod. You can correct any imbalance by heating the ankle and bending the figure in the desired direction.

The finished figure is shown in Fig. 147.

☐ BASES

There are several approaches to the form of bases. One is the simple flat metal base on which the artist's name is stamped with a die (made from a sample of his signature), or done in block letters with a cold chisel. This type of base may be made from a bronze similar to the rod used, or from nickel silver. You may also use a brazed steel plate, but this will oxidize in time. The flat base can be quite attractive. However, if you wish to become more involved with natural forms, you can make your bases an environment of rocks, soil, and other natural forms that will show your figure's relationship with the earth. Which base you choose depends on your compositional ideas.

It is always best to begin with the simple, and grow toward the complex; otherwise, you will often be discouraged by failures. You must have the satisfaction of finishing some work, even as a beginner, for art should not be built on frustration, but on pleasurable accomplishment. As your experience grows, you will automatically attempt more difficult projects; your skills will mature.

The more complex base is made with sheet bronze or nickel silver that has been cut into small pieces and assembled into the shapes of natural forms. The technique for this has been partly described in the chapter on abstract forms.

The complex base should be composed first in clay or wax, because these are the sculptor's easiest sketching materials. When you have made your sketch, you will have a pattern from which you may build exactly or copy freely.

You will find the study of rock forms and various earth forms necessary to do convincing work. These forms have their structural logic, just as the figure does, and you will have much pleasure studying them. Take some time to go into the country and study how boulders lie, or how sandstone and granite erode. The study of nature gives meaning to your work, a quality obtainable in no other way.

147. *Finished welded figure mounted on base, back view.*

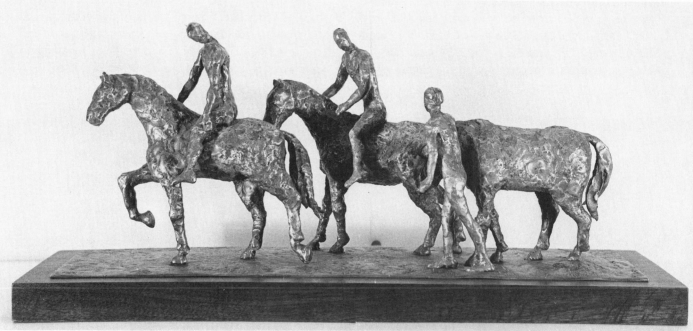

The Child Ambassador, (top) manganese bronze, 8" x 17", private collection. This composition of eleven figures consists of two groups which both contain a smaller group. The figures on the left are standing still and the figures on the right move toward them. The small child, near the center, moves forward from the group on the right and is seen as a separate unit or sub-group. On the left, a column of space separates the far figures into a second sub-group.

Three Riders, (below) manganese bronze, 10" x 20", courtesy Midtown Galleries. These horses and riders were constructed in the same manner as the single Horseman. However, it was necessary to work out the composition carefully before the horses were started, so that the action of the horses (which alters their construction) could be accurately constructed in the armature stage.

After the sculpture has been brought to the point where the basic form and expression are established and the welding is done, the major part of the work is over; at least your inner urge to create form is sated. It is at this point that your creation should begin to relate to the surrounding community. You should look on your sculpture as a kind of communication that goes beyond words, a kind of communication that has been part of the development of mankind from the very beginnings.

No matter how shy or anti-social the artist may seem to be, he is involved in the business of human communication. And anyone who dedicates his life to communication has a deep desire for his works to be seen and understood by his fellow man. No one paints or makes sculpture for himself alone, regardless of what some esthetic play-actors may pretend. You can be sure that even the esthetic tragedian will weary of his own pose in a mirror—his posturing demands a public so that he may abuse their sense of naturalness. So if you accept the fact that your art is intimately dependent on your fellow men—and this involves responsibility to your fellow men—you will have made the first long step toward reaching your public.

The person who buys a work of art pays for it with money he has earned. The price of a piece of sculpture created by a professional artist can equal the price of a refrigerator, a stove, a two week vacation, even an automobile or a piece of real estate. If people are willing to pay substantial amounts for a work of art—and perhaps sacrifice other things in order to pay for it—this indicates that the artist has a serious obligation to deliver the finest possible work. Part of this obligation includes the best possible craftmanship in surface treatment and basing of the sculpture. This sense of quality should include the permanency of the sculpture and its safety—for the people who come near it, as well as for the furniture and building in which the work is situated.

☐ BUYER'S VIEW

The buyer is searching for several things. What he buys has a lot to do with his own background and aspirations, as well as the development of his taste and discernment. He looks for an object of art that is both esthetically pleasing and challenging; he also wants something that will enhance his collection or the decorative scheme of his home. He is justified in expecting certain standards of craftsmanship for his money, because his money is no doubt hard earned. And what is more, being the buyer, he has probably shopped around and may be choosing from several alternative pieces, all of which may come close to being the sort of thing he wants.

Regardless of the thought and labor you have put into your work, your buyer will more than likely choose the piece that is closest to what *he* wants in size, color, and expression—*and* the one that has the most attractive presentation. Even if your piece is the best choice *artistically,* it might be the one he rejects if you have not given it a first-rate presentation. In other words, you cannot send your best effort out in shoddy garments expecting the visually overburdened public to discover your golden talent through the rags. That would really be working against all the time and labor you took in creating the piece.

☐ CLEANING BRONZE AND NICKEL SILVER

Sculpture that is welded of any of the copper alloys is always, to some extent, coated with flux, oxide,

and fire blackening when the welding is completed. The first step in presentation is to remove these substances from the metal. There are several reasons for this. One is to remove the flux; if the flux is not removed it forms a salt which sheds for months and even years after the piece is finished. Another reason for careful cleaning is that the mottled surface coating of flux and oxide obscures the form. The cleaning will dissolve the flux and the oxide and will open the pores of the metal so that the patination (which I will explain later) may evenly affect the whole surface of the piece.

The best way to clean bronze or nickel silver sculpture is by soaking the piece in an acid-water solution (Fig. 148). The solution is prepared in a large earthenware crock—the kind that used to be used for making "homebrew," but is now used for various commercial purposes. These are round, glazed ceramic vats that range in size from five gallons up to ten, twenty, even fifty gallons. The ten gallon size is adequate for most small sculpture studio needs and is quite reasonable in price.

When you prepare the acid solution, always put water into the crock first and then *add acid to the water! Never* put water into acid, as this can create a violent reaction that can spatter and burn your clothing, face, and eyes. The acid is added very slowly to the water, with great care. It is advisable to wear transparent goggles, old clothes, and gloves when you are pouring acid or with cleaning solution.

When you are placing the sculpture in the solution, never drop it into the crock, as this can easily crack the ceramic bottom. Instead, hold the sculpture with a piece of bronze welding rod bent around the neck, an arm, or any projection of form, and slowly lower the piece into the solution. In order to be thoroughly cleaned, the piece should soak in the solution from six to twelve hours. The welding rod is left on the piece. When the piece is ready to be taken out of the solution, lift and hold it above the crock so that the excess acid can drain off. Then rinse the piece in clear water. Large sculpture may have to be put in twice, alternating each end of the piece.

Either nitric or sulphuric acid is used for cleaning copper alloys. The proportion to use is forty parts water to one part acid. Such a solution can be used for quite a long time if you keep the crock covered with a ceramic or wooden cover. From time to time, you may add water to keep the solution at the same level; every few months a small additional amount of acid may be added.

Another word of caution: *acid is deadly dangerous.* The bottle of pure acid should be kept in a cabinet under lock and key. The cleaning solution should be kept in a place that is not accessible to children or pets.

For most purposes, immersing the sculpture in the acid bath for a period of six to twelve hours is the best way of cleaning. But occasionally circumstances may require you to use other methods. For cleaning the surfaces of larger pieces that cannot be immersed in the cleaning solution, sand blasting can be used. There are firms that specialize in this process and their fees are quite reasonable. You only have to deliver your work to the shop and specify the type of cleaning you need.

Another method for cleaning larger pieces is to swab them down with a cleaning solution of twenty parts water to one part acid. This is best done by a stick with a rag tied to one end, or with a very long handled brush. When you have coated the piece thoroughly several times to completely saturate it, wrap

148. *Cleaning sculpture in acid solution.*

Coarse Medium Fine

149. *Effects of textures.*

it in plastic and make it as airtight as possible. This is the method the sculptor, Abe Satoru, has developed to clean his larger pieces, and it is quite effective. The plastic is removed after eight hours, and the salted-off flux is brushed away. The solution is then re-applied and the piece is again covered. Continue this process until the flux no longer salts off.

In combination with the method mentioned above, power tools can be used to clean bronzes: a rotary wire brush mounted on a drill motor, or on a powered flexible shaft, is an excellent tool for cleaning. This will easily clean off the residue left after the Satoru cleaning method. The residue left from a gas-flux equipped torch can be removed by a wire brush alone. High speed grinders and sanding disks can be used to clean bronze or nickel silver, too, but they leave very coarse finishes that are more appropriate for large abstract works. David Smith used this method for cleaning his large stainless steel sculptures and liked the finish so much that he kept it as the final treatment.

☐ TEXTURE

If the sculpture has been welded over the entire surface, it will have a rough texture that may or may not be suitable for the piece. A heavy texture on a small piece may break up the form so much that it will be almost impossible to see the work. The same texture on a large piece may catch the light and accentuate the form perfectly.

On welded sculptures, the surface must always be considered, and at times it must be ground down or textured again in a way that is appropriate to the piece. A most useful tool for this purpose is a die maker's grinder. This tool can hold a variety of rotary burrs, files, grinders, and sanders. Or if you prefer hand tools, files, chisels, and chasing tools may be used on welded sculpture in the same way as on cast pieces.

The proper use of texture is a subtle art that depends, in large part, on the individual's taste. Texturing cannot be taught directly, but must be developed as a by-product of modeling. In building up form, you contrast the textured surface with smooth areas to create different effects of light. A very large grained textured surface breaks up and diffuses form; medium textured grain gives the form a coarse look; and a fine textured grain absorbs light and gives a subdued glow to the surface (see Fig. 149). Polished surfaces, on the other hand, reflect light in varying degrees, depending on the contours of form, and tend

to break up the form with many tiny mirrored reflections. A mirrored surface makes a form extremely difficult to see, often giving it a mechanical "made in Detroit" look—sometimes sought by "pop" sculptors.

I believe the effects of texture should be made secondary to the modeling of form. The form should produce the major tones of light and dark. If you work to develop your understanding of form first, and keep form uppermost in your mind, the proper use of texture will come in time. The best textures for welded work are made by grinding down the welding texture already on the piece. Leave the welded texture in some areas, and grind down other parts to create a smooth metal surface. The effect obtained will considerably enhance the sculpture.

☐ PATINAS

Once the sculpture has been cleaned of the flux and the surface has been ground down and properly textured, the piece should be patined. But before you put on the patina, make sure that everything else has been finished. The surface should be completely worked and you should take care of welding any bolts or attachments needed on the underside of the metal base. If you later find that you have to do any more welding on the piece, or must do any surface work *after* the patina has been applied, you will probably have to redo the patina completely; heat tends to discolor and scratches will mar most patinas.

Aside from actually mounting the piece on the final wood or marble base, the patina is the last thing you do to the sculpture. Even if you do not actually make the base until after the patina is done, all the bolting arrangements and the base size should be completely worked out *before* the patina is begun.

Why is a patina needed? It may seem to the beginner that the patina is just a way of coloring the sculpture. However, the patina is much more than this. Just as texture is used to accentuate or subdue certain forms within the work, the patina unifies the light and color of the whole sculpture. The right color patina catches the light in just the right way and shows the piece to its best advantage. When you have seen your sculpture go through this process from raw bronze to its final patina a few times, you will understand clearly how important this final touch is. Conversely, a bad patina can, for all intents and purposes, ruin the finest piece of sculpture.

If you apply various chemical substances to the metal surfaces, bronzes, brasses, and nickel silver can be colored various hues through the oxidation of the base metal. There are countless formulas for making different patinas. There are also professional craftsmen who do nothing but patine bronzes. In my opinion, though, a sculptor should not become too involved in the minutiae of techniques, but should spend most of his time sculpting. So rather than give you many formulas, I will suggest only a few basic ones for your use.

Brass, bronze, or nickel silver will oxidize naturally if left outside in the weather long enough. In dry desert air, these metals tend to turn brown; whereas in a moist, salty climate, they corrode and turn green. Green is a more attractive color than brown; most sculptors prefer green. Old fashioned methods for turning these metals green include immersing the sculpture in sea water, soaking the work in urine, or burying the sculpture in earth for long periods of time. All of these methods work, but they are not easy to control, and require more time than you can usually give to this process. But you can turn these metals green artificially by painting them with any of the following solutions, and covering the piece with plastic until it is dry.

DARK GREEN
1 ounce acetic acid
1 ounce salt
1 ounce water

LIGHT GREEN
2 teaspoons salt
2 teaspoons ammonium chloride
2 teaspoons ammonia
1 pint vinegar

ANTIQUE GREEN
3 ounces copper sulfate
½ ounce ammonium chloride
1 quart water

When the surface is well colored and dried, it may be sprayed with lacquer or lightly waxed for further protection.

Turning copper alloys black is rather simple, once the piece has been thoroughly cleaned. Heat the piece slightly with your torch until it is warm, *not hot*. Hold the torch flame so that the last feathery end of the flame, furthest away from the cone, is an inch or two away from the piece, not touching it. Then paint on a solution of one part ammonium

Bolts silver soldered to base underside

Nuts attached to base underside on metal straps

150. *Bolt and nut attachments.*

sulfide to five parts water with a brush. By heating occasionally with the torch keep the piece warm while you apply the solution. Once you have covered all the surface, allow the piece to stand for several hours; then spray it with lacquer or wax it.

To turn manganese bronze and brass to a rich, light brown or a deep, dark brown, here is an excellent method that I have developed. You immerse the sculpture in the cleaning solution for eight hours. Then you heat the piece to a near-red heat by slowly moving the oxyacetylene flame (2″ or 3″ from the inner cone) over the entire surface. Allow the piece to cool and then immerse it in the cleaning solution for another eight hours. Heat the piece again with the torch; the lighter the heat you apply, the lighter the shade of brown you obtain. Conversely, the longer the piece is heated, the darker brown it becomes. With the second heating care must be taken to prevent the metal from reaching red heat; this will make the patina scale off and leave the piece with a mottled surface. After the second heating, allow the piece to cool; then it can be lacquered or waxed.

For turning nickel silver black, you can use the same process as with manganese bronze. This will give the metal a rich, deep black durable patina.

In cases where no patina at all is used, the metal can be burnished with a rotary wire brush on a powered flexible shaft, and brought to a high satin finish. Or if it seems appropriate, the piece can be buffed to a mirror finish with cloth buffing wheels that are also mounted on the flexible shaft and used with polishing and buffing compounds.

As I have said, patina is a matter of taste and appropriateness. It takes time and experimentation to learn what will work best with the style of your work. The best thing for you to do is to try as many of the possibilities as you can, using limited textures and the limited patina formulas I have given. Settle on a few simple and effective ones. When you go to galleries and museums, try to see how other sculptors have solved these problems. In time, you will gain enough experience to find your own methods.

☐ CLEANING AND PREPARING STEEL

The dictionary defines steel as a form of commercial iron which contains carbon in any amount up to 1.7% as an essential alloying constituent, and is malleable under suitable conditions. Mild steel is readily available and remarkably cheap. In all industrialized countries, it can be picked up in scrap form

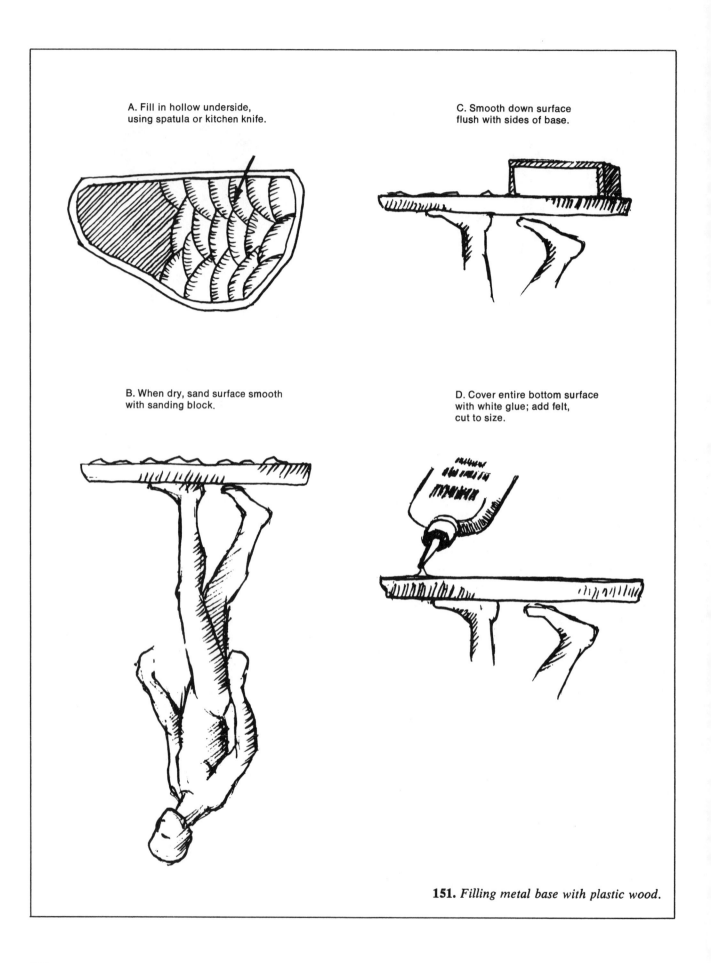

A. Fill in hollow underside, using spatula or kitchen knife.

C. Smooth down surface flush with sides of base.

B. When dry, sand surface smooth with sanding block.

D. Cover entire bottom surface with white glue; add felt, cut to size.

151. *Filling metal base with plastic wood.*

simply for the effort of stooping and rummaging through the scrap heap. Steel is a fine material for sculpture; it is strong, malleable, has good color, and is very easy to weld. The only trouble with steel is that it oxidizes readily, and if weather conditions are moist and salty, steel will thoroughly oxidize in a remarkably short time. So, when used for sculpture, steel must be treated to withstand the elements.

The surface of a steel sculpture will be completely covered with a thin oxide film after welding. This oxide is a gray substance that can come off in brittle, metallic flakes; it forms on the top and bottom surfaces whenever steel is heated to a high red heat. Some of this film can be knocked off if you tap the piece with a hammer or if you flake it off with your torch after the piece has cooled. The sudden heat of the torch makes the film expand rapidly so that it pops off from the rest of the metal surface. You should remove as much of this loose oxidation as possible because, otherwise, it will flake off later and shed, much like the flux on uncleaned bronze.

When the whole top surface of a welded steel piece has been welded over with the torch, a thick and durable coating of fire oxide is formed:

Any one of three methods can be used to prevent this surface from rusting, and will give a finish to welded steel sculpture. If the piece is just waxed without removing this oxide, the film turns a dark blue-gray. This is often enough treatment to take off the glare and give the entire piece a feeling of unity. As a second alternative, lacquer will make this oxide surface blacker and glossier. A third possibility is linseed oil, which will darken the surface, but will not make as glossy a finish as lacquer.

For abstract and geometric pieces that are constructed from large steel plates connected by welded beads, it is preferable to clean the entire weld surface so that the welded metal will blend into the rest of the form. This can be done manually with files and abrasive cloths, or it can be done with power tools (sanding disks and grinding wheels). Or the piece can be sent to the sandblaster to have the whole surface cleaned. A combination of hand and power tools gives the best results. Sandblasting steel leaves it a uniform, unappealing, dull gray color, which must always be reworked. Sometimes it is advisable to use *all* these methods with large pieces. The finished surface can be waxed, lacquered, or oiled.

From the point of view of texture, probably the handsomest treatment of steel is a combination of the welded surface with a ground down and smoothed surface. This gives the sculpture a pitted, aged look, reminiscent of old armor. This surface, which Theodore Roszak has used superbly, is best preserved by lacquering.

Once steel has been cleaned of oxidation, it can be colored various hues by heating it to different temperatures. These heat-treated colors cover the whole range of the spectrum. However, over the basic gray color of the steel, the spectrum colors do not all stand out brilliantly. The most distinctive of the heat treated colors are brown and blue; brown gives the metal an almost rusty look, while blue is the color of gunmetal or spring steel. Neither of these colors works out too well for most sculpture, though, as they are associated with either rusted metal or machinery parts.

Steel can also be preserved and patined by painting. David Smith's earlier works were treated in this way, and often with the most interesting results. Plating, which is done for you by commercial firms, is also a possible surface treatment which can give good protective covering for steel. Copper, chromium, silver, and gold are the commonest metals used for plating. But whatever way you choose to treat the surface of steel, remember to complete all the surface work and put on all the attaching elements for the base *before* you work on the final finish, just as in bronze sculpture.

□ BASING WITH WOOD OR STONE

I have tried to impress you with the fact that the decision about the size of the base, and its method of attachment, must be made before the sculpture has been patined. Weld the bolts or threaded attachments for the base to the bottom of the piece; they can also be brazed or silver soldered on (Fig. 150). Most sculptors seem to leave the finishing of the base for their last step in the sculpture process. As a matter of fact, there is something extremely satisfying about completing the base and mounting the sculpture on it. In the completion of this final stage, the work is realized and finally visible as it was first imagined. The base sets off the work and presents it to the observer, the critic, and (hopefully) to the buyer.

A great deal of work may have gone into making the piece of sculpture. Each piece of a sculptor's work represents all his years of development and thought up to the time when the work is completed. All these factors consolidate into the moment of

pleasure when the base is bolted on and the final waxing and polishing are over. Or at least these are the feelings that are possible when the work has been well realized.

If you want to consider yourself a professional, then you must begin to present your work in a professional manner. The correct base on your work can make the difference between your being able to pay your studio rent and continue working at sculpture, or having to take a job working at something you do not like. The extra effort you take to make your work presentable will pay you in the end.

Bases are made of wood or stone, cut to an appropriate size for the piece. Sometimes the sculptor or the collector will prefer to have no base other than the metal base that is part of the sculpture. In that case, it is best to fill in the underside of the metal base and apply felt to it, so that it will not scratch the buyer's furniture. If the area of the metal base is not too large, it can be filled in with plastic wood (Fig. 151); otherwise, it is best to carve a piece of wood to fit inside the metal base. Glue this filling in place and apply felt to it. If the base is flat metal with no recessed space, the felt is glued directly to the cleaned metal surface.

If your sculpture does require a wooden or stone base, you should plan the method of attachment and have the dimensions all figured out (and written down) before the patina is on. You cut out the wooden base whose size you have determined, or give the stonecutter the dimensions for the stone you want. In either case, decide on the exact position of the bolt holes, their size, and the depth of the countersink (Fig. 152). If you are using stone, give all these dimensions to the stonecutter with exact instructions. If you are using wood, make careful measurements and markings so that the holes correspond exactly to the attachments (bolts, etc.) on the metal base of the sculpture. If these holes do not line up correctly with the bolts, you may either have to get another base or reweld the attachments on the sculpture, and therefore have to redo the patina. In either case, you have gone to unnecessary trouble.

If the stonecutter makes your base, he will also polish it. So all you will have to do is mount the sculpture and bolt it on.

With the wooden base you have made yourself, on the other hand, you will have to do all the finishing yourself. If you do not texture your base by carving it with a pattern of curved chisel marks, as is sometimes done, you will have to sand it and prepare the

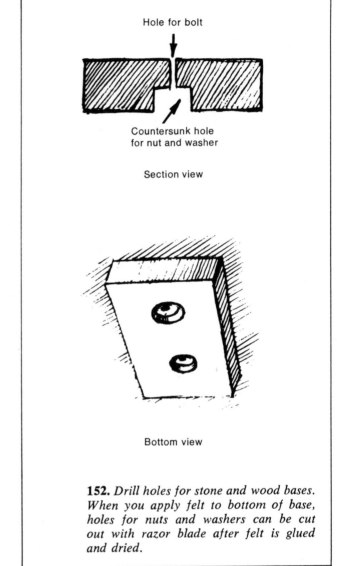

Hole for bolt

Countersunk hole
for nut and washer

Section view

Bottom view

152. *Drill holes for stone and wood bases. When you apply felt to bottom of base, holes for nuts and washers can be cut out with razor blade after felt is glued and dried.*

wood to bring out the grain. Begin by taking the saw marks out with a machine driven belt sander. Then sand the surface down by hand, using three different grades of production sanding paper in succession. Start with #80 paper and sand out all the marks left by the belt sander. Be sure to use a sanding block. Then change to #120 paper to bring the surface down further. Finally, use a very fine paper (#240) for the finish. This should remove all the sanding marks and scratches. As a final touch, go over the entire surface with very fine steel wool to give the wood a smooth, glassy surface.

Cut the felt for the bottom, leaving an excess of ¼″ on each side. Turn the base upside down on some newspaper (so that the wood will not be scratched) and apply white glue thinly to the bottom. Make sure

that none of the glue runs down the sides. Press the felt down on the glued surface, turn the base bottom down again, and weight the top, making sure that the wood is covered to prevent scratches. In thirty minutes, when the glue has dried, you can trim off the excess felt. Use a mat knife or a single-edged razor blade. Be careful not to cut into the base. Then cut the felt away from the countersink holes so that the piece can be bolted on.

Selecting the proper kind of stone or wood for a base is a matter of taste—as is the size of the base. There are no definite rules for bases. My best advice is that you constantly observe these details in museums and galleries. There are a few rules of thumb, though, that may help you in the beginning. Proportion is important: do not use a large base for a very small piece, or a very small base for a large piece.

The base should balance the sculpture visually and be large enough and heavy enough to support the piece. The base should not be altogether unobtrusive, but neither should it compete with the sculpture for attention. Its material should enhance the color and shape of the sculpture.

Some marbles are altogether too dominant in color and pattern to be used for bases on anything but the largest work, just as some wood grains are too pronounced for most uses (zebra wood, for example). In woods, the best plan is to stick to hardwoods: rosewoods, cocobolo, and mahogany are favorites, and can be finished beautifully. In stones, aside from the marbles, there are sandstone and terrazzo. Gray, white, or beige sandstone can be more attractive for certain uses than the more expensive marble.

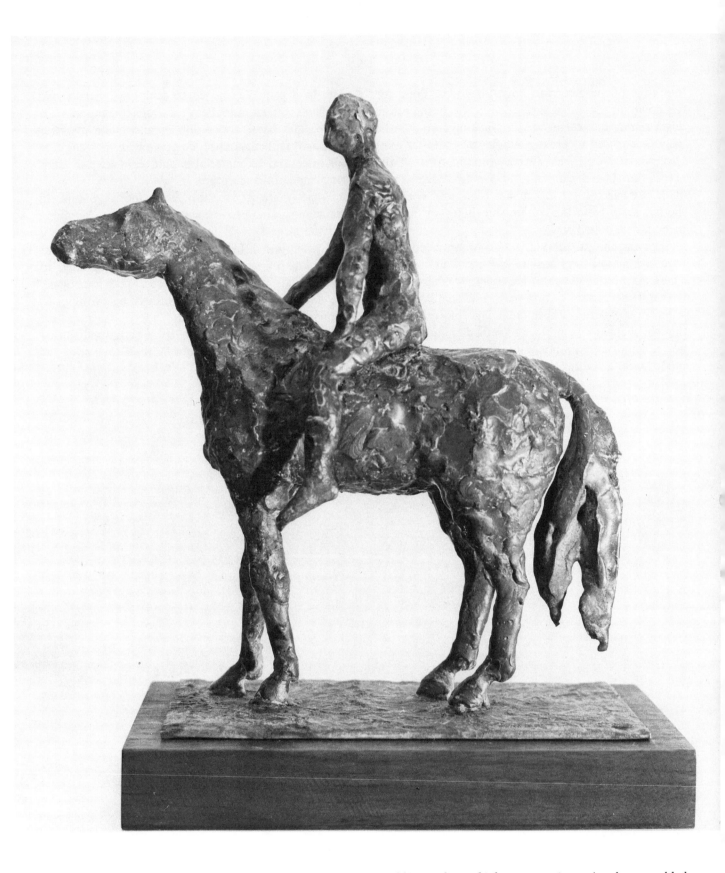

Horseman, *manganese bronze, 9″ high, collection, Dr. Thomas Matthews. The construction of the horse was done on the same principle as that of the fish exercise in Chapter 4 except that the horse was constructed of the forms of head, neck, belly and rib cage, and the pelvis-thigh area. These forms were first done in a profile of* *welding rod to which cross sections of rod were added. These forms were then built up with plate cut to the appropriate sizes. Legs and tail were modeled in much the same way as the arms and legs of the solid figure in Chapter 5. The rider is a solid figure which was bent into position and welded onto the finished horse.*

7 □ Welded Steel Sculpture with the Electric Arc

Any book dealing with the technique of welded sculpture would be incomplete without some discussion of the arc welding processes. Today, arc welding is more generally used in industry than oxyacetylene welding, and arc welding has some important applications to welded sculpture. But as these applications are less important basically than oxyacetylene methods, this chapter will include only a brief survey of the uses of electrical welding in sculpture. It will be left up to you to investigate the field more fully when you have perfected your skill with the acetylene torch.

Comparing the sculptural versatility of the two methods of welding, oxyacetylene can be used for more purposes than the arc. But the electric arc can do some things much better and much faster than oxyacetylene.

This process is mainly used for steel. With the arc you can weld heavy steel plates together very quickly and without preheating the metal—required when such a job is done with oxyacetylene. Once the electric arc has been struck on the metal plate to be welded, the temperature of the metal in the weld area is raised to an incredibly high level. This makes the instantaneous welding of thick plates a relatively simple matter. Actually, in arc welding, a great amount of energy is released to create this heat. It is this great release of energy that gives the arc all its advantages as well as its few disadvantages.

The principle of arc welding is based on an important characteristic of electrical energy: to circle back to its source, or to the ground, and create a circuit. When electricity is generated, it does not pour out from the end of a wire like water out of the end of a pipe, but rather, the energy forms a circuit by going through the structure of the conducting material, as well as forming a field of tension around the wire.

The work is done by this energy as it makes this journey through the circuit in a circular path.

We can turn the current on and off, retard or increase the flow of the energy, accumulate energy, and make it jump across short distances of space and atmosphere to another wire that continues the circuit. Arc welding is based on our ability to step up current and to make it jump across (or *arc*) through the atmosphere.

At some time you may have touched two electrical wires together and seen the sparks fly. The electric welding machine is designed to let the welder do the same thing. One "wire" is the welding rod and the other "wire" is the sculpture or object being welded. The welder uses the spark to melt the first "wire" (his welding rod) at the end where the current jumps across to the object being welded; the spark also melts some of the second "wire"—the object or sculpture. In this way, the two "wires" (welding rod and sculpture) are melted together and *fused*. The welding machine builds up a high charge of electrical energy, and much of this energy is released in the form of heat and light as the spark jumps across the gap between the welding rod and metal surface.

□ DIFFERENT TYPES OF ARC WELDING

There are two different types of arc welding. One is done with D.C., or direct current electricity, and the other with A.C., or alternating current electricity. There used to be two different welding machines required to produce A.C. and D.C. current, but today there are welding machines that will produce either kind of current, at the flip of a switch.

However, machines that produce one current or the other, alone, are still manufactured (Fig. 153). The D.C. machine consists of a motor driven direct

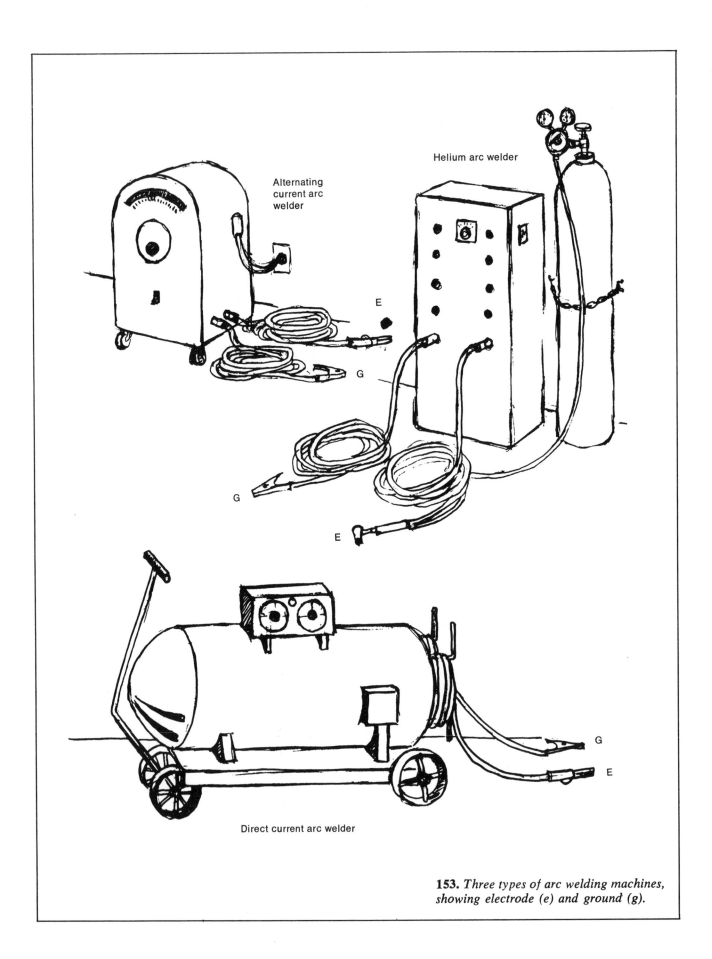

Alternating
current arc
welder

Helium arc welder

Direct current arc welder

153. *Three types of arc welding machines,
showing electrode (e) and ground (g).*

current generator (the driving motor may be electrical or gasoline powered). The A.C. machine has no moving parts and requires no driving motor. It uses a series of windings of copper wire to step up or transform the current that comes over the regular power line (as long as that current is A.C.). But the new A.C.-D.C. welders *are* built on the transformer principle. In these machines an A.C. current is produced which is converted or rectified into D.C.

In essence, both types of welding machine do the same thing: each type produces electrical energy, which in turn releases heat and light as it arcs, which in turn melts the metal of the electrode (welding rod) and base (object or sculpture being welded). But D.C. can be used for some things that A.C. cannot, such as welding bronze alloys and aluminums. On the other hand, A.C. has certain characteristics that are superior to D.C. in certain situations— such as a more stable arc flow. For the moment, however, these fine lines of difference do not concern us since they come up only in situations encountered by the job welder, not the sculptor-welder.

An additional development in electrical arc welding is the inert gas, or shielded arc welding method. This uses a high frequency electrical current which is sent through a tungsten electrode which does *not* melt off into the welded material. Instead, welding rod is fed into the arc flame area in the same manner as in the oxyacetylene process. A jet of helium or argon gas is sent through the electrode handle under pressure. This jet of gas surrounds the arc and the work surface while the welding rod and base material are being melted. This jet of inert, noncombustible gas shields the molten metal from the surrounding atmosphere and prevents the weld metal from oxidizing. This method of welding, called Heli-arc, makes the most beautiful welds possible, in materials like aluminum, magnesium, and stainless steel.

Of course, a beginner has no need for such expensive equipment. And a more experienced sculptor who might require the use of such equipment, for just one job, would be wiser to rent it. For the beginner, it is best to buy a small A.C. machine when he is ready to go into arc welding. You can buy a small arc welder that runs on A.C. house current (110 or 220 volts). And if you ever need a larger machine, trade this in or sell it at a good price.

☐ CLOTHING

Before I describe how you begin arc welding, I should describe the clothes that are needed.

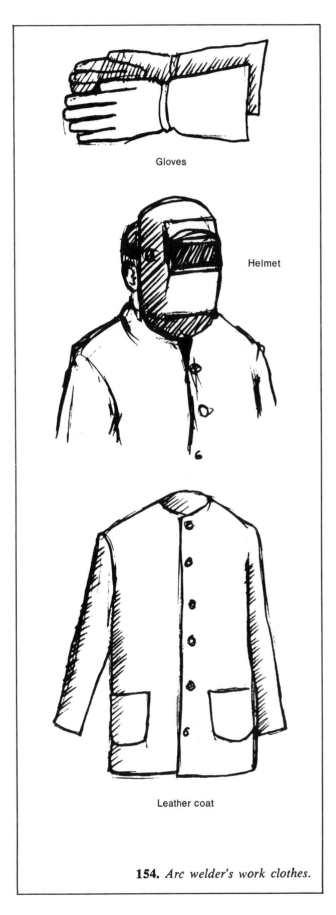

Gloves

Helmet

Leather coat

154. *Arc welder's work clothes.*

The best type of work clothes for the arc welder are denim pants and jacket covered by a leather welder's jacket or welder's leather apron (Fig. 154). To protect the hands and arms from arc radiation and the spatter of hot steel, leather arc welder's gloves of the gauntlet type should also be worn. There should be no cuffs on the trousers or open pockets on the jacket.

For eye and face protection, arc welders use a hard fibre helmet that covers the entire front of the face and neck. On the front, this has a rectangular opening which is covered by a dark glass which filters out the intense light rays. This dark glass is covered by a clear protective glass on the outside, which can be changed when it becomes too cloudy or spattered. To enable you to look at the work when you are not welding, the whole hemlet can be raised; the outer protective shell of the helmet is attached by joints to a headband that fits around the welder's head. This headband can be adjusted to fit different head sizes.

Oxyacetylene welding goggles cannot be used for arc welding because the dark glass is not dense enough to give you enough protection. In addition, the radiation from the arc is much too intense to expose the face safely.

Once you have donned the proper clothing and have your work laid out, you are ready to start the arc welding process.

☐ TECHNIQUE

The welding rods used for most arc welding purposes are called shielded arc electrodes. These electrodes are about 14″ long and coated with flux, except for 1″ of bare metal that is held in the electrode holder. The flux melts, thereby shielding the molten metal from oxidation, protecting the arc, and coating the deposited weld metal with flux.

The electrode holder is a spring clamp device, set into an insulated handle. When a welding rod has been melted down to the end held by the clamp, the welder releases the clamp and the remaining bit of rod is thrown away. A new rod is then clamped in. The handle, or *stinger*, as the welders call it, is connected to the end of a long rubber covered cable that goes to the welding machine and is connected to one of two connecting poles. The electrode is held in the same way as the oxyacetylene torch. The electrode cable can be connected to *either* pole of an A.C. machine, but on a D.C. machine it must be con-

nected to a *specific* pole. On either an A.C. or D.C. machine, the other pole is the ground cable (the name given to the second cable that completes the welding circuit), which has a clamp that is connected either to the work or to the metal table on which the work rests.

In simplified form, here is how the circuit works (Fig. 155). The circuit begins at the welding machine, travels through the electrode cable to the electrode (held in the welder's hand), then through the work to the metal table, and finally back through the ground cable (clamped to the metal table) to the welding machine. The welder is like a switch that opens and closes the circuit by touching the electric arc (from the electrode) to the work or withdrawing the arc.

To begin a weld, you select the proper alloy of welding rod for welding the type of steel you are using, and the correct thickness of rod for the size of your plate. Clamp your rod into the electrode holder. Turn on your machine and set it to the current setting recommended by the manufacturer for the type of rod and the thickness of the work. Adjust your helmet and gloves. Make sure your ground clamp is secure to the table or work. With the electrode holder in your right hand, approach the work. The rod is then held *near* the area where the weld is to be made; but, by all means, do not touch the work with the rod before your helmet has been lowered. With the end of the rod about 4″ from the work, snap your helmet down into position with a quick nod of your head. For a moment, you are in the dark (because the dark glass screens out all normal daylight) until you start the arc. The electrode is then immediately scratched across the surface of the work where you wish to weld, in the same way that you strike a match (Fig. 156). This starts the arc by beginning the flow of energy from the end of the electrode, across the short space of atmosphere, to the work.

Fig. 157 is a close-up of the process. When the arc has been started between the electrode and the work, great heat is instantly created. This heat melts the metal from the end of the electrode and also creates a pool of molten metal on the work surface. The metal from the electrode fuses with the metal of the pool on the work and solidifies as the welder moves the electrode forward. This creates a rounded seam (bead) of weld metal. Fig. 157 shows the electrode rod in the process of melting in the arc. The flux turns to a gas that protects the molten metal

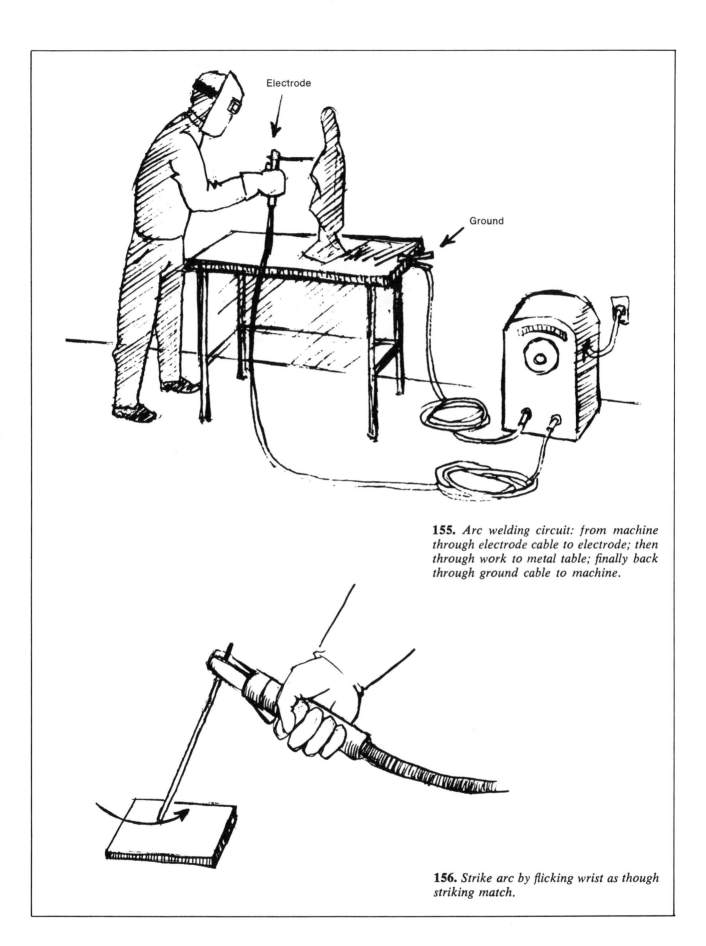

Electrode

Ground

155. *Arc welding circuit: from machine through electrode cable to electrode; then through work to metal table; finally back through ground cable to machine.*

156. *Strike arc by flicking wrist as though striking match.*

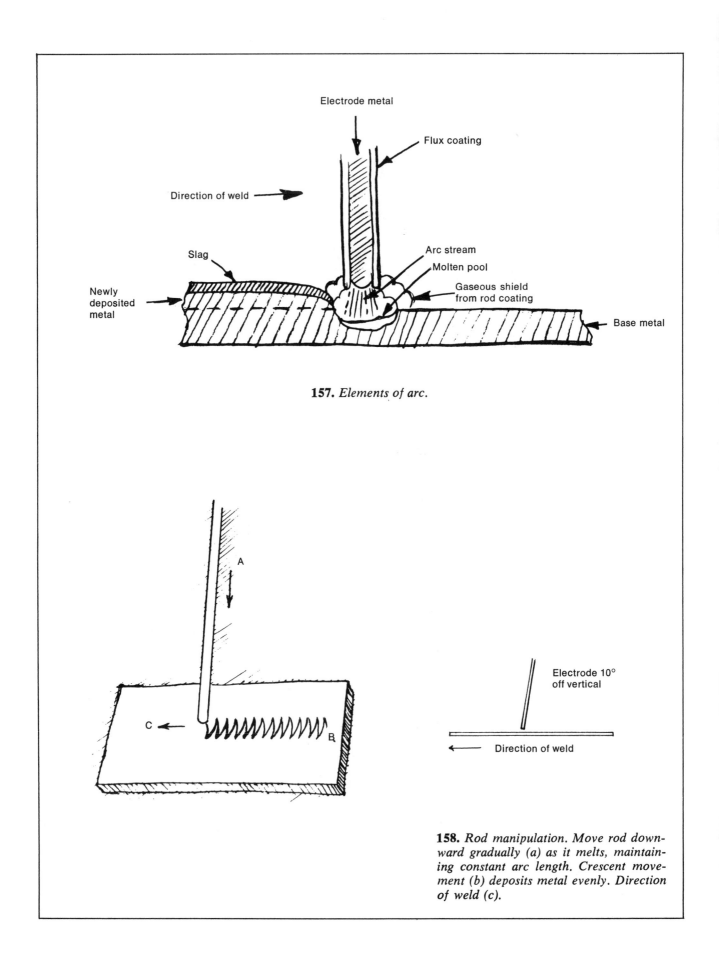

Electrode metal

Flux coating

Direction of weld

Arc stream

Molten pool

Slag

Newly deposited metal

Gaseous shield from rod coating

Base metal

157. *Elements of arc.*

A

C

B

Electrode 10° off vertical

Direction of weld

158. *Rod manipulation. Move rod downward gradually (a) as it melts, maintaining constant arc length. Crescent movement (b) deposits metal evenly. Direction of weld (c).*

from oxidizing, then turns into a slag coating on the newly deposited metal; this slag is later chipped off.

Your task is to maintain a steady distance between the electrode and the work surface (Fig. 157). This distance is generally about 1/8″. If the end of the rod is too far from the surface, the flow of contact will be broken and the arc will stop. If the electrode is brought too close to the surface, so that the fused metal of the electrode *and* the fused metal of the surface actually *touch,* the arc will stop, the metal will cool immediately, and the electrode will be stuck fast to the work. So, when the arc is broken because the electrode and the work surface are too far apart, the electrode is scratched across the work and the arc is started again. In the case of a stuck electrode, first release the electrode from the holder and set the holder aside. The electrode can be broken loose by twisting it back and forth, or by hitting the joint with a chipping hammer. If the rod is undamaged, it can be reinserted into the holder and the welding resumed.

The arc itself is an intense release of energy, the center of which can reach a temperature of up to 10,000° F. The light given off from the arc makes it possible to see the work quite clearly through the heavy protective glass while you work, but the light is very intense—in the ultraviolet range—and dangerous to your eyes if you look at it without a helmet. Looking at the arc directly (without a helmet) can result in an arc burn, which is such a hellishly painful experience that it cannot be imagined, and it should not be experienced just to find out what the pain is like. Looking into the arc without a helmet can cause serious damage to the eyes if it is done repeatedly.

As with all high energy release phenomena that man has found in nature and attempted to divert to his own ends, arc welding should be treated with maximum attention to personal and public safety. Concern with safety must become an ingrained trait when you use these processes. If you find that you cannot be bothered with these tiresome safety measures, you have no business welding.

Now to get back to the welding process itself. The holder and the electrode are manipulated with the right hand, while the other hand is kept free, used only when you replace welding rods. Rod manipulation is not difficult to learn if you have had previous experience with oxyacetylene welding. The movement of the rod in arc welding is the same as the movement of the torch in gas welding: a side to side,

crescent movement (Fig. 158). Position the electrode holder so that the rod is slightly slanted toward the weld (the direction of welding would be from right to left).

As the metal is deposited on the work, the rod burns down, thus becoming shorter. Your hand must follow this downward burnoff, moving gradually closer in order to maintain the proper arc length. At the same time, your arm must follow the crescent motion to deposit the rod in uniform ripples, as well as to continue the forward motion along the line of weld. It may seem quite complicated to the beginner, but with practice you will get to the point where you are comfortable doing all these things at once.

Just as with oxyacetylene welding, there are various positions possible for doing arc welding: overhead, vertical, horizontal, and flat positions, all of which can be learned with practice. In any of these positions, the welding seam, if properly made, will be covered with a solid coating of flux (or slag). This flux should be chipped off, when the seam is finished, by tapping it with the chipping hammer. It comes off quite easily and exposes a fresh, shiny metal bead beneath it. But great care should be taken when you chip the flux off, as it can easily fly into your eyes. Cover your eyes with safety glasses when you clean your weld. A chip of hot flux in your eye can be every bit as dangerous as an arc burn. I have experienced both, and have had a lot of unnecessary pain that I could have avoided.

There are several ways to make bad welds in arc welding. A serious error can be made if the arc is held too high from the work surface. This causes the metal and flux to be deposited unevenly and makes an unclean weld that does not have the proper penetration. A short arc length—the distance between the electrode and the weld surface—makes a good, sound weld. But if the speed of forward travel is too fast, the sides of the weld will be undercut (see Fig. 38, Chapter 2). If the speed of travel is too slow, the sides of the bead will overlap the base metal without fusion or penetration. Other problems can be caused by the metal base warping because of uneven welding temperatures. This can sometimes be prevented by tack-welding the whole seam or by welding the seam in sections: the starting area, the end area, the middle section, and then the areas in between.

☐ ADVANTAGES OF ARC WELDING FOR THE SCULPTOR

Instantaneous welding heat and metal deposit are great advantages to the sculptor using the arc, par-

ticularly when you are composing abstract elements that need to be quickly arranged or tacked in place. The arc is also extremely useful when you weld very thick steels, since no pre-heating is required. This makes it possible to put together large structures in a short time. When it is a matter of putting together pre-cut or pre-designed steel forms, the arc is far superior to oxyacetylene.

Of secondary but important interest is that sculpture armatures, tool stands, metal frameworks, and various other kinds of useful shop equipment can be built with the arc welder in a very short time and at minimum cost.

☐ WHERE THE ARC CANNOT BE USED

For the type of welded sculpture that requires modeling or any kind of subtle surface handling, the arc is unsuitable. The instantaneous heat and penetration can burn through a delicate structure in no time at all.

For doing close modeling or delicate work, the heavy helmet and gloves (required in arc welding) prevent you from getting close to the work. The very equipment of arc welding forces the sculptor to be somewhat removed from the substances he is dealing with. Arc welding is in no way an intimate medium.

Another interesting drawback is that the high energy that is released produces an atmosphere of positive ionization around the welder. And positive ionization tends to drain the energy or stalemate the energy in organisms, giving them the physiological symptoms of ill ease or anxiety. Negative ionization, which arc welding does *not* produce, gives the opposite effect—that of well-being and restfulness. I suggest you counteract this positive ionization effect of arc welding by showering after a session of work, or going for a swim. Running water produces negative ionization.

☐ MAKING SHAPES

The techniques for shape making are the same for both kinds of welding. The only real difference has to do with the speed of the arc and the fact that arc welded work must be attached to the ground cable at all times. If you decide to try arc welding as a sculpture medium, I suggest that you make all the abstract shapes that were described in Chapters 3 and 4.

It may be somewhat difficult for you to hold the small pieces in place while you are tacking the structure together, but this ability comes from practice in manipulating the electrode. Before you strike the arc, you are working in the dark because the helmet completely covers your face. At the beginning, it will probably be better if you use ⅛″ material, as it is less likely to be burned through if you misjudge the time you hold the arc for tacking. Once you get a shape all filled in, and do all the seams, you can create a textured surface by welding over the shape. But make sure to chip off all the flux before you start the surfacing, as the metal will not bond properly if the flux is not cleaned off. Also, when the work has been surfaced, be sure to clean all the flux off again, as the metal will oxidize more quickly if it is not clean.

Some modeling of the form can be done on the surface of the shapes by laying down successive beads of metal and by building up one layer over another. Again, be sure to clean off all the flux when doing this. Tacking is very simple with the arc; you only have to touch the work momentarily with the electrode. Because of this ease in tacking, you can make all sorts of temporary jigs and supports to aid you in holding the piece while you are working on it. The pieces you tack to the work—to support it or hold its parts together while you are welding them—can then be easily broken off with a sharp blow from a hammer when they are no longer needed.

☐ FOUND OBJECT SCULPTURE

Found object sculpture is easy to make with the arc welder (Figs. 159 and 160), as it is primarily involved with assembling ready made objects. To put metal objects of this sort together, you make only simple beads to join the component parts. These parts can be any steel objects which you wish to put together to construct your formal image.

Found object sculpture is, in a sense, cartooning, but in another sense it is built on the sculptor's recognition of the lifelike movements, functions, and shapes that manufactured objects possess. Found object sculpture at its best *can* have some of the same ritual or totemic qualities as African sculpture. No one can advise you what objects to put together to make this kind of sculpture, as the major content consists of the originality of the sculptor's choices.

159. Town Meeting, *arc welded found objects.*

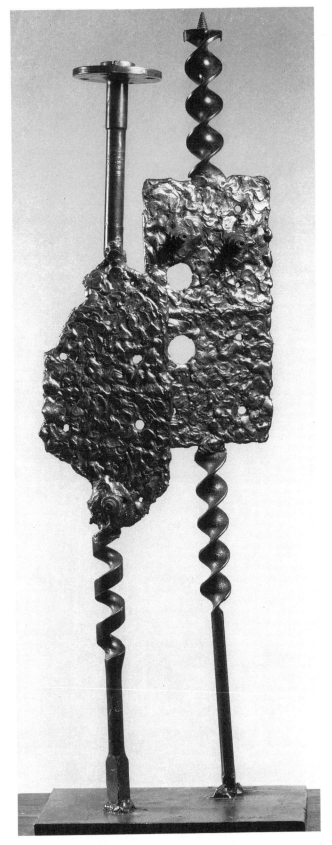

160. Picador and Wife with Wounds, *arc welded found objects.*

□ GEOMETRICAL SCULPTURE

Sculpture that is built on plane concepts—which involve the overlapping of planes or the juxtaposition of squares and rectangles of pre-cut plate—is very easy to accomplish with the arc welder. This work merely involves cutting out the shapes you desire and tacking them together in the arrangement that seems most suitable. When you have decided on the right composition, you merely weld the seams that you have tacked.

The solid, geometrical free form made of squares, rectangles, and triangles, such as the ones you did in the exercises of Chapter 3, is an ideal type of form for the arc welder.

There is always a certain amount of mystique involved when the person who does not understand welding looks at a welded shape. Even though the creation of this kind of sculpture is about on the "Tinker Toy" level, so far as the understanding of form goes, it often is very impressive to the critic or museum curator, particularly if the work is done on a large scale.

□ FINISHING ARC WELDED WORK

The most important thing to remember about arc welded sculpture finishing is: get that flux off (Fig. 161)! Most of the flux comes off with the chipping hammer, but there may also be a residue of small nodules of steel, which can be taken off with a wire brush or a chipping hammer. If the balls of spattered steel stick too closely to the plate, they can be removed with a cold chisel.

Welds and surfaces can be ground down with high speed grinders or worked with hand tools. The steel surfaces should be lacquered or painted. But if stainless steel is used, the surface can be ground or gone over with a sanding disk to clean off the scale and flux and then left as it is. Weather will not bother it.

□ THE ARC WELDING SHOP

When you plan to install an arc welder, the most important requirement is that the proper electrical current comes into the shop. Though there are arc welders that will run on regular house current (110 volts), the best current for dependable welding operation is 220 volts (or better). The characteristics of electrical current vary a great deal from one country to another, and you should consult with welding

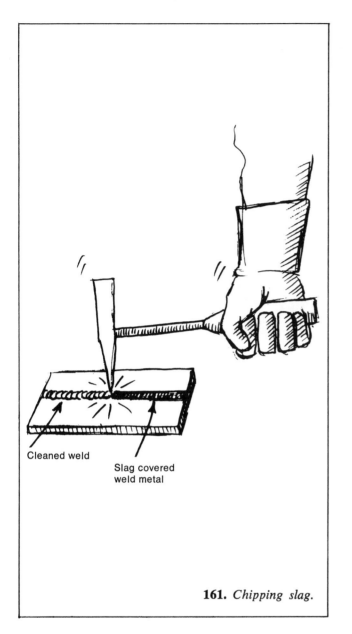

Cleaned weld

Slag covered
weld metal

161. *Chipping slag.*

equipment with a much more jaundiced eye than they do an arc welder. There is, I must admit, a greater danger of explosion and large scale conflagration (at least potentially), with oxyacetylene equipment. But even though there is no explosive potential with the arc welder, it is best to take sensible precautions in the studio and to keep all inflammable materials, such as paints and solvents, in a separate area and in an enclosed metal cabinet. Either a wood or a concrete floor can be used; but the spatter of small bits of steel from the arc is a constant occurrence during welding, and a wooden floor should be swept clear of any flammable materials and all cracks should be sealed up. On the whole, a concrete floor is always preferable to wood for welding shops.

The welding table should be made of steel, and it may be the height and dimension that you think will work out best for your own needs. Welding shops often use a slab of steel an inch thick for the table top. (Thinner steels will warp with heat.) This might measure anywhere from 2' x 4' to the size of the whole plate as it comes from the mill. The ground cable from the welding machine is clamped to the table top so that the work can be moved freely over the table surface. Since the table has the ground attached to it, anywhere the work touches the table surface will automatically ground it. The framework for the table slab can be made of 2″ pipe with ¼″ wall thickness, or of 2″ x 2″ x ¼″ angle iron. If the table top gets too covered with arc spatter, it can be cleaned with a high speed disk grinder.

Air supply and ventilation are very important in a shop using arc welding—just as important as with oxyacetylene. The burning of the flux coating on the rod gives off a considerable amount of smoke. This smoke is not harmful in a direct way—as zinc fumes are—but the less you have to breathe of any impurities, in these days of air pollution, the better your health will be. And, of course, if you did weld in a closed area with no ventilation, you would be in danger of being overcome by the smoke. So if your shop has a door opening to the outside, or large windows, they should be left open while you are arc welding. If the ventilation is not good, use a strong exhaust fan to clear the air.

Arc welding requires the same tools as oxyacetylene welding. The only additional tools needed are the chipping hammer and a wire brush. The helmet and gloves described earlier are all that you need to complete the outfit.

supply firms about your local requirements and the most suitable set-ups. Only the heavy industrial welders require current as high as 440 volts, so you will not have to worry about finding that kind of service. With a current of 220 volts (or thereabouts) wired into your shop, the installation and operation of an arc welder is quite simple. Some of the smaller types of machines will just plug into a socket, while others may have to be wired right into the line; but that is no difficult matter. Consult with an electrician if you are in doubt as to how to make your hook-up.

As far as fire regulations for arc welding are concerned, they are generally very simple. Fire departments, for some reason or other, regard oxyacetylene

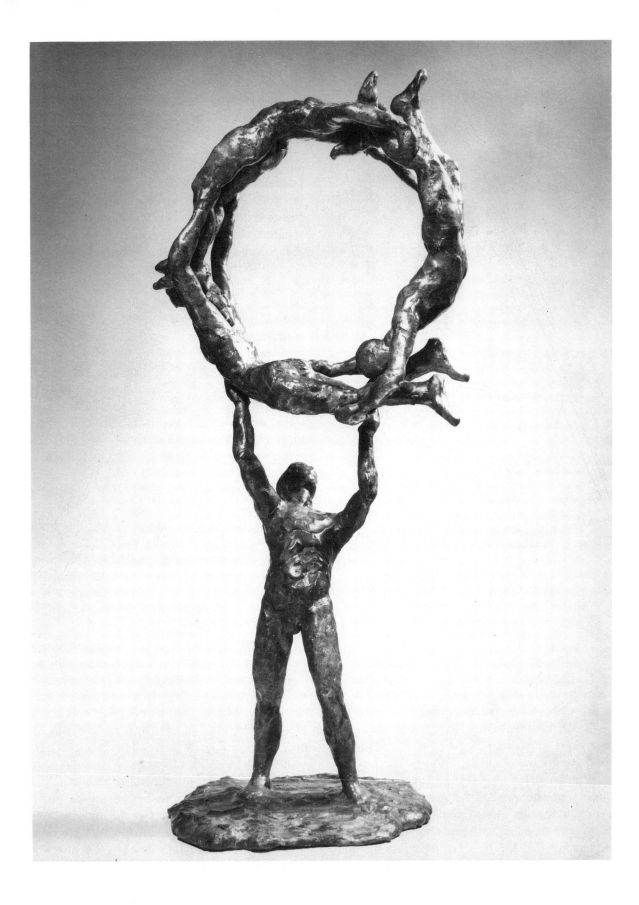

Atlas Wheel, *nickel silver, 14" high, collection, Mr. and Mrs. Henry Brunie. All the figures of this composition have been given considerable action and bend in the torso. The supporting figure was first placed on the base. Then the figures of the wheel were connected to one another by fusing hands and positioned on the uplifted hands of the Atlas figure, which were, in turn, modeled onto the place of contact.*

Sculptors do not often produce large scale works unless they have been commissioned to do them or have some specific use for such a work. Large works require large storage spaces, and are expensive to crate and ship to exhibitions. Unless the artist is very well known, very large works are difficult to sell, as collectors generally want smaller pieces that will fit into the decorative scheme of a home or office. Another aspect of this problem is that large works in metal represent sizeable investments in capital and labor; sculptors cannot afford the kind of investment that may never be returned. Finally, the professional sculptor understands that he can best work out any form in a size scaled to his studio space and storage facilities, which are usually modest.

However, aside from all this good common sense, every sculptor should have the opportunity to make a few large scale white elephants. They give him good experience. And even though they may never sell, the worst that can occur is that they may eventually have to be broken up and carted to the scrap heap. If you have never put your hand to a large work, you may never really be confident about accepting a large commission when one comes along.

When the day comes when you feel you absolutely must do a very large piece, I suggest that you use the enlarging technique I describe in this chapter; while satisfying the urge for monumentality, you will also learn a very valuable sculpture process.

Some day, after a certain point in your development, you may meet an architect or a building owner who feels his building needs some sculpture to set it off. In that case, you should know the legal and technical procedures necessary for doing a commissioned work. I intend to discuss these aspects of sculpture, plus the emotional and esthetic problems that are part of doing architectural sculpture.

□ CLIENTS

If you are contacted by an architect (or if you contact him) for the purpose of doing a work of architectural sculpture, and you find that he will be responsible for approving your designs and paying you for your work, he is your client. Generally, however, the client is not an architect but a person, firm, committee, or builder responsible for the erection of the building or structure. In this case, your client will pay you for your work and approve your designs, and will probably want the architect to approve them, too. Most architects insist on having a say about anything that involves the buildings they design, and a client who commissions a work generally has a specific kind of sculpture in mind.

Since the early part of the last century, when artists became free agents—working without clients, seeking their own goals, and exploring their own esthetic purposes—artists have moved farther and farther away from the state of mind of those Renaissance and baroque masters who worked for wealthy patrons, the state, or the church. With this new found freedom, artists have had total responsibility for their work, from beginning to end. This independence (or isolation, if you prefer) has not encouraged the frame of mind necessary for doing collaborative work.

Architectural sculpture introduces other factors into the art process, factors that are often disturbing to the independent frame of mind that the twentieth century has given the artist. One of these factors has to do with fitting sculpture harmoniously into an architectural space—and this is the key point in your relationship with the architect. Another factor is the subject matter or the content of the sculpture which, in the case of a commission, is generally dictated by the client. Because the client is the one with the

money and the job, you must face the problem of being the agent who expresses someone else's ideas, or dealing with people who will be very critical of the ideas and forms *you* express. For these reasons, the design of sculpture for architecture is often fraught with political maneuverings, esthetic vanities, and high pressure tactics of the most unesthetic kind. Therefore, it seems obvious that architectural sculpture is not a realm of art recommended for the person who is extremely sensitive, naive, or mystical.

As a profession, architectural sculpture requires toughness of character; political skill in dealing with people and organizations; ability to estimate costs in large amounts of money; the skill to supervise workmen; the capacity to carry out obligations on time; and a good knowledge of the technical problems of architectural sculpture. Some artists seem to possess the kind of character that naturally adapts to this field. To others, doing architectural work is the most burdensome kind of work imaginable.

☐ THE DESIGN PROBLEM

Designing architectural sculpture is always the first problem that faces the sculptor. Usually, a certain amount of money has been set aside for the art in a building, and usually the client has some vague design in mind that he hopes can be done for the sum available. Analyzing these two factors, you get a rough idea of the scope of the work and you can tell the client whether or not the project can be done. Then you sit down at the drawing board and begin to work out designs to submit for the client's approval.

Unfortunately, in the planning of buildings in these times, sculptors are not consulted at the beginning architectural stages to help determine what type of sculpture is best suited for the building. In most cases, by the time the sculptor sees the plans, the architect or building committee has already decided on the kind of sculpture, its size, and, more than likely, the material to be used. So by the time the sculptor has been called in, his work has, in many respects, already been designed by the architect or building committee. The average architect has the attitude (if he has any attitude about sculpture at all) that sculpture can be bought and installed like plumbing. Many sculptors accept this as the natural state of things and grind out miles of uninspired work, but any architectural sculptor worth his salt

will, in all cases, attempt to make the major design decisions about his own work, or face the truth that he does not make art—only a kind of decorative carpentry.

As a sculptor working in architecture, you must attempt to be involved in the planning from beginning to end. This means that you begin to work with architects as a matter of habit. If you make friends with architects and get them interested in your work, you will stand a much greater chance of being included in the whole design process. Try to meet architects whose work you admire, and they may possibly become interested in collaborating with you. Of course, the only thing that can change the over-all situation is to have sculpture students and architecture students work on projects together when they are in school. This has been successfully done in the Cornell University College of Architecture, under Dean Burnham Kelly and sculpture instructor, Jack Squier.

Beginning the sculptor-architect collaboration in the schools may be the answer to changing the random and uneven quality of so much work that is done. However, there is no quick cure. It may take a decade or two of actual practice before any tangible results come from these experiments. But long range programs are the only way to achieve solid cultural results. It takes a whole environmental attitude to produce many highly skilled professionals rather than just an isolated genius or two who may have the strength to rise out of chaos. And such a program would be more than worth its salt if it produced only a few more architects like Percival Goodman, Gordon Bunshaft, Ulrich Franzen, Morris Ketchum, Philip Johnson, or Richard Snibbe, bold planners who have fought for the incorporation of sculpture in modern architecture.

☐ MAKING PRELIMINARY DESIGNS

Assuming that you have come to some agreement with the client and/or architect about the type, size, and medium of the sculpture in very general verbal terms, you begin negotiations by making a series of drawings suggesting possible compositions. Make the sketches only after studying the building blueprints so that you can relate your sketches to the scale and forms of the building.

162. *Sketch of walking man, 10″ solid figure for presentation to client.*

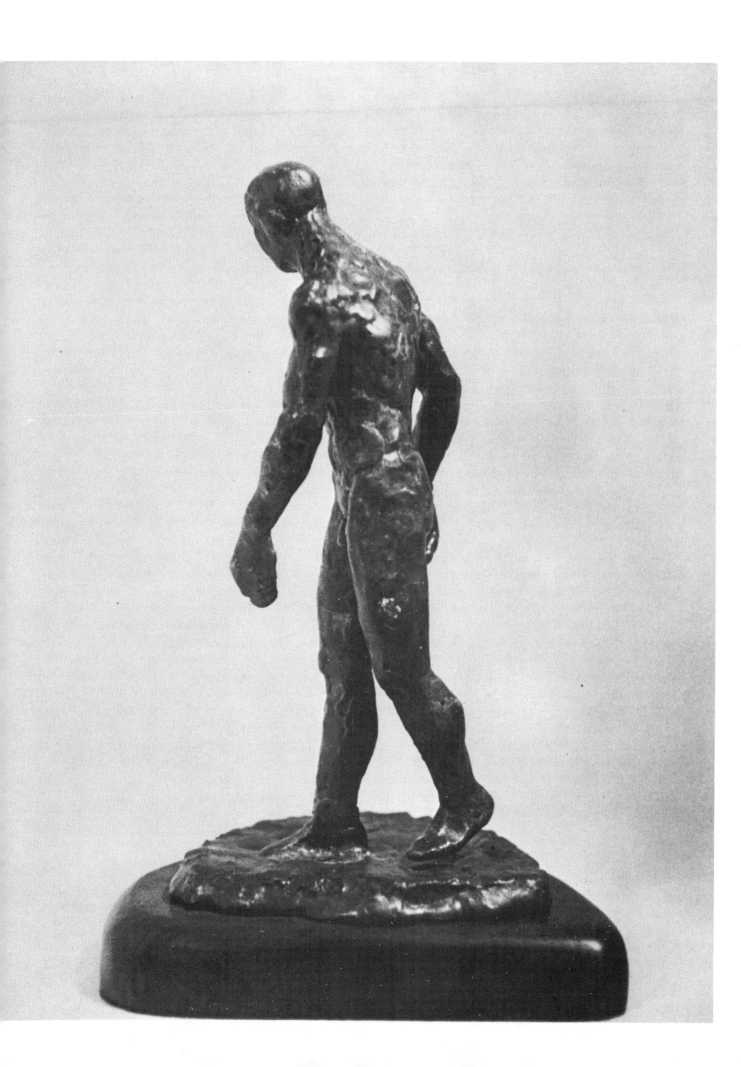

If you are a figurative sculptor, your designs should be in the figurative vein; or if your work is abstract, you should stay within your style of expression. It is a great mistake for a sculptor to work in styles that are not natural to him. And changing style at the drop of a dollar is not conducive to the finest kind of public art.

☐ CLIENT VS. ARTIST

The client will examine your designs (and the designs of any other artist who has been asked to submit his work) and select the design he prefers. If you have done a thorough job of it, and if luck is with you, he will pick yours. He may also choose your design, but ask you to alter it or do new ones.

The client is in the position of having money to spend and with this goes the responsibility of selecting the right art for the building. He might fear that he will be criticized for having allowed the sculpture to be put up, and this may make him interfere or become over-critical of your work. One client may not interfere in the sculpture process, but another may feel that he has the right to direct or interfere with the artist's every move. This kind of interference is the biggest hurdle to leap in doing any architectural sculpture. The academician leaps this barrier by starting out with a trivial, empty manipulation of forms that panders to pompous, middle class tastes. The good artist will fight for what he believes should be done; he will work to win over the client to his point of view.

When submitting designs for architectural sculpture, you should go to any lengths to explain why you have made your design decisions. You should be able to listen to intelligent criticism (and some architects and clients are very intelligent about art), and be able to make alterations in your designs if they will benefit from the changes. But you must always be in command of your own position, so that if the architect or client goes too far with unreasonable demands, you can face the possibility of giving up the work, if it seems necessary.

☐ MAKING A SKETCH IN METAL

If the client accepts your designs and you feel that you can handle the commission, your next step will be to make a small bronze sketch (Fig. 162) to give him an idea of what the work will look like in three dimensional form. For making the sketch, you can use the technique described in Chapter 5 for making small bronze figures. When you complete this little bronze, you should give it a nice patina and base.

Your purpose in making the sketch, aside from presenting your concept to the client in tangible form, is to make a preliminary analysis of the sculpture problem. Making the sketch gives you an opportunity to work out the methods necessary to construct a quarter scale model when the time comes.

The time and money you spend in making original designs and the small bronze sketch are generally done at your own expense, as an investment in getting the job. Some artists regard doing designs and sketches as a great imposition. They resent doing them and feel they should be paid for them. I do not feel that this attitude is reasonable, as it would cost the client money that should go into the commission itself. Furthermore, if this were the custom, beginning sculptors would always be overlooked and not be given as many opportunities to submit designs as the older professionals with known skills.

A busy sculptor of established reputation would be justified in charging for his time, as he could be turning his hand to other work which would bring him money; but for a beginner to attempt to charge for preliminary designs and a welded sketch would be mere vanity. There is no other way for beginners to gain commissions. And doing preliminary designs for possible clients, even though you may not get the jobs, gives you invaluable experience with architectural problems. Most old professionals will tell you that if you get one commission out of ten or fifteen that you do preliminary designs for, you will be doing very well. So another important quality an architectural sculptor must have is the ability to tolerate rejections.

But once the client has seen the bronze sketch and accepts the design, you will be ready to draw up a contract which both parties agree to and sign. However, before you are ready to make a binding legal agreement, you should make an exact estimate of the costs of the sculpture, as close to the last penny as possible. Once you have signed the contract, you must be sure that you have enough money to complete all the stages of the work and, of course, also show a profit when the work is completed.

163. Quarter scale model: two views of clay study (facing page), welded armature, and completed hollow welded figure (next two pages).

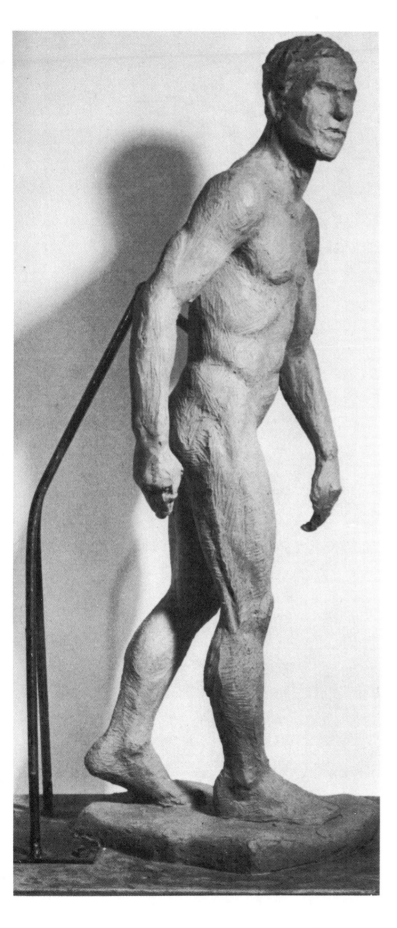
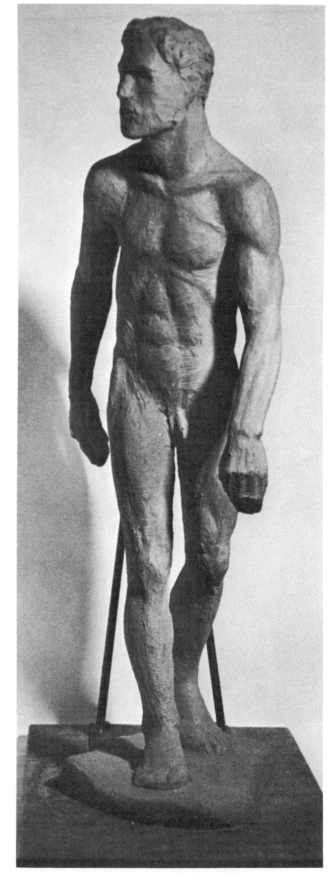

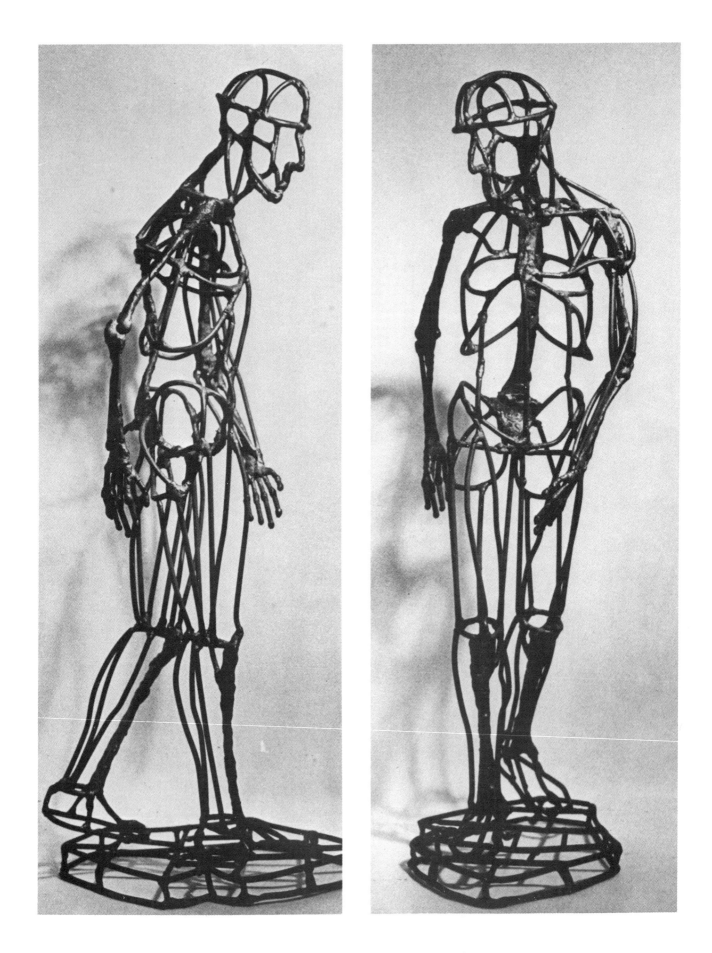

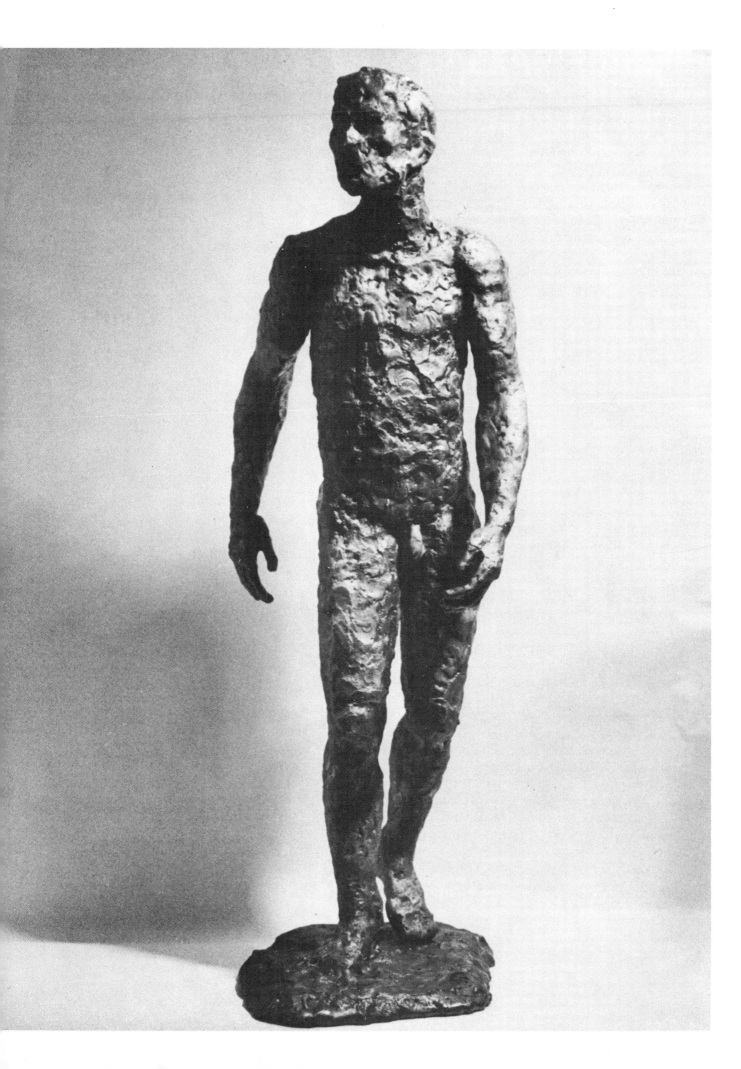

ESTIMATING THE COSTS OF THE COMMISSION

Your estimate of the total cost of the sculpture is based on the cost of the materials, your shop overhead, your time, the installation costs, and a certain percentage of this total for profit. This estimate should include the cost of doing the scale model (which is next in order after signing the contract), as well as doing the full scale finished work.

Start by figuring the amount of metal plate you will need. Once you have decided on the thickness of the material, you make this estimate by figuring out the square footage of metal plate that your design will include. Add 25% to this figure for the scale model, and perhaps another 3% for spoilage and miscellaneous needs. Next, estimate how much welding rod you will need; there is generally no waste of welding rod, as you tack the small ends of used rod to the new ones and melt them down. Figure amounts of rod for all the seams and for the surfacing, and also add 25% to this amount.

Calculate the amount of oxygen and acetylene your work will consume. This is done by estimating the hours of welding with a certain size tip. Once you have figured out how much time will be spent in actually welding, your welding supply dealer can give you an idea of the amount of oxygen and acetylene you will need. It may also help you to figure out the actual length of metal seams you will have on your full scale piece and then make some test welds on the same material in order to determine your welding time.

In your estimate of costs, also consider any special tools and equipment you may have to rent or purchase for the job. It is easy to forget that tools may be broken or wear out. A small "miscellaneous fund" may cover this item.

To these items, add your shop overhead for the entire time of the commission—rent and all utilities. Add any labor and hauling costs that may be required for the installation. Then add your own wages for the period of the commission. And finally, add your percentage of profit. This percentage is up to you to determine, and it may range from zero (if the job is one you are really interested in doing) on up to about 20% if the traffic will bear it.

If the total figure comes within or below the figure allotted by the client, you can afford to take the commission. As I have said, it is sometimes advisable to take on work on which you do not make a profit but only break even, if you really like the job. It is also better to stay busy than be idle, and if you are busy enough, you will find that commissions breed more commissions.

THE CONTRACT

Your contract should be drawn up by your own lawyer and it should stipulate a number of definite things. There should be a complete description of the proposed work. This should include its exact site or position on the building; the type of material used for construction of the sculpture; as well as the kind of base or mounting to be used. The contract should also mention which party will be responsible for installation, mounting, and the attendant costs.

The total fee to be paid should be specified, plus a schedule of the payments. This means that you should be paid percentages of the commission money as the various steps of the agreement are fulfilled. A common schedule of payments agreement is that the sculptor is paid one third of the total amount when the contract is signed; this covers studio expenses and the costs of materials. The next payment of one third is made when the quarter scale model has been completed and approved by the client. The final third is paid when the full scale work has been approved and installed. This final payment should represent the termination of the contract.

The contract should also include a schedule of time conditions that obligate you to deliver the various phases of your work on certain dates: the scale model completed in a certain time, the full scale work completed in another interval, and the final installation by an ultimate date.

There may be certain variations in the exact kind of agreement because of specific situations, but be sure to have your lawyer read and explain every detail and give his approval to the contract. You may be dealing with thousands of dollars and a great deal of time, so it is of the utmost importance that both parties understand the terms and obligations. If you do not have a clear contract, you may have to work under great tension because of the lack of a basic agreement. You may even have the unhappy experience of losing a great deal of money if your work is not legally protected. It goes without saying that you should not accept this type of work unless you are capable of prolonged effort and responsibilities.

MAKING THE SCALE MODEL

When you make your model, you must take the scale and form of the architectural setting into full consid-

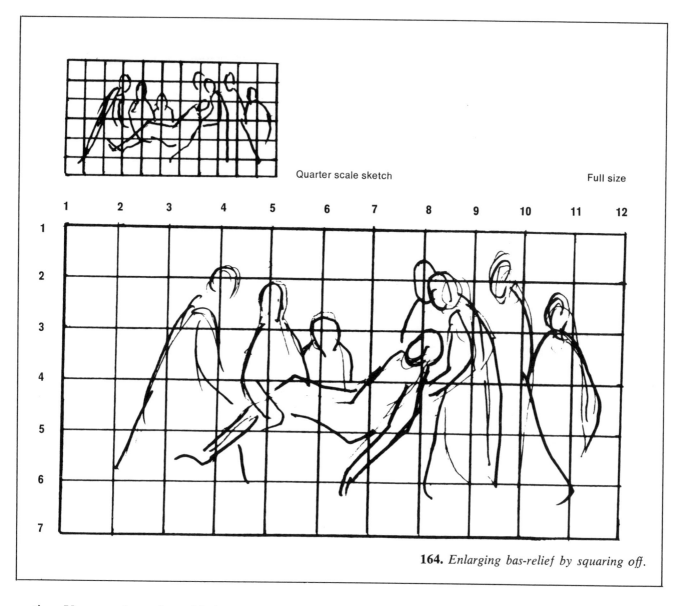

Quarter scale sketch Full size

164. *Enlarging bas-relief by squaring off.*

eration. You may have done this in making the first drawings of your design, but when you build the scale model it is advisable to build it in relation to some of the actual shapes of the architecture. For this purpose, it is useful to erect a quarter scale mock-up (Fig. 163) of the architectural framework in your studio. You will have been given a set of the building plans by the architect, which you can follow in constructing the mock-up. But you must be very exacting in taking these dimensions. Check them over several times. Any error at this stage can result in the finished work being entirely out of scale.

Your architectural mock-up can either be drawn on the wall, if the parts of the building relating to the sculpture are flat, or it can be constructed of wood if the sculpture is to have a more three dimensional setting. Once the quarter scale mock-up has been constructed, you can now start to work on the armature itself.

Use your small bronze sketch as a guide, and be as careful and exacting as possible in constructing the armature. This means that you must work out all the planes and curves of the forms exactly, since these forms on the quarter scale model will dictate the shape of the full scale work. Any fuzziness or indecisiveness in the form at this stage will only be magnified in the enlargement, and an enlargement is much more difficult to alter than a quarter scale model. In making the armature, you can adapt the techniques described in Chapter 3, 4, and 5.

Once you have made an accurate and well thought out armature, you can proceed to close up the form. Be sure to fit the covering pieces with just as much care as you used in making the armature. When all

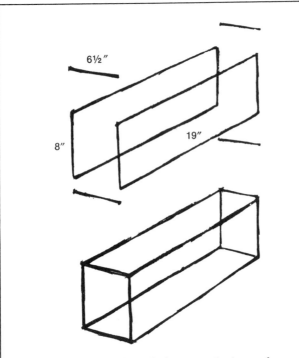

165. *Steel rod framework for enlargement box to contain quarter scale figure.*

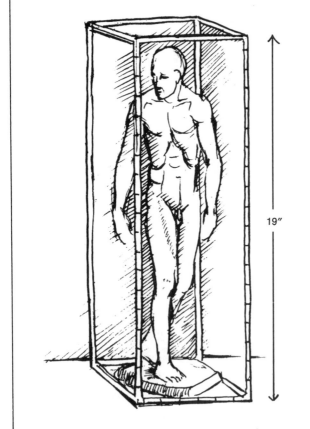

166. *Quarter scale figure in enlargement box (chassis).*

the forms are covered, check them to make sure that they are exactly as you want them, and make any final alterations before you weld the seams and surface the piece. This model should indicate all the major forms of the sculpture, but it does not have to show all the surface detail that you intend for the full scale piece. When the piece has been surfaced, you should give it a good patina and mount it on (or in) the mock-up just as it will appear on the building. Finally, call the client to view the work and to give his approval.

When you have finished the scale model and have made it ready for presentation, you should be absolutely certain of your design. You must show complete confidence to your client, even though you may be somewhat nervous. Of course, everyone is nervous when large sums of money are involved, including clients who may be used to handling millions. But try not to show your natural apprehensiveness, since you want your client to feel relaxed and receptive. Let your work do the talking for you and answer only those questions that the client might bring up. Present your work in the best possible light; set the stage for viewing it as carefully as you would present a play or a one man exhibition.

☐ ENLARGING TO FULL SCALE

There are several methods used to enlarge sculpture, but all are based on the same principles. There are two methods that I recommend as being easy to understand and very easy to apply.

Squaring off: One method often used for bas relief enlargement consists of *squaring off*. With a pencil, the surface of a sheet of paper is divided into 1"x 1" squares, like a checkerboard, and the outline of your quarter scale bas relief is traced onto this surface (Fig. 164). A full scale surface is then squared off in 4" x 4" squares. It is easy to transfer the flat design from the smaller to the larger surface simply by matching each small square to a corresponding large square and duplicating the lines that appear in each square.

Enlargement by chassis: For work in the round, the best method is called *enlargement by chassis,* and is really an extension of the squaring off method into three dimensions. While the above method can show only one side of a form, you can locate any part of the form's height, width, or depth by using planes squared off like a checkerboard and constructed in

three dimensions in the form of a box. Thus it is easy to reproduce any three dimensional form in an enlargement by the method I will describe.

The chassis, made of metal bar stock, is a rectangular box-like framework, open on all sides and made to fit over the quarter scale figure or any form you wish to enlarge. If you wish to enlarge an 18″ figure to life size (6′) you would build the framework so that each one of four side pieces is cut to 19″ long; the height of the chassis framework should be slightly higher than the sculpture (in this case, 1″ higher). For the shorter pieces that connect the four side parts, you measure the widest part of the sculpture (perhaps 6½″), and also measure the longest dimension from front to back (let us say 8″). You cut four pieces for each of these dimensions and use two 8″ pieces and two 6½″ pieces for the top, and the same for the bottom of the box (Fig. 165). The object is to have the whole quarter scale sculpture fit inside the framework.

For the quarter scale model, the framework pieces can be made of ¼″ steel bar. To assemble the box, cut the pieces and make two rectangles, each measuring 19″ x 8″. Each of these rectangles can be made by placing two 19″ pieces on the welding table parallel to one another and connecting the two pieces at the ends with 8″ pieces of rod. When the pieces of each rectangle have been properly placed, the ends are tacked and welded. After this is done, all that remains is to connect the two rectangles with the 6½″ pieces so that they form the box framework. Do this by resting both rectangles on edge on the welding table along the 19″ dimension. Prop each of them so that the sides are perpendicular to the table surface. Insert two 6½″ pieces at the ends, tack and weld the corners. Once this is done, turn over the structure and insert the two remaining 6½″ pieces at each end. When these pieces have been tacked and welded, the structure is complete.

The 19″ members are then marked off in inches; use a three cornered file so that the marks are legible. The inch marks on all four pieces should be exact and match up all the way around. These marks are made so that when the framework is placed over the figure you can read the height of any form by relating the form to the marks on the frame. A cross piece is clamped on the frame with spring clamps. This cross piece is also marked off in inches so that not only the height of a point can be determined, but also its distance from the side planes of the framework. A third piece (also marked off in inches),

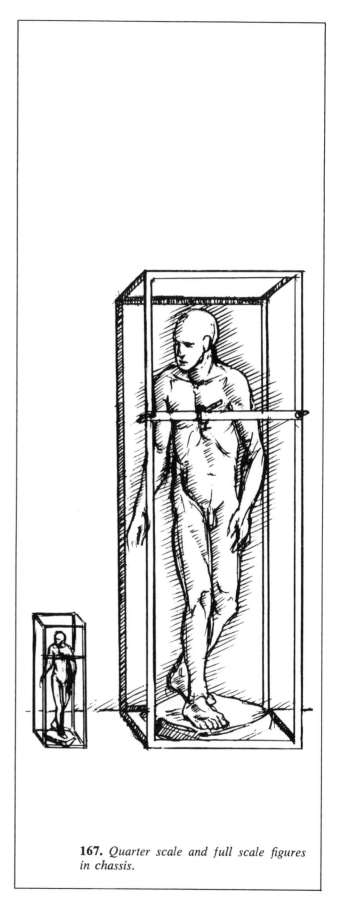

167. *Quarter scale and full scale figures in chassis.*

which we can call a depth stick, is then used to find the depth of the anatomical point from the plane of the framework; this depth stick is not clamped on, but simply hand held for measuring.

For example, if you wish to locate the xiphoid process of the sternum, you would bring the horizontal piece up to the height of this anatomical detail on the front plane of the framework and clamp the piece in place so that it is level. For the xiphoid, the height would be 13¾". Then you read the inch marks on the horizontal piece. In this case, the point of the xiphoid process is three inches from the right end of the horizontal piece. Then, measuring in toward the inside of the box with the depth stick, you find that the xiphoid process is 2⅞" in from the front plane of the framework. In other words, by finding the relationship between the anatomical point and the various measurements of the chassis framework, you are able to fix the location of that point in space. And because all points of the figure can be measured in this way, it is then a simple step to transfer these points to a larger figure or form inside a larger framework with the same proportions—let us say four times larger.

You may now easily visualize the steps required to make a full scale figure from the quarter scale model (Fig. 166).

You begin by erecting another rectangular box framework, exactly four times as large as the first one. You *can* use wood, but steel is preferable for welding purposes. Instead of marking off your large chassis in 1" increments, you mark it off in 4" divisions. The large armature, in this case, would be 76" high, 32" deep, and 26" wide. The material could be 1"x 1" angle iron or any shape of steel rod thick enough for a structure of this size.

A full sized armature (Fig. 167) is erected within this framework by transferring the measurements of the important anatomical points to the framework of the larger chassis. You begin by locating the points of the base and constructing its outline within the chassis—actually welding the form inside the chassis. Next, the points of the feet, ankles, and knees are located and erected as rods of the armature. Next the femurs are erected up to the greater trochanters, and the trochanters are connected by a cross piece. Locating all the anatomical points (or abstract forms) that you used to construct your quarter scale figure is merely a matter of transferring the height, width, and depth of them onto the large chassis and welding the corresponding bit of armature in place.

For example, to locate the xiphoid process on the large chassis from the measurements you have already taken, you count up 13¾ units on the framework and clamp the horizontal piece on. Next count three units from the right, and from that point insert your depth stick 2⅞ units. Since all these anatomical elements are four times as large as the corresponding pieces on the quarter scale chassis, all the dimensions taken from the small framework will be enlarged four times. The xiphoid process will be located at a height of 41¼" without your having to do any complicated arithmetic. The same will be true for all the rest of the measurements. Erecting the entire armature is only a matter of transferring the important anatomical junction points from one scale to another. And once the large armature has been constructed (so that the major masses of the figure or abstract form have all been outlined), it is a simple matter to block in the forms and then make whatever alterations might seem necessary.

☐ FULL SCALE ARMATURE

When constructing large forms, the armature material should be made of rod heavy enough to support the weight of the large forms. This does not mean that you have to use expensive bronze rod for the armature; it is just as good to use steel for the inner parts of the armature. But it is advisable to construct a core of very heavy material to act as a skeletal support which remains inside, as part of the structure. This core framework should be attached to the external part of the armature at important points—ankles, knees, pelvic crests, spine, sternum, shoulder joints, elbows, wrists, and occiput.

The inner armature structure should be well engineered so that there is a core of solidity and support to the whole sculpture. In some cases, the inner armature will have to support hundreds of pounds of metal. Because of this, it is particularly important to reinforce points of greatest stress, such as where the ankles attach to the feet and the base. If you are in any doubt as to how much strength you need for an armature in a piece of architectural sculpture, by all means check out the problems with an engineer, so that the work will be safe for the public.

☐ INSTALLATION

Since the problems of covering the armature and surfacing the sculpture have already been fully dis-

cussed, the only remaining problems involve the installation of the work. Probably the worst thing that can happen when you are doing a commissioned piece is that you finish the work, have it delivered to the building site, and then find that the bolts and attachments on the building or the base and those on the sculpture do not match. This situation happens much more often than sculptors like to admit; the only way to avoid it is to make extremely accurate drawings of your installation fixtures, and to actually supervise the placement of the fixtures at the building site. This placement of the fixtures should be done *before* the work leaves the studio.

If the work is to be mounted on the building wall, you must make sure that the wall structure is able to support the weight of the sculpture. You will also have to construct attachments on the back of your sculpture which must be strong enough to support the weight of the piece; moreover, these must line up with the support pieces on the building. And most important, you must remember that you will have to be able to reach behind the sculpture to tighten the nuts and bolts. An attachment that you cannot reach will be totally useless. In the same vein, if you have too few attachments, this can mean that the installation is unsafe, or that, at the very least, the sculpture will sway in the wind. There is no such thing as too many attachments for a heavy piece of sculpture—within reason, of course. At least two or three extra will do no harm.

The transportation of the sculpture to the site should be carefully worked out before the work leaves the studio. Your piece may require supports under it, and these should be ready when the truck arrives. It is always wise to have plenty of padding to protect the surface, too. Work out the route of transport and drive over it beforehand if you can. This might eliminate all kinds of problems. In other words, take full charge of all aspects of your work.

When the sculpture is safely delivered to the installation site, all the staging, supports, and blocks and tackle should be waiting and ready to use. You must be as sure as possible that all the moves are worked out beforehand so that there will be no hitches in the installation process. If you are at all uncertain about handling the job with skill, by all means consult an expert in the field. You may also find that you will have to use union help in your area, or that there are certain local rigging regulations that you will have to abide by. The architect may have some good advice to give, and it would also be advisable to discuss the problems with the building contractor; but your best bet would be to consult with a local sculptor who has done a lot of architectural work.

☐ IDEAS AND BELIEFS BUILD THE CULTURAL SHELL

The very great art expressions of the past in sculpture have always been intimately linked with architecture. In the greatest periods of man's achievement, the men of these two fields have worked together to produce structures that have embodied the whole philosophy of their culture. This ripening and flowering of culture may or may not happen in the latter half of the twentieth century. But if it does not happen, it will not be because the tools and raw materials of such an expression are unavailable. Any failure in this direction will be a human failure.

You, as a sculptor, or student of the art, must remember that the first ingredient of a great work is always the idea—human values and moral content. In creating architectural sculpture, we are dealing with symbols that may affect thousands of people for many years. So it is important that you do not lend your talents to erecting trivial, misleading, or destructive public works. Just getting commissions is not the mark of a successful sculptor: doing only the finest and most beautiful work, the most meaningful work of which you are capable, will be what makes you a fine artist.

At times you may be serving art and the community more significantly by *refusing* a project in which you really do not believe than if you took the job and made a large amount of money. The danger about architectural sculpture is that—difficult as it may be to do—once done and installed, it is far more difficult to remove.

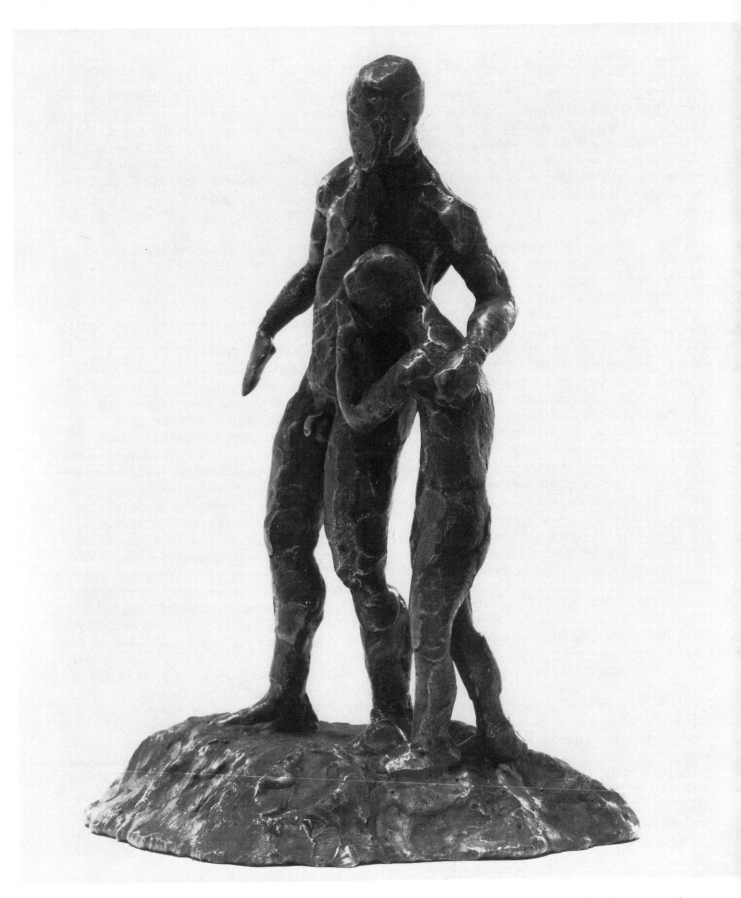

Solace, *manganese bronze, 8" high, private collection. These two figures were constructed in the manner described in Chapter 5. The action was planned before welding the figures to the base. The left arm of the adult figure was made and joined to the torso without a hand, so that the attachment of the hand to the child's back could be modeled directly onto the figure.*

One of the unfortunate things about art schools is that they teach no classes in the economics of art. The art student may be filled with the grandest ideas and plenty of facts about other aspects of art, and he may even develop his talent in art school. But when he is ready to go out on his own, he has few criteria for evaluating the economic problems of art or for making business judgments. He often does not even know how to begin setting himself up as an artist, and he may waste a good deal of time finding out some rather simple things.

After a little discouragement, he may (and often does) take the seemingly simple alternative route of teaching art, if he has a degree. Of course, this does not solve the problem, but it is a sure way of continuing to confound himself and continuing generations of fine art students. Such a teacher rarely knows anything first hand about the professional practice of art, and this is what art students need to know. The schools are full of this kind of teacher, these days, and all of them have to put up a front of competence in the classroom—which they do not have in the outside world. So school life and teaching can become an end in itself.

I experienced this lack, myself, in my student days. In later years, when I began to teach after having won some knowledge of art economics through trial and error, I saw this lack of experience again, in some of the art teachers that I came to know. This made me determined to pass on some of the things I have learned about art economics to those who might find them useful.

□ KEEPING YOURSELF ALIVE

In order for you to begin to produce art, you are required to make an initial investment in training, tools, materials, and work space. Theoretically, you should then earn enough from sales and commissions to maintain your life's needs and all the costs of continued work. This cost of continuing work includes studio rent and the cost of new tools and materials needed for future work (your inventory), so that you may begin new works whenever you are able to develop an idea. The unfortunate thing is that it is very difficult to do this on the sale of art works alone. It is especially difficult for beginners. It was not always so in the past, though, and if enough artists understand what has actually happened to change art, it might not be the rule for the future.

Before the invention of practical photography and the invention of photo engraving, all newspapers, magazines, and book publishers employed artists to make drawings, engravings, and lithographs for their pictorial needs. Thus the field of employment for the artist was very large. But the photograph and the photo-engraving process have eliminated the need for these direct artistic skills in these businesses. Many of the very best artists of the past began their careers with this kind of job, and their work encouraged the development of skills related to their development as fine artists. During the same time, sculptors could find employment as plaster modelers, casters, wood carvers, and stone cutters. But these types of work have also been supplanted by modern technology, machine made decoration, and barren geometrical design. So the conditions which, at one time, made it possible for artists to earn their living with their skills, and at the same time develop their talents, no longer exist—except in rare situations.

Today there are commercial art jobs available that involve drawing, but this type of drawing is usually stylized and sterile. At the same time, the commercial art field is highly competitive, and a position is

likely to be filled by a person who looks on commercial art as a lifetime career, and who may *enjoy* doing this kind of work. So it makes little sense for the fine artist to compete for long with career commercial artists. He can look on commercial art only as a temporary stopping place. It is better, in the long run, to consider other means of gaining a livelihood, although a little knowledge of commercial art can be of real value for working out your own brochures and folders.

It is not a bad arrangement to work at a part time job every day, and devote the remaining hours to sculpture. I have done this myself, at the beginning, and found that it worked very well. The only drawbacks are that part-time employment earns you limited funds; this means that your studio rent must be low, and you must keep your sculpture or painting projects limited. Also, if you put in eight hours working at art after the job, there is very little time left for friends and entertainment. But many artists work in this fashion their whole lives long, supplementing their earnings, from time to time, with money from sales of paintings or sculpture.

It is also possible for a healthy young person to work at a full time job and spend the remaining hours at work in his studio. But this will drain your energy sooner or later. As you grow older, this method becomes physically more and more difficult. It is a depressing and joyless solution to the problem.

Should you, as a beginner, be filled with enough vigor and determination to work at either a full time or part time job, and at the same time work at your art, you will be making an investment in your own development, in the same way a businessman invests money in developing a product. In a few years, you may have developed your skills enough to enable you to create *saleable* art, capable of competing on the art market with the work of professionals. You may then find it much more reasonable to work at a part time job than a full time one. But there is no *guarantee* that you will sell your work, even if it is first rate—it's just that the odds of selling are very much greater as your work develops.

☐ **PUBLIC AND PRIVATE SUPPORT**

This brings us to consider the reasonableness of accepting help from others. To begin with, there is always talk of the possibility of government subsidy for the artist. In some western European countries, various plans of government support for the arts exist. Several of these countries give support, of one kind or another, without the government dictating style or subject matter. But there are, of course, certain official hurdles to leap over, in order to qualify for support, and these, for all I know, may be as difficult for some artists as a prescribed art program. In the Communist countries, the governments do directly support the arts, but there is the burden of conforming to the program of Communist art doctrines. Art, in the true sense, always requires personal freedom of expression, and perhaps the artist is better off when he must pay for his freedom by supporting his own development. At the present time, in the United States, there is some token interest in government support of art, but it has yet to take any definite shape.

Nevertheless, in the 1930's, because of the severe economic depression, there was a government sponsored art project. Many people (including most of the artists who participated) have expressed the view that this was responsible for the art surge in post-war America. Many of the leading abstract expressionist artists, who dominated American art after World War II, had gotten a start in the pre-war government art project. When, at the end of the war, the G.I. Bill was passed, this afforded training and support to many new artists who might otherwise have found schooling impossible to afford. I, for one, can attest to the fact that the support was invaluable.

There is no question about it: artists do develop when they are helped. But I also worked part time during my entire art school career because I did not like the idea of being totally dependent on the state. This attitude also helped me later, as it made me feel responsible for the support of my own work.

But if the government has no set policy for aid to the arts, if G.I. benefits have gone dry, and if you cannot earn sufficient money at a job and still find time to work at art, then you must turn to other individuals for help. If you are fortunate enough to have a wealthy family who may be willing to support your efforts, or if you have a personal income, you will have no difficulty in devoting yourself to art. If you do not have these advantages, you may find a wealthy patron, or marry into a family with money, who value art and understand the necessities of the artist. Both of these are perfectly respectable solutions, except that patrons and wealthy wives can be as irritatingly opinionated about art as Communist governments. And once the artist starts conforming

to outside esthetic pressures, his work loses its vitality. But this solution is a personal one, and it may work out well, depending on your temperament.

Probably the best kind of personal aid comes when the artist marries someone who is genuinely fond of him, who believes in his work, and who also has some profession that earns income outside of the art field. If the wife (or husband) believes that the artist's work is worthwhile, it is perfectly proper for the two to work as a team, in the sense that the wife *invests* in the artist's development of his talent, reputation, and sales. Many successful artists have succeeded through their wives' making this kind of investment in their talent. Each sale or bit of recognition brings satisfaction for *two* people.

Whichever solution you gravitate toward, you must always have a clarity of purpose and complete honesty about your motivations—honesty with yourself, your patron, or your partner. If there is clarity and honesty in your "terms of agreement," there can never be any recriminations or regrets. The ability to produce good art requires a basic atmosphere of honesty, as art itself is a form of truth.

There is one other source of money for artists, which may be of some value. This is foundation money in the form of grants and fellowships. I look upon these as windfalls—fine for the person who wins one. But the grant or fellowship does not in any way solve the artist's long range economic problems. When a beginner wins a grant, it tends to build up an attitude of false confidence that has little meaning once the grant period is over. The artist still faces the same economic problems when his money runs out. In my opinion, the artist should first come to grips with his economic problems, and think of possible grant money as a chance of providing interim relief later on. Then, if he wins a grant, the money will have the meaning it was really intended for.

☐ THE BUSINESS OF ART

Assuming that you find a workable solution for your income problems, you still have the task of managing the business aspect of your career. This involves buying materials; running a studio; fixing prices on your work; promoting, exhibiting, and selling your work. The more you know about how these things are done, at the beginning of your career, the better off you will be. And if you learn them well in the beginning, you will improve with practice. If you become successful later, others will perform some of these functions for you—your dealer, perhaps—but at the outset you must do these things for yourself.

At the outset, the rent for the studio and the cost of tools and equipment are paid for by money from your part time or full time job. During the beginning period, you should learn exactly what your monthly and yearly expenses amount to. These, of course, will vary from person to person. It will take some time to understand what tools are needed, what the necessary inventory of raw materials should be, and what your miscellaneous costs are. But once you do understand these costs, you will have enough feeling for your economic situation to try various ways of improving it gradually.

The best way to begin to change your economic set-up is to make a concerted effort to sell enough work to realize something more than the cost of materials, so you can begin building up your inventory of raw metal, welding rod, and base material. In other words, your first objective should be to realize some working capital. In the beginning, your work will be sold for a minimum amount. This beginning is important because it will acquaint you with the problems and mechanics of selling, and it will also get your work to the public more readily than if you charge high prices. At the beginning, it is not important to realize the *full* cost of your overhead: rent, material, and labor cost. But it is important for you to begin getting *some* return; price your work just a bit over the cost of the metal, welding rod, flux, and gas used for the piece, plus the cost of the base.

Decorators and small shopkeepers can be approached and asked to take your work on consignment (be sure to get receipts for whatever you leave). Once you have enough pieces out, you will begin to get an inflow of sales that may not be tremendous, but it will be the beginning of your functioning as an economic unit.

There is, of course, the problem of the artist who hides his shyness and his fear of rejection behind a pose of superiority or a disdain for public opinion and for these business functions. This fellow has a perfect built-in excuse for any failure he might make; he has an automatic mechanism which will prevent him from learning the techniques for getting his work public acceptance. He is caught in the play-acting role of the misunderstood artist. And he often rather enjoys wallowing in the bog of rejection. Of course, people will generally be delighted to accommodate him with all the rejection he wants. But if this artist would spend the time it takes to act the

martyr and use it to acquire some of the acumen of any simple businessman, he would have some real acceptance. He would learn that one cannot reach the public heart by rejecting and abusing it.

☐ EXHIBITING YOUR WORK

At this time, you should also make an effort to submit work to juried exhibitions and group shows. As your work begins to relate to the world, you will also begin to get a feeling for the marketing of art. You will, through trial and error, learn whom you should deal with and whom you should not. You may lose some money at first, but this will prevent your making business errors later, when it might *really* cost you money.

You should make some effort to meet your contemporaries and, to some extent, take part in the activities of your local art world. Introduce your work to the directors of the smaller galleries by making appointments to show them slides of your work, or by inviting them to see your work in your studio. Try not to expect these people to recognize you as a genius right at the beginning; just be friendly and be satisfied to get acquainted. Gallery directors see many artists—it is part of their job—and everyone they see wants to have his spark of genius recognized. But your goal should be inclusion in some of the gallery group shows, only that. Perhaps it would be more to the point if you recognized the spark of genius in the *dealer*, for they have their vanity, too.

If you continue to show your work, as it develops, to some dealers, sooner or later one of them will develop an interest in you. Recognition of an artist's work is a personal thing with every dealer. Dealers must become involved with an artist's work over a period of time to really know it, and in the process of getting to know it they can become involved in the artist's career. So build relationships with dealers whom you like and respect well enough to deal with over the years.

When you are well enough acquainted in your local art world and have exhibited in a few group shows, you may be able to join an artists' *cooperative* gallery (all the artists pay the rent and take turns gallery-sitting), or you may be taken in to a small gallery. At this time, it will be reasonable for you to raise your prices to the level of the market: the going level of prices for similar works of art sold in this type of outlet. Do not, by all means, put the highest prices on your work. People who buy art at this lower level are either beginning collectors who cannot afford high prices, or people who like to buy art cheaply because they know that artists at a certain level need to sell. There's nothing wrong with this. It's a lot like horseplayers who enjoy backing a long shot.

One way or another, *high* prices for a beginner do not impress anyone, but tend to drive people away. Your object should be to show your work and compete with your peers for sales, critical interest, and the interest of the art public. The better your sales are, the stronger your relationship will be with your dealer, for the affections of the art dealer are a mixture of esthetics and pure business.

Everything you sell at this early stage will begin to work for you, because people who buy art love to praise the artists they have collected. One thing to remember: collectors are proud of the items in their collections, regardless of what they paid for them. Only in the old master brackets are the collectors proud of having paid big prices. The average collector is proud of his taste and esthetic judgment.

Success, for an artist, is a mixture of the genuine appreciation which people give to his work *and* his ability to increase the amount of money he earns through sales every fiscal year. Artists are too often emotional about prices, rather than being businesslike about them. It takes years of development to build up the price of an artist's work—there is no shortcut. The development of the art itself is the only possible way that this should occur. But there is no guarantee that better sales will come even then. Although no good artist turns his back on society, the only person who can really give you recognition is yourself, as art is basically a process of revelation within your own consciousness. Insight is the major reward of art—not money.

In time, if your work develops, you will be included in more invitational shows and group shows. You will occasionally have a one-man show and you will become known for your work. This means that, because you have continued working and showing over a period of years, you have established yourself in the art world as a serious artist. This is more important than it may seem. Many people make beginnings in art, have a show or two, and then defect to the suburbs and to other more lucrative or steady occupations, under the pressures of life. To endure as a producing artist for ten or fifteen years is quite a feat in itself. As Robert Frost once wrote: "If you would have the young do something heroic, I suggest

you consider the fine arts." Although there are no kudos given for staying power alone, it is one of the prices paid by anyone who wishes to be considered a serious contender in the arts.

Once you have reached the ranks of the serious contenders in the field, you will stand a chance of being taken on by a serious, established art dealer. This is the dealer who handles artists of some reputation, and who, by dint of long years of experience, is known as something of an expert at judging art. He also has the business skills (and perhaps the financial backing) to have survived in the gallery business as you will have survived as an artist. At this point, you may still not be making a living from your sales alone—your wife may still be working, too—but your sales will improve, your prices will gradually rise and stay there (if you consult with your dealer), and you will be considered acceptable for some of the better teaching jobs. But if you wish to stay on the professional level, you must really settle down and develop your skills and insights still further if you aspire to the ranks of the serious minded, tough, talented, and dedicated artists.

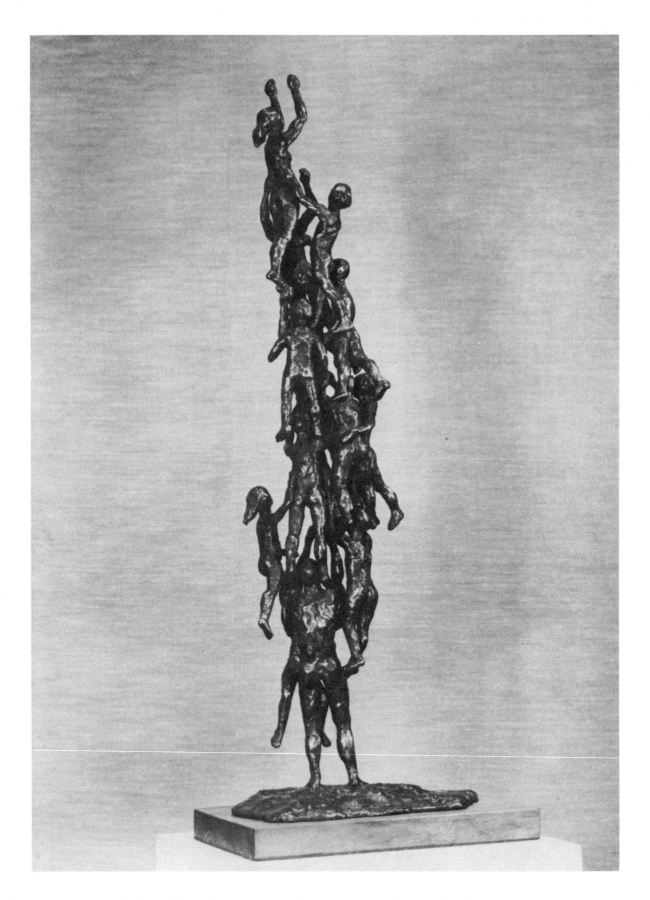

The Heritage, *nickel silver, 25", collection, the John Hernon Art Institute. This composition is based on a vertical, anti-gravity movement of the figures supported by the male figure, who forms the basic trunk of the* structure. *The smaller figures are attached by hands and feet to one another and there is a spiralling movement as the figures rise in the air.*

Although Julio González created the first welded sculptures made by an artist in 1927 (followed a few years later by some experiments done by his friend Picasso), working welders had been playing at assemblage and form making, in their idle moments, ever since welding methods were invented. Which is to say that the potential for art lies in *tools,* since they are extensions of man's creative anatomical functions. So, even though the first working welders never thought of their doodles as art, or precursors of art, the art potential was somewhere at hand. And even though González was the first to begin to develop the medium, he merely scratched the surface of its potential. The men who have come after González have widened the horizons of welded sculpture enormously; to this day, the pioneering exploration of this medium is still going on. All the artists mentioned in this section have done major pioneering work in the field.

After González made the first brave step, it did not take long for artists to grasp the possibilities of this medium. In the 1940's, the big impetus for welded sculpture came from Theodore Roszak and David Smith, followed closely by Harry Bertoia, Herbert Ferber, David Hare, Ibram Lassaw, Seymour Lipton, Bernard Rosenthal, and Sahl Swarz. All these pioneers are now considered as the "old masters" of abstract welded sculpture. In the 1950's, the medium really came into its own; many other sculptors began adding to the tradition, including a very small number of artists who worked with the human figure.

This section presents the work of thirty-three pioneers in the field. Each artist uses welding as his major medium; each has evolved his own style; and each has added something concrete to the tradition and craft that succeeding generations of sculptors can build on.

Of course, this selection by no means includes *all* of the vast number of artists who have made welded sculpture. There are some who could not be included because of space limitations. In the main, I have included sculptors of importance with whose work I am familiar—but particularly those whose work has impressed me. And I make no claim to universality of taste. My opinions are limited by my experience as an artist with strong figurative direction. As it is, I have included far more abstract than representational artists, mainly because there are very few first-rate figurative welders practicing today.

In my comments on the work of each of these artists, I have two purposes. One is to describe the technique the sculptor used to construct his piece; my description is based upon guesswork in those cases where I was not intimately familiar with the artist's methods. In these extended captions, I try to relate the artist's forms to the portions of this book which describe the same or similar construction methods. Guessing "how he did it" is a game most artists must learn to play, and my purpose in playing it here is to show you that the methods described in this book are almost universally applied in the field of welded sculpture.

The other purpose of the comments I have made is to pay tribute to the accomplishments, courage, and integrity of these sculptors—to give credit where credit is certainly due. And I am grateful for the opportunity to include my own work with theirs, as the most rigorous test of the values and methods I have put forth in this book.

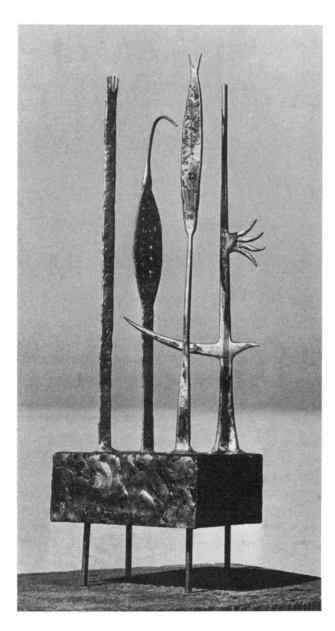

Oliver Andrews Shore Music, *welded bronze, 16" high, photograph courtesy Alan Gallery. Oliver Andrews has worked and lived mainly in California. Exhibited widely, his work is represented in many museums and private collections. Shore Music was done in 1955 in welded bronze.*

The four upright figurations stand on a base which is a simple welded box, similar in construction to the cube described in Chapter 3. These four upright shapes have been formed by welding together hammered and filed pieces of flat metal and rod, textured with brazed rod and/or filed down to remove welded seams, and finally attached to the box shaped metal base. The four supporting rods on the underside could have been added either at the beginning or when the piece was completed. My guess is that they were added at the end to create a little more of an airy quality.

These shapes are in no sense arbitrarily placed, but rather, have been juxtaposed with a great awareness of how each element relates to the others and to the whole. This kind of presence and this sense of space is characteristic of all of Andrews' work.

Reg Butler Box, *iron, 26½" high, collection, G. David Thompson. Born in 1913 in Buntingford, England, Reg Butler is one of the world's great sculptors. He is a pioneer in welding and his wiry, tenuous forms are charged with a strong emotional quality. Though much of the iron in his sculpture appears to be found material, he has gone far beyond mere assemblage and has invested these forms with a haunting, organic liveliness.*

Harry Bertoia Untitled, *welded bronze, 44" high, 12" wide, 12" deep, photograph courtesy Staempfli Gallery. Harry Bertoia, one of the old masters of welded sculpture, is a great technical pioneer as well as a marvelous innovator of welded forms. Every work he produces is masterfully conceived and carried out with consummate skill. Bertoia was born in San Lorenzo, Italy, in 1915. He has been welding since the early 1940's, and is known for such innovations in sculpture as the welded architectural screen done for the Manufacturers Hanover Trust Company branch at Fifth Avenue and 43rd Street, in New York.*

In the sculpture shown here, the outer supporting structure consists of a carefully made framework of what could be either solid bronze bar stock or bronze tubing of a heavy wall thickness. The construction of the outer structure was well planned and jigged, since the welding has not warped the piece and the joints are undetectable (note the section on pipe welds in Chapter 2 for description of this procedure).

The inner structures, made from suspended rods which quiver and sing in movement, are most ingeniously constructed. Welding a great many thin rods to a heavy base is a difficult job. As each new rod is welded on, the heat tends to unstick the other rods. My guess is that the upper group of rods was welded as a unit, and the under group was welded as a separate unit, both in the following manner. Two plates are drilled with a pattern of holes in which the rods are to stand. The ends of the rods are then inserted into the holes so that just a fraction of the ends protrude. Then these ends are fused with the under side of the plate and the two groups are mounted together into the supporting framework. The two plates will fit together end to end, giving the upper and lower rods very firm support.

Anthony Caro Twenty-Four Hours, *welded steel, 4' 6"
high, 7' 4" wide, 2' 9" deep, photograph, courtesy André
Ammerich Gallery.*

*Anthony Caro was born in London in 1924. He
studied at Cambridge University and at the Royal Acad-
emy. He was an assistant to Henry Moore from 1951
to 1953. At one time, he did figurative sculptures which
embodied expressions of horror, fright, and decay. But
he turned from the human figure and these emotional
preoccupations to develop a purely geometrical style.
He is now regarded as a leading sculptor of geometrical
environments.*

*This welded steel work is an early effort in this direc-
tion, done in 1960. This is a simply conceived arrange-
ment of geometrical shapes, cut from what appear to
be scrap steel and structural I-beams, with an oxyacety-
lene torch. More than likely, the forms are arc welded
together. The disk shape was probably a found industrial
throwaway.*

Costas Coulentianos Untitled, *arc welded steel, 6' high,
photograph courtesy Bertha Schaefer Gallery. Costas
Coulentianos was born in Athens, Greece, in 1918 and
has lived in Paris since 1945. His works are large,
vigorous, geometrical abstractions in steel and brass.*

*This piece has been constructed in the same way as
the angular free form in Chapter 3. Photographed in the
artist's Paris studio, this sculpture is larger than our
example, of course, and is constructed of heavier ma-
terial. Coulentianos may have used an internal arma-
ture to strengthen the connection at the base, but
essentially this type of sculpture is very strong and does
not require internal support. The piece was arc welded
(see Chapter 7).*

*This kind of shape is extremely handsome when used
in a contemporary architectural setting of the interna-
tional style.*

Lynn Chadwick Tower of Babel I, *iron, 20″ high, photograph courtesy M. Knoedler and Co., Inc. Born in London in 1914, Chadwick is one of England's finest sculptors and he has achieved well merited international respect. He has a keen eye for form and his excellent sense of scale undoubtedly derives from his early train-* *ing as an architect. In this sculpture, he has used welding rod, pieces of angle iron, and some found metal which he has unified into a fine spatial expression which has a strong flavor of architecture, but also conveys a feeling of a figurative group.*

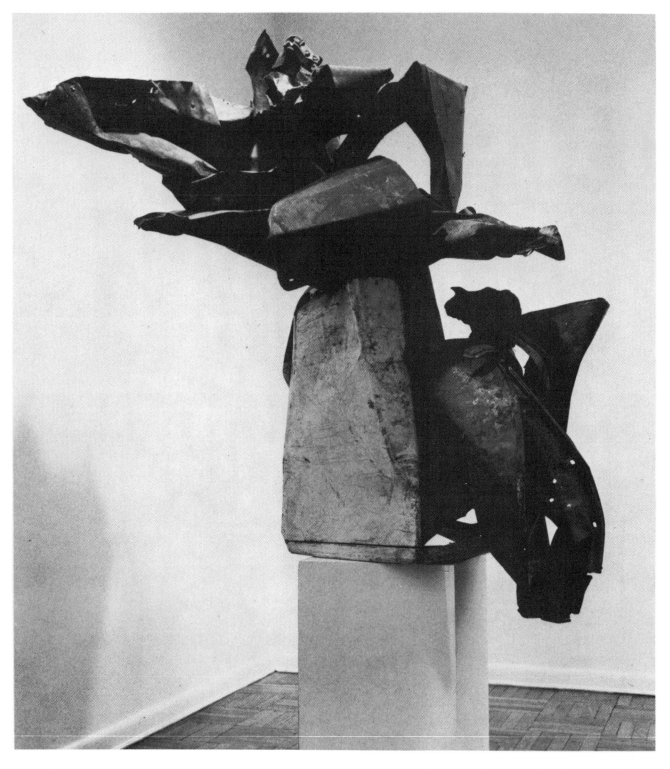

John Chamberlain Fantail, *welded automobile metal,
70" x 75" x 60", photograph courtesy Leo Castelli Gal-
lery, collection, Jasper Johns.* John Chamberlain stands
at the other end of that sequence of events that begins
in the automobile design studios of Detroit: from there
it proceeds to the production lines, on to the highways
at ever increasing horsepower (as well as constantly
changing seductive styles), and ends, of course, in the
vast panoramas of the constantly expanding automobile
graveyards. Searching these graveyards for raw ma-
terial, Chamberlain resurrects the smashed and shattered
remnants of the automobiles' gaudy sheet metal cover-
ings and tenderly welds them into images of our time.

Born in Chicago in 1927, Chamberlain has grown up
in a world of mechanized values and machine images.
If his work is not expressive of human values in a posi-
tive sense, or conceived with an understanding of
nature's forming processes, it is nonetheless expressive
of the comedy and tragedy of industrial culture.

The welding of Fantail is elementary tacking, de-
scribed in Chapter 2.

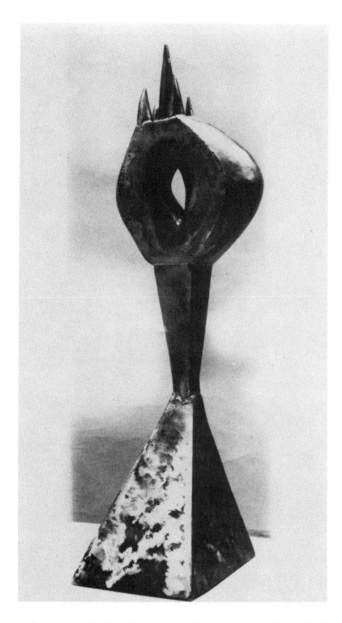

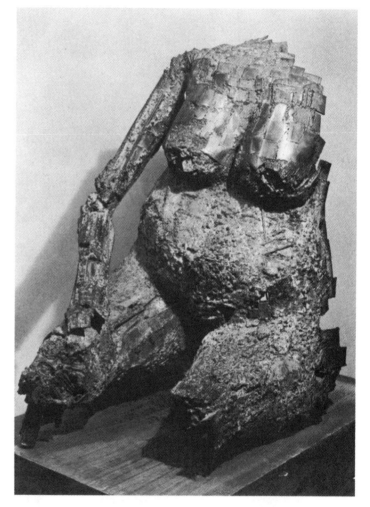

Robert Cronbach The Eye, *hammered and welded bronze, photograph courtesy Bertha Schaefer Gallery. Born in St. Louis, Missouri, in 1908, Cronbach studied at the Pennsylvania Academy of Fine Arts and was Paul Manship's assistant in Paris and New York in 1930. Although skilled in other media, he began welding in the mid-1950's and has concentrated on welding since that time. He has executed many architectural commissions and is particularly noted for his fountains.*

The Eye is made of hammered and welded sheet bronze. For the most part, the shapes are constructed in the manner described in Chapter 3. The rounded shape, at the top of the form, has been made by hammering out and fitting pieces from originally flat stock. The welds and surfaces have been ground with an emery wheel and also filed.

Cesar Torso, *welded iron, 30⅜" high, collection, Museum of Modern Art, Blanchette Rockefeller Fund. The French sculptor, Cesar, uses the intense heat of arc welding (which can partially destroy the metal) to produce a sense of corruption and fragmentation in the human form. In this piece, dated 1954, he combines polished rectangular plates with rods and rough, crumbly surfaces. It appears that the figure was first assembled from the small rectangles and rods, which were then partially melted and partially fused as the sculptor developed the rough surface, which is partially slag and rust.*

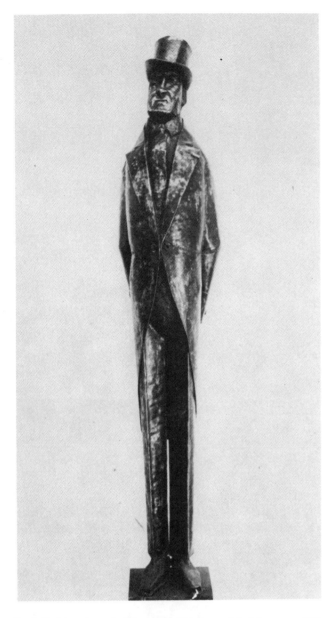

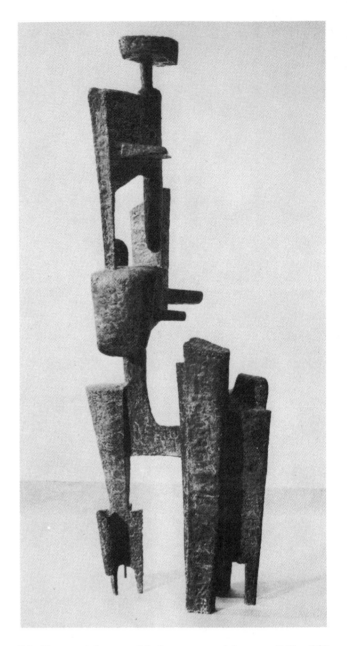

Ludvik Durchanek Homo Politico, *welded bronze, 80"*
high, photograph courtesy Graham Gallery. Born in
Vienna in 1902, Ludvik Durchanek came to the United
States in 1927. He began painting early in life. In 1952,
he turned to welded sculpture and has been working in
this medium since that time. Though a gentle, white
haired man, Mr. Durchanek creates savagely satirical
figurative sculpture.

His works are mostly life sized or even larger. Homo
Politico *was done as part of the series called "The Great*
Society" in 1964-5. While this figure is constructed of
sheet bronze, Durchanek also works in sheet copper and
nickel silver. The forms are shaped by hammering thin
metal into the necessary shapes and then by welding
the shapes together at the seams and joints. The forms
of the figures are simplified in a geometrical way simi-
lar to the forms described in Chapter 3. The geometric
quality of the figure serves to show the pretentions and
rigidity in the bodies and characters that Durchanek
depicts, such as Homo Militare, Homo Scientifico,
Homo Religioso, *etc.—the whole spectrum of human*
falsity.

Lin Emery Adam, *welded copper and bronze, 74" x 30"*
x 24", photograph courtesy Sculpture Center. Aside
from being an excellent sculptor, Lin Emery is a pretty
and charming woman. Born in New York City, she was
one of a group of sculptors who learned welding and
developed their skills at the Sculpture Center in New
York. The Center, first known as the Clay Club, was
founded and is directed by Dorothea Denslow.

Miss Emery worked there for several years and then
moved to New Orleans, where she has become a lead-
ing sculptor. Among her many commissions have been
a number of beautifully designed mobile fountains.

Adam *is constructed of copper and bronze. The*
shapes have been built like those described in Chapters
3 and 4, although the rounded shapes may have been
made by hammering out the forms. The final surface
was created by welding over the forms with bronze rod.

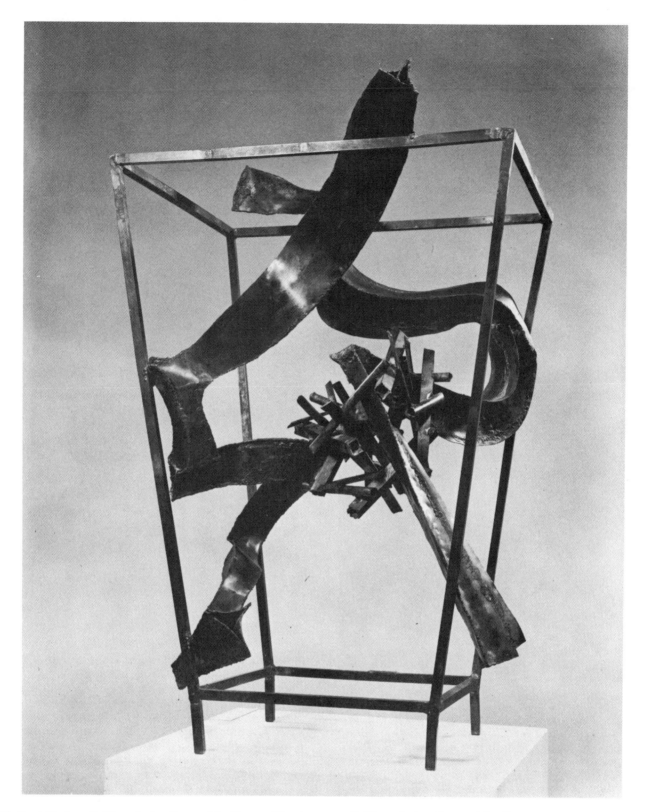

Herbert Ferber Calligraph in Cage with Cluster No. 2, II (With Two Heads), *hammered and welded copper and brass, 46" x 32" x 36", photograph courtesy André Emmerich Gallery, collection, Walker Art Center, Minneapolis. Herbert Ferber was born in New York City in 1906. He is one of the first pioneers, an old master of welded sculpture. He began to weld in the 1940's. Since that time, his works have been shown in the major museums of Europe and the United States.*

Calligraph in Cage with Cluster No. 2, II (With Two Heads) *was done in 1962. The outer structure appears to be made of square brass tubing (see section on pipe welding in Chapter 2). The large inner forms are hammered and welded structures, fitted and welded like the geometrical shapes in Chapter 3. The cluster of small shapes in the center consists of short lengths of square and round tubing and metal strips which are tacked together to form an open construction.*

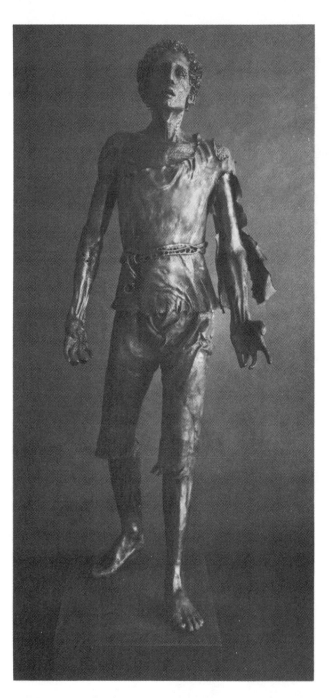

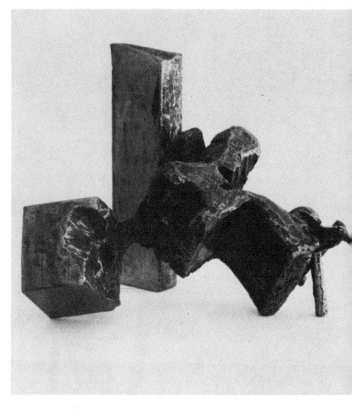

Joseph Goto Number Nineteen, *welded steel, 14" high, photograph courtesy Stephen Radich Gallery.*

Joseph Goto was born in Hawaii in 1920. Besides being trained as an artist, he spent several years working as an industrial welder. His works have been personal favorites of mine ever since I saw them for the first time several years ago. Because of my own experience of working as an industrial welder, I tend to be highly critical of even the greatest sculptor welders when it comes to their feeling for metal, but Mr. Goto's work has my unqualified admiration. His personality has fused with the tools of welding and with the great thicknesses of metal he uses, to achieve volcanic force in his sculpture. At the same time he has exquisite taste, restraint, and respect for natural forms.

Number Nineteen is wrought of solid steel. These massive pieces were cut and shaped with a cutting torch, and pieces were then assembled and fused with the arc. Mr. Goto grinds and files his surfaces and, more than likely, he lacquers them to prevent oxidation.

Kahlil Gibran Figure, *hammered and welded iron, 6' high, photograph courtesy of the artist, collection, Mrs. Lee Kolker, New York City. Kahlil Gibran was born in Boston in 1922. He studied painting at the Boston Museum school and exhibited widely as a painter until the mid-1950's, when he began to do welded sculpture. His brilliant work clearly shows his genius and originality, as it demonstrates his technical skill, anatomical knowledge, and great expressive intensity.*

Figure was done in 1965. The forms of the head, neck, part of the thorax, hands, and a few other small parts have been modeled with pieces of steel welding rod. This use of rod serves three purposes: it shows the direction of the form, gives a strong textural quality, and serves to cover the forms of the masses. The remainder of the figure, the garments, part of the arms and legs, are made of sheet iron.

174

Julio González Torso, *hammered and welded iron, 24 ⅜" high, photograph courtesy Museum of Modern Art, collection, Museum of Modern Art. González was the first to use welding as a sculpture medium. Born in Barcelona, Spain, in 1876, he died in 1942. His father was a gold and silversmith and González learned something about metal work at an early age. He did not, however, go into this trade, but instead he was trained as a painter. It is interesting that he knew Pablo Picasso as a young man in Barcelona and renewed the friendship later when they were both in Paris. In his early days abroad, González turned his hand to doing some forged and wrought pieces of metal sculpture, but it was in 1927 that he began to do welded sculpture. Then he began to use oxyacetylene welding as an adjunct to*

his methods of hammering and forging. He had learned the welding process while he was employed at the Renault factory during World War I It is noteworthy that González, a Spaniard, was the one to find a new expressive use for iron in art; Spain was for centuries noted for her metalsmiths and workers in ornamental iron.

Torso, done in 1936, is made of hammered and welded iron. This piece was not constructed with an armature, but was roughly formed by putting small pieces of metal together in the round general shape of the figure. Then the piece was hammered and wrought into a more exacting shape. González had a good understanding of anatomy; the structure of the pelvis reveals forms that can be done only with anatomical knowledge.

175

Nathan Cabot Hale The Adventurous Horseman, *welded manganese bronze, 12" high, photograph courtesy Midtown Galleries. The author was born in Los Angeles, California, and studied at the Chouinard Art Institute in Los Angeles and at the Art Students League of New York. Initially a painter, he began to do sculpture in the late 1940's. A job on a ship repair crew first introduced him to welding in the late 1940's and he subsequently spent four years in industry in order to find methods and techniques for sculpture.*

Though his painting worked through most of the schools of twentieth century art, including and ending with abstract expressionism, his work began to focus on natural forms in 1951. At that time his interests began to center on the human figure and his work began to evolve toward a concept involving the ages of man and the cycle of life, quite independent of any outside influence. The fact that he has been able to weld sculpture has made it possible to work out these concepts rapidly, in experimental compositions, and still do the work in a form that is suitable for the galleries. The author feels that welding has given him a great sense of independence, which his kind of work seems to require.

The Adventurous Horseman *is welded of manganese bronze. The figure is modeled by the process described in Chapter 5, while the horse is a hollow construction.*

Roy Gussow Two and One, *welded stainless steel, 30½" x 9½" x 8", photograph courtesy Grace Borgenicht Gallery. Born in Brooklyn, New York, in 1918, Roy Gussow studied with Moholy-Nagy and with Archipenko. He began welding in the late 1940's. His work shows his concern for refined geometrical shapes and highly finished surfaces. The shapes of his sculpture are always concise and well defined and done with meticulous care and craftsmanship.*

Two and One *is constructed of stainless steel sheet. The shapes were formed and fitted together; then the seams were welded with the Heliarc process. The seams were then ground down, and the surface buffed to a mirror-like finish.*

David Hare Horizon Line, *welded steel and bronze, 37" long, photograph courtesy the artist. David Hare is one of the original pioneers in welded sculpture. Born in New York City, in 1917, he has had a distinguished career as an artist. His work is owned by leading museums and private collections in the United States and Europe.*

This piece, Horizon Line, *is welded of steel and bronze. The materials seem to be plate, square bar stock, and welding rod. These elements are fused into a whimsical and elegant arrangement of form, so characteristic of Mr. Hare's work.*

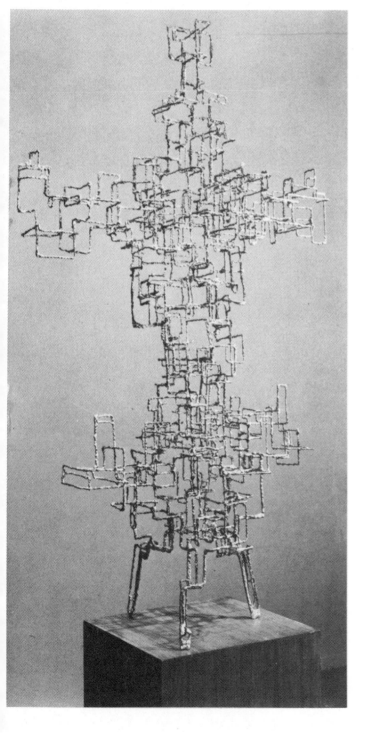

Ibram Lassaw Kwanon, *welded bronze and silver, 6 high, photograph courtesy Museum of Modern Art, collection, Museum of Modern Art. Ibram Lassaw was born in Alexandria, Egypt, in 1913. He studied sculpture with Dorothea Denslow at the Sculpture Center in New York, in the early years when it was still known as the Clay Club and was next to the old Whitney Museum on Eighth Street in Greenwich Village. Mr. Lassaw is one of the pioneers of welded sculpture and his particular specialty has been to explore the uses of various metals in combination. These investigations have introduced a wide range of color possibilities into welded sculpture.*

This sculpture, an early work done in 1952, is 6' high and has been welded of bronze and silver. Its basic structural element is bronze welding rod that has been built up by adding weld metal to it. Lengths of this built-up rod have been fitted together, at right angles, to make interconnecting squares and cubes in outline. Perhaps a general outline of the whole piece was first constructed, or it is possible that the piece was built from the ground up. The silver appears to have been brazed over the bronze; the natural colors of the metals give the finish.

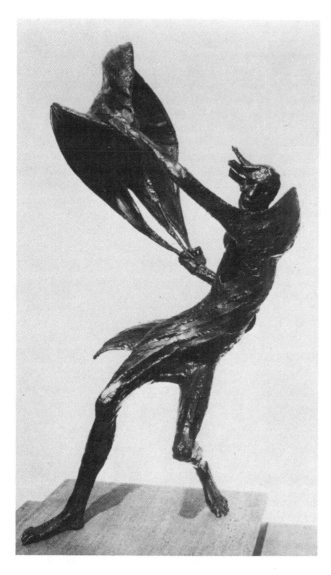

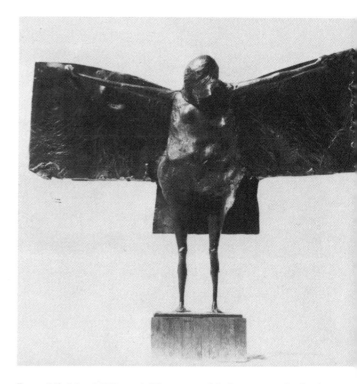

Barbara Lekberg Man and the Wind, *welded steel, photograph courtesy Sculpture Center. Barbara Lekberg was born in Portland, Oregon, in 1925. She was a member of the nucleus of sculptors that began their careers in welding at the Sculpture Center. Miss Lekberg has been given high recognition for her work, which has been consistently in the figurative vein. Her technique is her own very original innovation: she has developed a flexible and unique method of forming the figure with strips of steel plate. Her figures are always in superb motion, seeming to live in the focus of a cyclone, striving against nature's forces.*

Man and the Wind *is constructed of steel. Miss Lekberg uses strips of 1/16″ plate of a similar thickness which are cut and fitted into the shapes of the anatomical masses. There is no guesswork here; this artist knows her anatomy. I have heard that Miss Lekberg often makes small wax sketches of her compositions in order to work out the forms of her compositions. These models are then enlarged to the final scale, which is often one quarter or one third life size.*

Juan Nickford Winged Figure, *welded copper, 9″ high, photograph courtesy Sculpture Center. Juan Nickford is another brilliant welder who developed his skills under the aegis of the Sculpture Center in New York. Mr. Nickford was born in Cuba in 1925. Arriving in the United States on an art scholarship in 1947, he has worked here since that time and has become a citizen. He has a truly masterful skill as a welder and has done first rate work in many different metals.*

About 9″ high, Winged Figure, *and all of Mr. Nickford's recent work, has been welded in copper. This metal has never before been used for welded sculpture in this way. Mr. Nickford's technique in copper is an exciting innovation. This figure is constructed, in part, by a modeling technique similar to that described in Chapter 5 and also with methods that approximate those described in Chapters 3 and 4. The surface is the natural copper, which has a deep, rich color.*

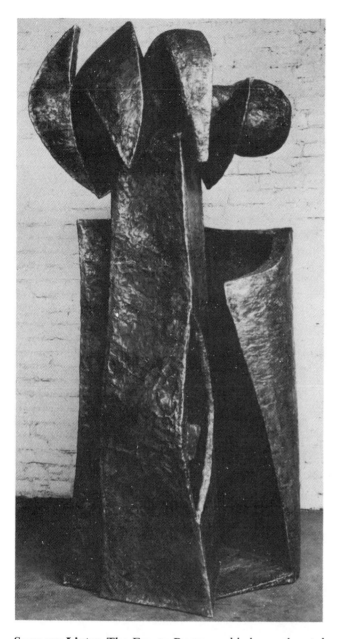

Seymour Lipton The Empty Room, *welded monel metal and nickel silver, 77" high, photograph courtesy Marlborough-Gerson Galleries. Seymour Lipton is one of the great old masters of American welded sculpture. Internationally known and honored, his works are solid expressions of his welding skill and his masterful knowledge of form. He was born in New York City in 1903. He is credited with having been the initiator of the brazed-over surface, so much used now in welded sculpture. Initially he used brass or nickel silver over steel and later over monel metal.*

The Empty Room is 77" high and was completed in 1964. The sculpture is constructed of monel metal (an alloy of nickel, copper, iron, and manganese) which has been hammered and formed to the desired shapes by cutting and fitting. When welded, the structure was then brazed over with nickel silver rod, heavily and richly modeled on the surface. Chapters 3 and 4 discuss the methods of this type of construction, but it must be remembered that it requires a good deal of experience to handle forms as large as this.

George Rickey Eight Lines Horizontal, *welded stainless steel, 8" high x 18" wide, photograph courtesy Staempfli Gallery. George Rickey was born in South Bend, Indiana, in 1907, but grew up and was schooled in Europe. He turned from painting to sculpture in 1949, and has specialized in kinetic sculpture. Mr. Rickey not only uses welding, but also adapts many other techniques of modern industrial metal working to his artistic needs. His constructions may be bolted, spot welded, riveted, or machined as well as being welded.*

Eight Lines Horizontal was made in 1966 from stainless steel; it is 8" high without the base, and is 18" wide. The kinetic elements are balanced and mounted on pivot joints which are attached to the upright members, and move when touched or agitated by the wind.

Theodore Roszak Night Flight, *welded steel, 92" x 125",
photograph courtesy Pierre Matisse Gallery. Theodore
Roszak stands in the front rank of the innovators of
welded sculpture, alongside González, Picasso, and
David Smith. He is the great modeler of welded sculp-
ture, who changed the medium from a technique used
largely for construction, or an adjunct of repoussé, into
a flexible and fluid sculpture process. Roszak gave
welded sculpture those qualities which enable the me-
dium to stand on an equal footing with cast bronze,
carved stone, or carved wood. And aside from this
major accomplishment, Roszak (born in Poznan, Poland,
in 1907) produces sculpture of consummate expressive-*
ness. His work has been acclaimed throughout the
world; in recent years, Mr. Roszak was appointed a
member of the United States Commission of Fine Arts
by President Kennedy.

*This powerful sculpture, Night Flight, is made of
welded steel, 92" x 125". It is constructed of formed
and fitted pieces of steel which are welded into the final
shapes. These forms are then modeled and textured with
the torch and finally ground and polished. Similar
methods are described in Chapters 3 and 4. I do not
hesitate to say that some of my own methods have de-
veloped as a direct result of careful study of this great
innovator's work.*

Bernard Rosenthal Jericho III, *welded bronze plate, 9'
high, photograph courtesy of M. Knoedler & Company,
Inc. One of the younger old masters of welded sculpture,
Bernard Rosenthal was born in Highland Park, Illinois,
in 1914. For a number of years, his studio was in Cali-
fornia, and during that time he almost singlehandedly
made the West Coast aware of the possibilities of welded
sculpture. He has produced many very fine architectural
sculptures as well as first rate studio works.*

In this photograph of the sculpture Jericho III *you
can see part of the artist's studio, including his big
metal saw, which is a very important tool in his work.
This sculpture is constructed of bronze plate, cut to the
desired size with the saw. The pieces are then welded
together to make the individual shapes that are part
of the sculpture, as explained in Chapter 3. After these
forms are textured by cutting into the surface with the
saw blade and by grinding, they are welded together
into the final compositional form; then the weld areas
are textured. The result of this technique is that the
forms seem to be constructed of solid metal and there is
an illusion of great weight and mass, even though the
piece is reasonably light. All of this may sound simple,
but remember that this work is the product of superb
skills and a great deal of experience.*

Abe Satoru Inverted Tree #2, *copper sheet, steel, and
brass welding rod, 41" high, 14" wide, 10" deep, photo-
graph courtesy Sculpture Center. Abe Satoru is a man
of genius, a sculptor of the front rank. His work is
totally original, imbued with an indefinable sense of
life, of growth, and of time.*

*Born in Hawaii in 1926, he studied at the Art Stu-
dents League of New York and has worked for a num-
ber of years at the Sculpture Center.*

His work shown here, Inverted Tree #2, *is construc-
ted of copper sheet, steel welding rod, and brass weld-
ing rod. For his sculptural base, Satoru constructs a
framework of steel welding rod that accurately produces
the shape of the form he wishes to make. Over this
framework, he fits copper which he welds in place. The
surface of the piece is then brazed over and modeled.
These methods resemble those described in Chapters
3 and 4.*

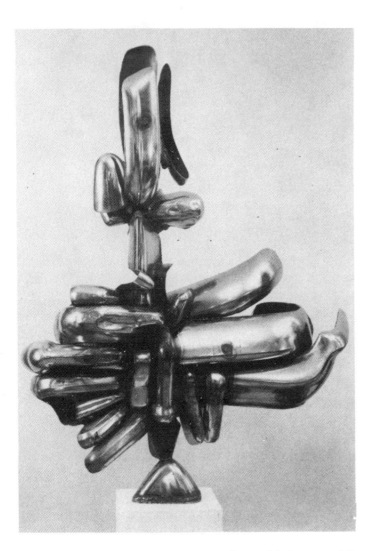

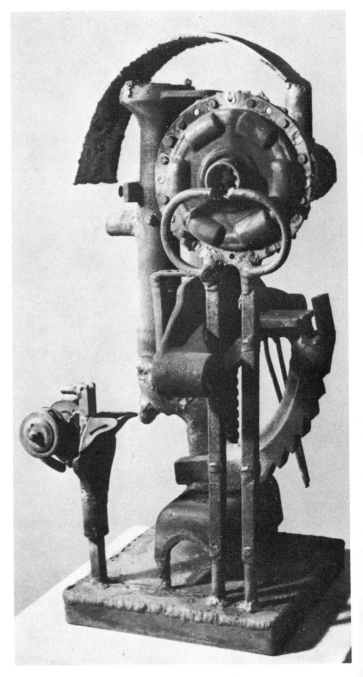

Jason Seley Baroque Portrait #3, *welded automobile metal, 60½" high, photograph courtesy Kornblee Gallery, collection Jean and Howard Lipman. Jason Seley was born in Newark, New Jersey, in 1919. He has become well known through his interesting specialization in found object sculpture. He specializes in consolidating the forms—taken from the bumpers of scrapped cars—into sculptural compositions. As these forms are already highly modeled and stylized by skilled Detroit designers, they have certain built-in symbolic qualities which Seley exploits to the hilt. Also, there is a witty, delayed reaction quality to all of his work. And as long as Detroit continues its yearly assault on the public taste, this artist will have fresh material to work with.*

This piece, done in 1961, is ironically called Baroque Portrait #3. *As you can see, the elements have been composed and carefully fitted together, and then skillfully welded; the finish is the original chrome.*

Richard Stankiewicz Untitled, *cast iron and steel, 20" high, photograph courtesy Stable Gallery. Richard Stankiewicz's name is synonymous with found object sculpture. If he did not invent it, he just about dominates the field. He has created an incredible imagery from discarded machine parts, castings, gadgets, and various twentieth century metal gewgaws. He is a satirist, a wry social commentator, and without doubt one of the shrewdest eyes in modern art. If the function of art was once to hold the mirror up to nature, Stankiewicz has started the trend toward holding that same mirror up to the wistful obsolescence of machine parts.*

This work is untitled; it was done in 1959. Some of the elements are cast iron, such as the gear teeth and the gas stove burner duct. Other parts are steel, including the base, which is welded in the manner described in Chapters 3 and 4.

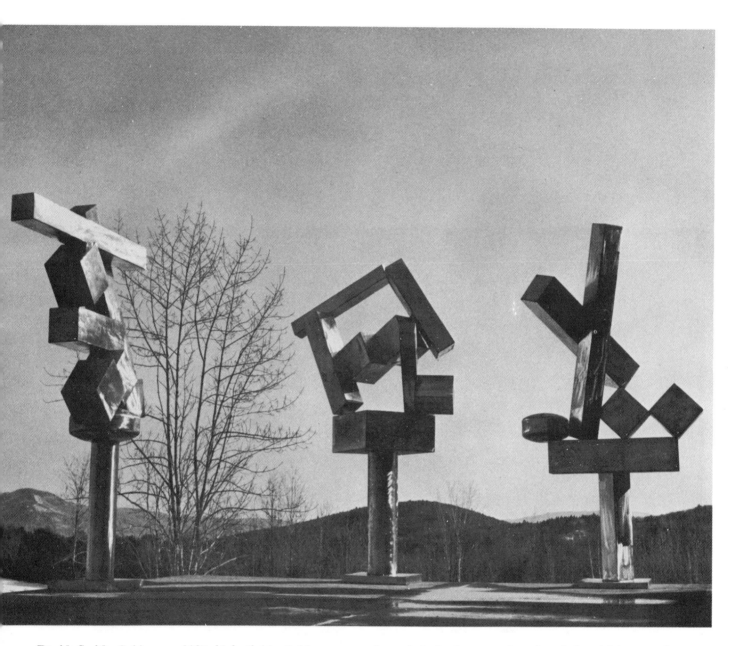

David Smith Cubi XIX, *113" high (left);* Cubi XVII, *107¾" high (center);* Cubi XVIII, *115¾" high (right); welded stainless steel, photograph courtesy Marlborough-Gerson Gallery and trustees of David Smith estate.*

David Smith was born in Decatur, Indiana, in 1906; he died in 1966. David Smith's work is one of the cornerstones of modern American abstract sculpture. A large part of the foundation of geometrical welded sculpture was the innovation of David Smith. Assemblage welding and wrought metal welded sculpture were greatly explored by him. His primary tools were the arc welder and the metal saw, but his shop was as well equipped as any structural iron works. He was well versed in all the technical advances of modern industrial iron working. Though his work was seldom concerned wtih organic shapes or the forms of growing nature, he led a massive exploration into the formal geometries suggested by plate stock, the I-beam, and other forms produced by the steel mills.

His last great works were huge geometrical monuments, constructed of stainless steel. These shapes are all constructed by the methods described in Chapter 3. They were welded by direct current arc and possibly some Heliarc. The surfaces of the metal and the welds were ground down and finished with a high speed disk grinder.

183

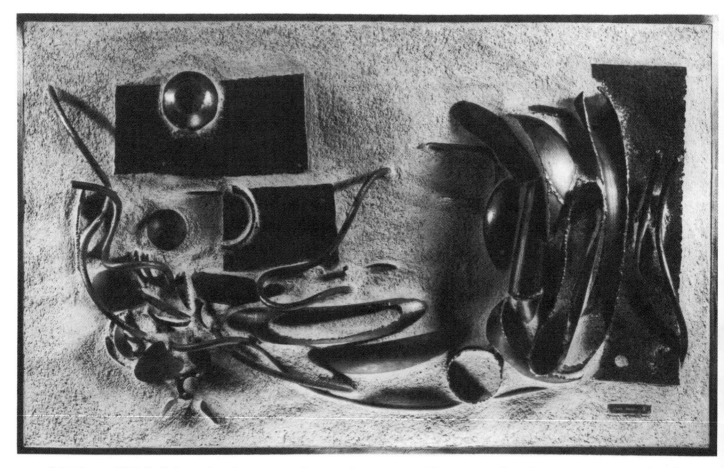

Sahl Swarz Wall Relief, *steel and concrete, photograph courtesy Sculpture Center. Sahl Swarz is one of the oldest hands at welding. For years he headed the welding department of the Sculpture Center, where he trained and influenced quite a few first rate welders. Swarz himself is an indefatigable innovator. He no sooner works out one new possibility for the welding medium, than he goes beyond it to open up another new realm. To use the old stock phrase, Swarz is a sculptor's sculptor. His work is always ahead of the critics and*

too mobile to ever allow for a proper appraisal in his own time. He was born in New York City in 1912.

This Wall Relief, *done by Swarz in 1966, is constructed of steel and concrete. The steel elements are rod, plate, tubing, and found objects. This construction has been set into a framework of angle iron. A rectangular piece of wire mesh, the same size as the frame, was probably used to reinforce the concrete. Once the metal parts are all securely tacked together, the concrete can be troweled onto the wire mesh.*

Jean Tinguely The Scooter, *found objects, 35½" high, photograph courtesy Staempfli Gallery. Jean Tinguely was born in 1925 in Freibourg, Switzerland, and grew up in Basel. He is the Mack Sennett of modern sculpture: his jerky, whacky, thumping, clanging constructions of motorized junk are both hilarious and heartwarming. They are hilarious because they use the products of industrial ingenuity and commercial, inventive guile in startling ways that make us re-examine the ultimate worth and value of our gadget ridden culture. And his sculptures are heartwarming because they thump, clamp, and clang with a pretentious vigor that one is certain will shake them to pieces: they are wrong, they are asinine, they are insane . . . they are wild teenagers, they are fractious children, they are shouting wives, sputtering husbands, rickety old grandmas, and cranky old grandfathers. They go against every tenet of the kind of art I hold most valuable and important, but I love them all the better for it. Vive le Jean!*

This Tinguely work is called The Scooter *and is constructed quite simply of a broken scooter and a soldier's tin helmet. The back wheel of the scooter is motorized by a motor inside the helmet. It is very simple, but at the same time, eloquent assemblage.*

Nina Winkel In the Pasture, *silver solder on copper, 19" x 6" x 21", photograph courtesy Sculpture Center. Nina Winkel was born in Borken, Germany, in 1905. She studied first at the Museum School in Frankfort and for a number of years studied and worked in Paris. She came to the United States in 1942. She has worked in various media, but she turned to welding in 1959. Her specialty is constructing forms of thin sheet copper which are brazed together with silver solder. Mrs. Winkel has a precise and accurate sense of form and design that one associates with artists like Barlach and Kolbe. She has the kind of craftsmanship we associate with traditional European training.*

In this piece, called In the Pasture, *her accurate sense of form and design is clearly seen. This is the type of work that demands precise analysis and fitting. The surface of this hollow piece is naturally textured by the silver solder on the copper. This combination of metals also gives an attractive color to the piece.*

Wilfred Zogbaum Lobos I, *steel, 22″ high, photograph courtesy Grace Borgenicht Gallery. Wilfred Zogbaum was born in Newport, Rhode Island, in 1915; he died in 1965. A grandson of Rufus Zogbaum, illustrator of the West and mural painter, he was a vigorous experimenter in welding, with his own unique approach.*

Lobos I is characteristic of Zogbaum's later work. It is welded from plate stock and bar stock and utilizes some found objects. Zogbaum often used field stones as parts of his constructions, to soften the geometrical forms and give a hint of the forming processes of nature in contrast to mechanical forms. These sculptures were often painted in bright primary colors, both to protect the metal and for their own brilliance. This piece was done in 1962.

When the present book was first published in 1968, my intention was to create a park and chapel of my sculptures of the Cycle of Life. At that time, I had been working with these concepts for several years, but my work led in a somewhat different direction.

Two factors brought me to a path more consistent with my development. First, I had invented a technique for welding small bronze figures and felt a responsibility to continue to develop this technique as fully as I could. A second, and equally compelling, factor stemmed from what I was then learning from the work on my next book, *Abstraction in Art and Nature.* In that book, I examined the elements of form in nature and, for the first time, described for artists the energy flows of nature as comprehensible sequences, or formative processes. It seemed important for me to express these basic movements of energy in sculpture, while continuing to learn as much as I could about these meaningful abstractions. This is the path I have followed in the last 25 years.

As I have worked at understanding these basic movements of energy, more of the abstract formative processes have been made clear to me. Three new developments in science during the twentieth century—the improved visual telescopes, the radio telescope and the electron microscope—have vastly increased our ability to envision the universe. These new instruments of science have helped me in my study of the origins of galaxies. New photographs of galactic phenomena have enabled me to trace the flow of energy from the beginning superimposition of the galactic streams to the spiraling, multiringed forms of the mature galaxies, and even further to the origins of the planetary nebulae. It is now possible for us to follow the process out to the formation of our own planetary nebula and our planetary systems. This is an important gain for artists because it enables us to

follow the processes of creation. And even further, it enables us to see these galactic movements in the growth and development of every form on our planet. All forms bear the stamp of these basic creative energy processes; in them we have found the essential abstractions of nature.

My use of the human figure to form the elements of the sculpture of these patterns has a particular logic to me. As humans we embody all of the galactic forms, and we function always to express these forms and proportions in relating to the planet and the galaxy. When we see the energy patterns of nature, we see them not only with our eyes, but with our entire bodies, for we are creatures made of perceiving protoplasm swimming in the energy ocean of the universe. I have always felt that my sculpture ideas have not come *from* me so much as *through* me. The sculptures that I have done in my life have been my way of echoing the images of movements of energy that pass through my being.

The welding process has been a great help to me in my work. The molten metal challenged me to overcome the resistance of bronze through the development of my skills in the uses of flame and my concentration on the broad movements of form. Welding is not a method geared to the smaller details of form, but one that forces the sculptor to focus on the main lines. I have found that welding offers the sculptor a modeling experience that lies in the subtle realm between the fluid and solid states of matter.

I feel now that my earlier desire to create a sculpture park and chapel were not entirely in error. I see now how important it is for the sculptor to be truly in touch with the human body as the source of all knowing, for the human body is itself a chapel (or temple if you will), and the park of the earth is a vast cathedral that sounds with the music of the creative energy of the universe.

The Rise of Consciousness.

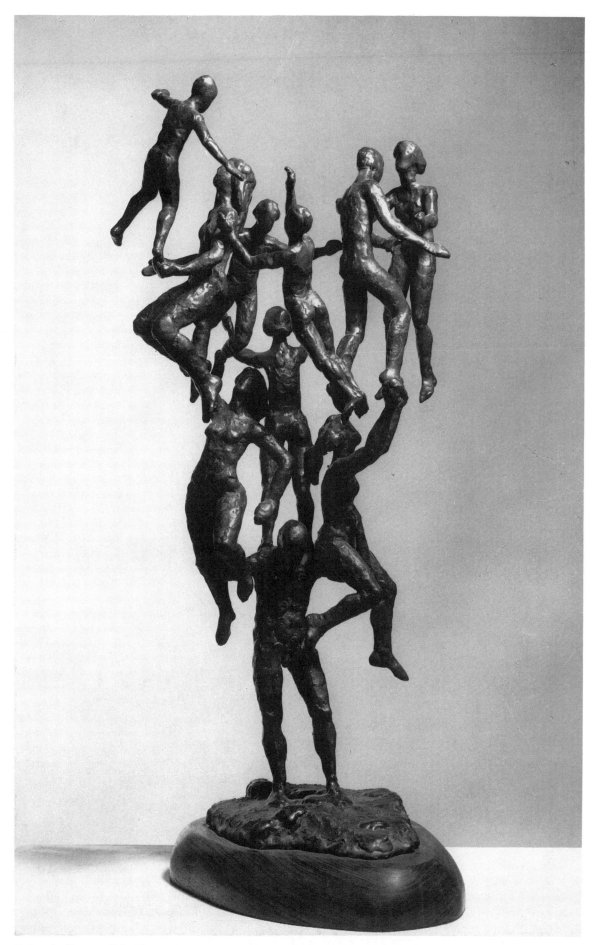

I Am the Past and the Future.

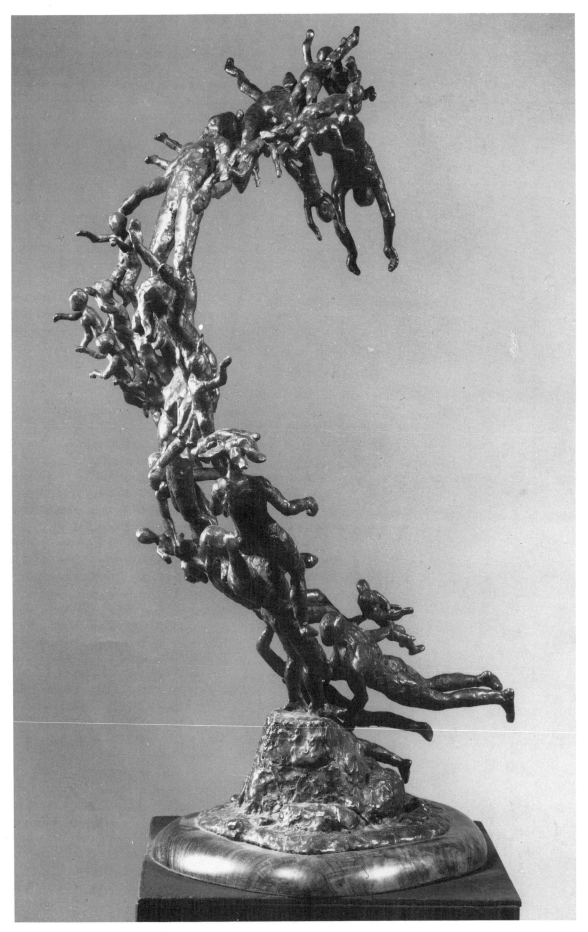

The Cosmic Flood.

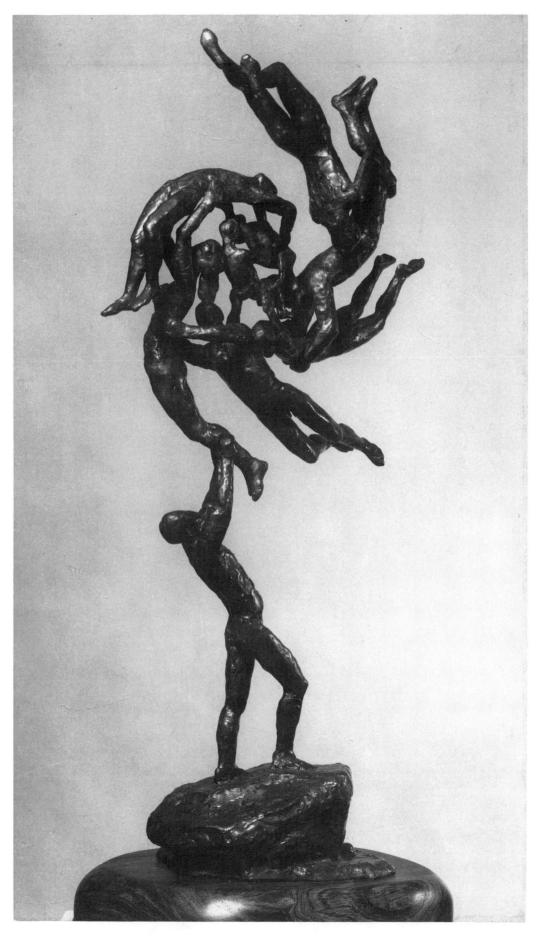

The Great Galaxy.

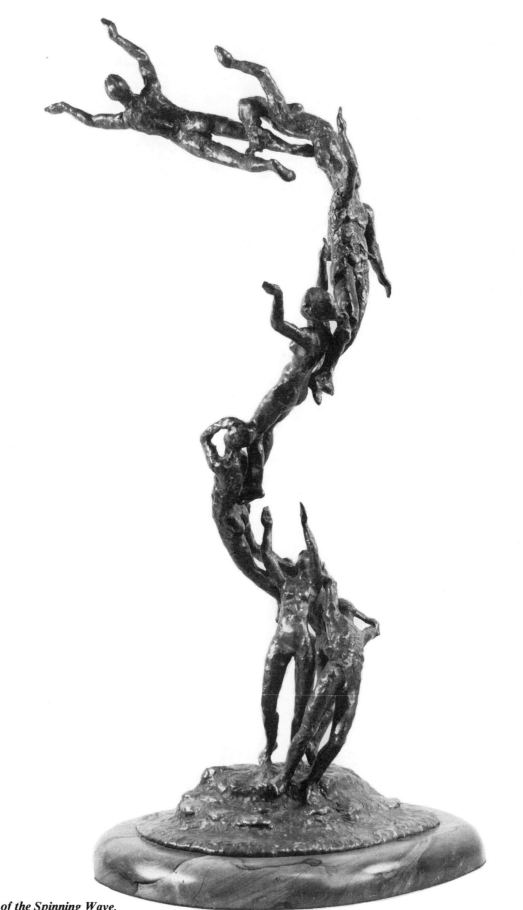

The Reach of the Spinning Wave.

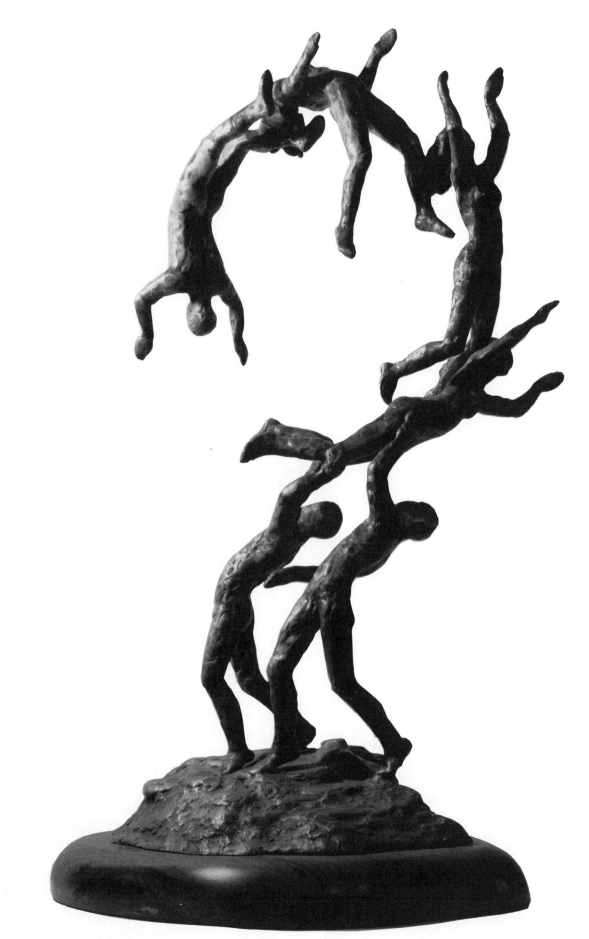

The Curve of the Straight Line.

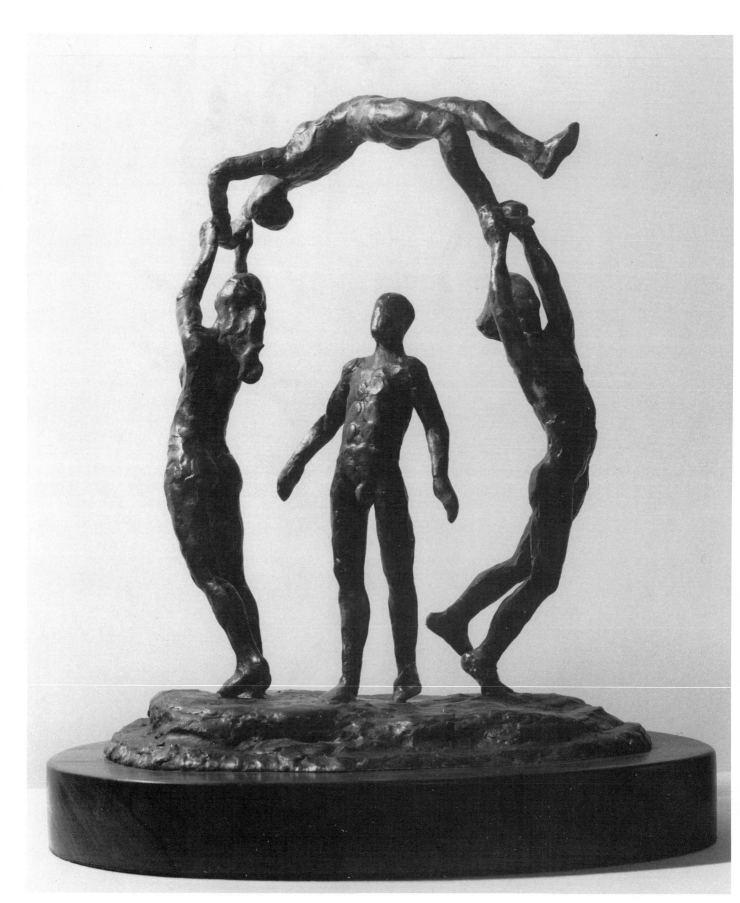

Into Maturity.

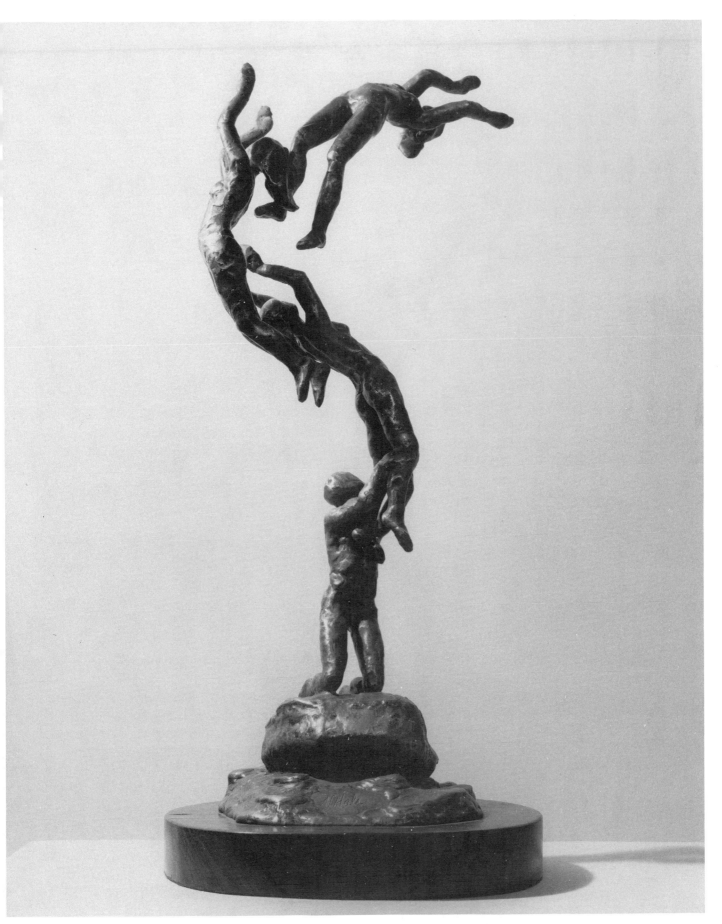

River of Desire.

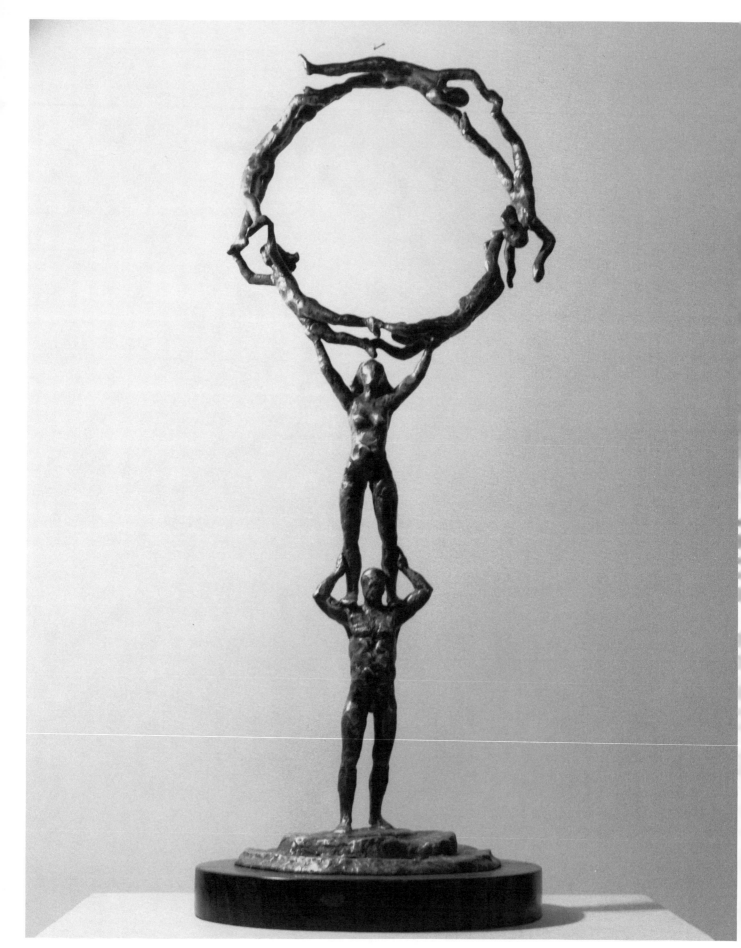

The Nature of Life.

196

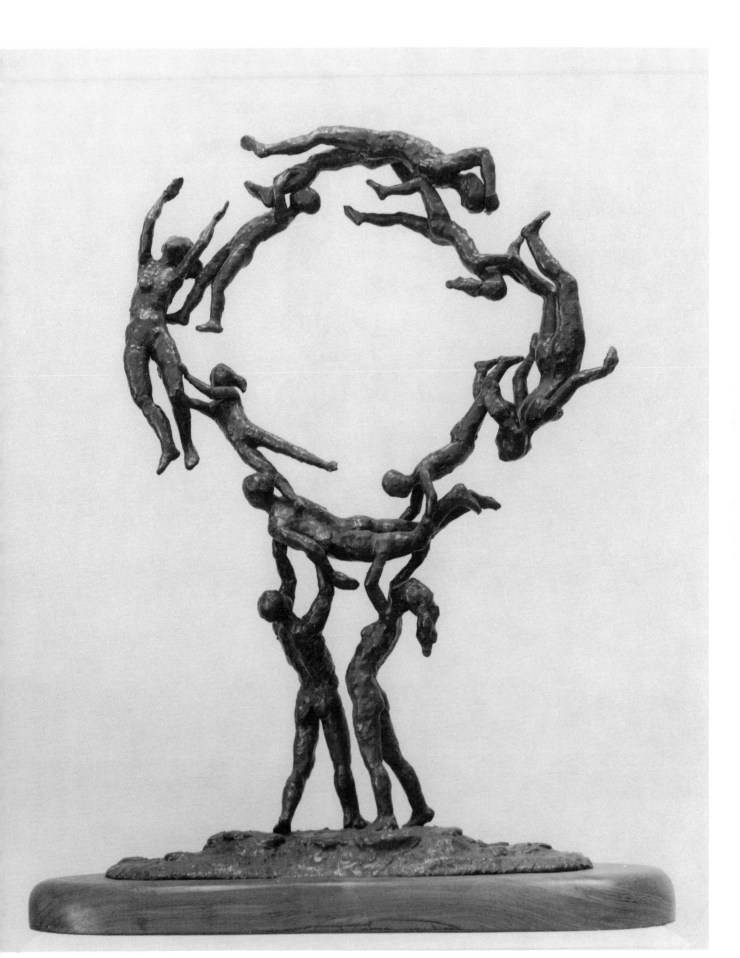

Community of the Living.

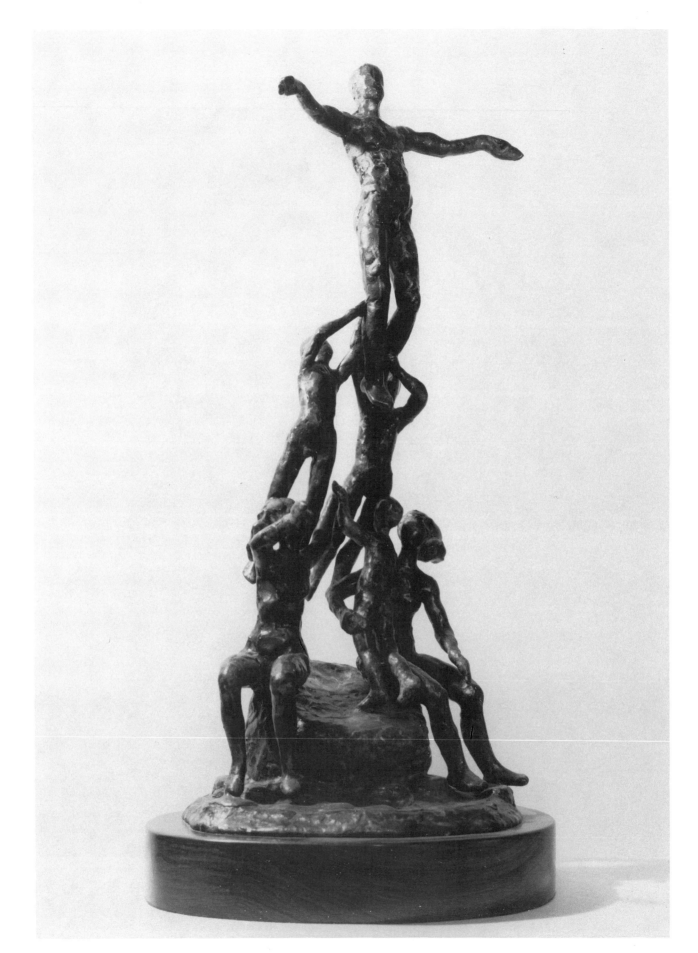

The Great Cross: Love, Work and Knowledge.

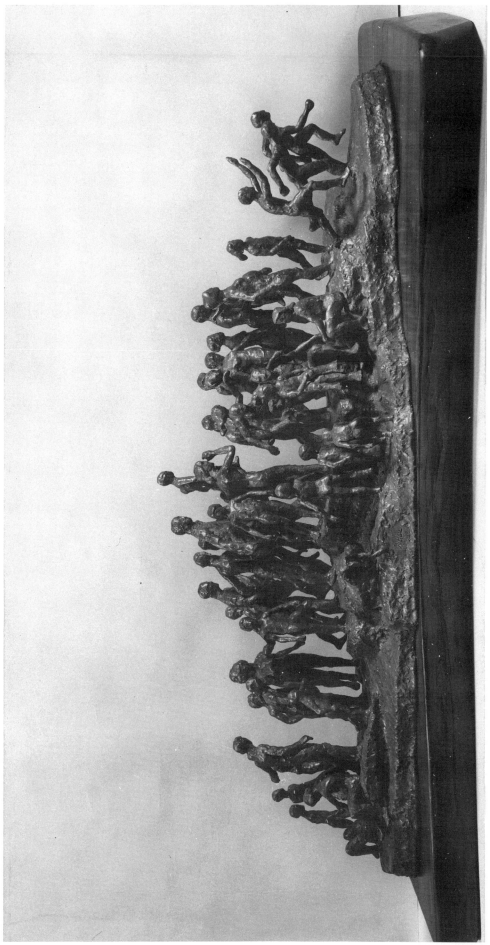

The River That Has No End.

Bibliography

☐ **WELDING**

Air Reduction Company, *Welding Manual*
Craftsman Tools, *Weldor's Handbook*
Linde Air Products, *Oxy-acetylene Handbook*
National Cylinder Gas Company, *Oxy-acetylene Manual*

☐ **ANATOMY**

Hale, Robert B., *Drawing Lessons from the Great Masters,* Watson-Guptill
Hatton, Richard G., *Figure Drawing,* Dover
Peck, S. R., *Atlas of Human Anatomy for the Artist,* Oxford
Schider, Fritz, *An Atlas of Anatomy for Artists,* Dover
Thomson, Arthur, *A Handbook of Anatomy for Art Students,* Dover

☐ **NATURAL FORMS**

Cole, Rex Vicat, *The Artistic Anatomy of Trees,* Dover
Thompson, D'Arcy, *On Growth and Form,* Cambridge

☐ **SCULPTURE**

Hoffman, Malvina, *Sculpture Inside and Out,* Bonanza
Lanteri, Edouard, *Modelling and Sculpture,* Dover
Rich, J. C., *The Materials and Methods of Sculpture,* Oxford

☐ **ARC WELDING**

Lincoln Electric Company, *Procedure Handbook*